CW00937804

It's Alive!

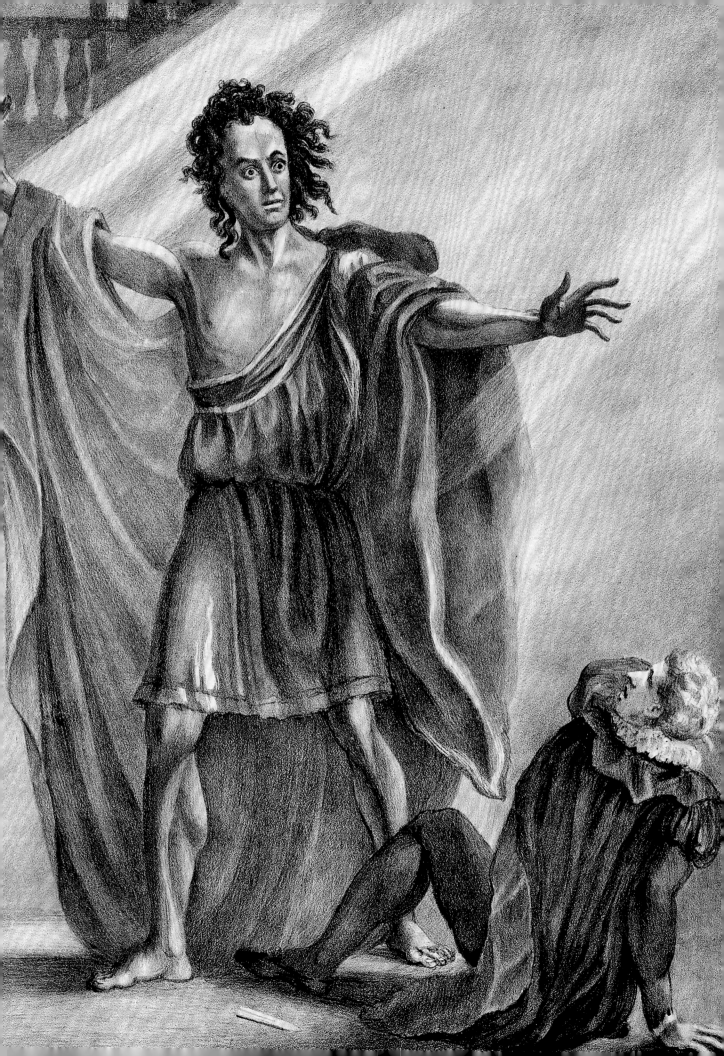

IT'S ALIVE!

A VISUAL HISTORY OF

FRANKENSTEIN

BY Elizabeth Campbell Denlinger

The Morgan Library & Museum, New York

in association with

D Giles Limited, London

2018

Published to accompany an exhibition at the Morgan Library & Museum, 12 October 2018–27 January 2019

Lead Corporate Sponsor
Morgan Stanley

The exhibition and catalogue are also made possible with lead funding from Katharine J. Rayner, Beatrice Stern, and the William Randolph Hearst Fund for Scholarly Research and Exhibitions, generous support from the Ricciardi Family Exhibition Fund, the Caroline Morgan Macomber Fund, the Franklin Jasper Walls Lecture Fund, Martha J. Fleischman, and The Gladys Krieble Delmas Foundation, and assistance from The Carl and Lily Pforzheimer Foundation, Robert Dance, and Lisa Unger Baskin.

Copyright © 2018 The Morgan Library & Museum
First published in 2018 by GILES

An imprint of D Giles Limited
4 Crescent Stables, 139 Upper Richmond Road,
London SW152TN, UK
www.gilesltd.com

LIBRARY OF CONGRESS CATALOGING-IN-PUBLICATION DATA

Names: Denlinger, Elizabeth Campbell, author.
Title: It's alive! : a visual history of Frankenstein / by Elizabeth Campbell Denlinger.
Description: New York : The Morgan Library Museum, 2018. | "Published to accompany an exhibition at the Morgan Library & Museum, 12 October 2018/27 January 2019." | Includes index.
Identifiers: LCCN 2018026429 | ISBN 9781911282419
Subjects: LCSH: Shelley, Mary Wollstonecraft, 1797/1851. Frankenstein. | Shelley, Mary Wollstonecraft, 1797/1851/Influence. | Frankenstein's Monster (Fictitious character) | Frankenstein, Victor (Fictitious character) | Frankenstein films.
Classification: LCC PR5397.F73 D46 2018 | DDC 823/.7/dc23
LC record available at https://lccn.loc.gov/2018026429

ISBN 978/1/911282/41/9

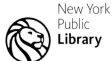
Published in association with The New York Public Library, Astor, Lenox, and Tilden Foundations.

Front cover: Barry Moser (born 1940), *A Stream of Fire,* wood engraving in Mary Shelley (1757–1851), *Frankenstein; or, The Modern Prometheus,* West Hatfield, MA: Pennyroyal Press, 1983. The Morgan Library & Museum, gift of Jeffrey P. Dwyer.

Printed in Canada.

CONTENTS

DIRECTOR'S FOREWORD

THIS EXHIBITION shows how Mary Shelley created a monster. Commemorating the two-hundredth anniversary of *Frankenstein*, it traces the origins and impact of her novel, first published in 1818 and now acclaimed as a classic of world literature, a masterpiece of horror, and a forerunner of science fiction. Shelley conceived the archetype of the mad scientist who dares to flout the laws of nature. She devised a conflicted creature, eloquent and repulsive, torn between good and evil. Her monster spoke out against injustice and begged for sympathy while performing acts of shocking violence. In the movies he can be a brute pure and simple, yet he is still an object of compassion and remains a favorite on stage and screen.

Theatrical adaptations created the fame of *Frankenstein*. As much as Shelley wanted to make money in the Gothic genre, she pitched the novel to a highly educated reading public and launched it in a modest first edition of only five hundred copies. She told the story within an intricate narrative framework, which includes disquisitions on religion, politics, social justice, women's rights, and scientific ethics. Her creature reads Plutarch and quotes Milton. In the theater, however, the monster is mute, a terrifying transformation accomplished by the gifted mime Thomas P. Cooke, who played that part beginning in 1823. Cooke took London and Paris by storm. "But lo & behold!" wrote the author after seeing one of his performances, "I found myself famous!" Dramatizations caught the popular imagination and inspired the movie versions, which spawned spin-offs, sequels, mash-ups, tributes, and parodies. Replicants of *Frankenstein* are so prevalent in today's culture that the name has become a meme and metaphor, signifying forbidden science, unintended consequences, and ghastly amalgamations.

The Morgan is in an excellent position to illustrate these developments. Its holdings of literary manuscripts, books, prints, and drawings are rich in documents about Mary Shelley, her life and work, her radical heritage, and her intellectual milieu. Some were acquired by the founder of this institution, John Pierpont Morgan, who was fascinated by the creative process and sought to explicate it with artifacts such as a first edition *Frankenstein* annotated by the author. Later gifts and bequests have enriched those resources. Endowed funds have given us the means to build on strength and pursue acquisitions such as the playbill for the first performance of the first theatrical adaptation, which came up for sale when we were beginning to think about this project.

Several institutions generously agreed to lend to the exhibition. The Bodleian Library, University of Oxford, allowed us to choose pages in Mary Shelley's autograph manuscript containing the most important passages in the novel. The Detroit Institute of Arts gave us the opportunity to display the greatest horror painting of the eighteenth century, Henry

Fuseli's *Nightmare,* a source for the novel and more than one of the movies. For artwork on related themes we are indebted to the Bibliothèque de Genève; the Bibliothèque nationale de France; the Derby Museums Trust; the Huntington Library, Art Collections, and Botanical Gardens; the Lewis Walpole Library, Yale University; the Pennsylvania State University Libraries; and the Yale Center for British Art. We have been able to evoke the Frankenscience of that period with experimental apparatus loaned by the Smithsonian's National Museum of American History and the New York Academy of Medicine Library. We can show how the monster appeared in the movies with graphics and makeup models provided by the Academy of Motion Picture Arts and Sciences; the California Institute of the Arts Library; the Harry Ransom Center, University of Texas, Austin; The John Kobal Foundation; and the Museum of the Moving Image. The novel begins and ends with references to Milton, whose influence on Mary Shelley can be demonstrated by her copy of *Paradise Lost,* which comes to us through the good offices of the Princeton University Library. Richard Rothwell's definitive portrait of the author is one of the centerpieces of the exhibition, courtesy of the National Portrait Gallery in London.

I should also acknowledge the generosity of collectors. Matthieu Biger, Robert Dance, Stephen Fishler, Clizia Gussoni, Alexander B. V. Johnson, Roberta J. M. Olson, and Craig Yoe have entrusted to us prints, drawings, and startling examples of merchandising ventures.

The author of this volume and the curator of the exhibition is Elizabeth Campbell Denlinger, formerly an assistant curator in the Morgan's Printed Books Department. She is now Curator of the Carl H. Pforzheimer Collection of Shelley and His Circle at The New York Public Library, in which capacity she has written and lectured extensively on topics related to *Frankenstein.* In addition to her expertise, I am very grateful for her advice and assistance in arranging loans of books, prints, and manuscripts in the Pforzheimer Collection and The New York Public Library for the Performing Arts. She has worked closely with Morgan staff members, most notably John Bidwell, Astor Curator of Printed Books and Bindings, the organizing curator of the exhibition, to whom I am extremely grateful. I thank also Karen Banks, Publications Manager, and Patricia Emerson, Senior Editor. Marilyn Palmeri and Eva Soos obtained the illustrations, many of which are from photographs by Graham S. Haber and Janny Chiu. Conservators Maria Fredericks, Frank Trujillo, and Reba Snyder prepared material for the installation, which was ably supervised by John D. Alexander, Senior Manager of Exhibition and Collection Administration, and Winona Packer, Registrar. The exhibition designer was David Hollely, the graphics were produced by Miko McGinty Inc., and the gallery lighting was provided by Anita Jorgensen. I should also recognize the contributions of the typographer Jerry Kelly, who designed this visual history, and the artist Barry Moser, who supplied visuals in this volume based on the wood engravings he made for his Pennyroyal Press edition of *Frankenstein.*

The exhibition occupies two galleries: one documenting the life of Mary Shelley and the composition of her book, the other showing how the story evolved in the theater and cinema.

It covers a lot of ground and has required extra effort to organize accompanying educational programs and public events. For these reasons we are all the more grateful for lead sponsorship from Morgan Stanley, for major gifts from trustees Katharine J. Rayner and Beatrice Stern, and to The Hearst Foundations for establishing the William Randolph Hearst Fund for Scholarly Research and Exhibitions in 2012, which also covered a significant portion of project expenses. Generous support was provided by the Ricciardi Family Exhibition Fund, the Caroline Morgan Macomber Fund, Martha J. Fleischman, and The Gladys Krieble Delmas Foundation, along with additional assistance from The Carl and Lily Pforzheimer Foundation, Robert Dance, and Lisa Unger Baskin. The Franklin Jasper Walls Lecture Fund underwrote the lectures on this topic and provided the means to rework those lectures for this publication. The Carnegie Corporation of New York has generously funded the production of an online curriculum with lesson plans keyed to selected highpoints in the exhibition.

The title of this publication—*It's Alive!*—has a long lineage in the movies, the theatrical productions, and the novel. Mary Shelley began to write the novel after hearing Percy Bysshe Shelley and Lord Byron discussing the origins of life and the possibility of animating a corpse by galvanic action. As she drifted off to sleep that night, she had a dreamlike vision of a "pale student of unhallowed arts kneeling beside the thing he had put together." The "thingness" of the creature became a recurring theme introduced by *it*, a frightening neuter pronoun. In the 1823 theatrical version, Frankenstein is heard offstage exulting at the success of his experiment, "It lives! It lives!" In 1931 the screenwriters for the iconic Boris Karloff movie improved on that line by having the crazed scientist look up from the operating table and exclaim, "It's alive! It's alive!" In this anniversary year, we can show that *Frankenstein* is still very much alive with vivid evidence of its literary stature, artistic influence, cultural versatility, and superhuman strength.

COLIN B. BAILEY
Director

TOO HORRIBLE FOR HUMAN EYES: THE *FRANKENSTEIN* MYSTIQUE

T HE REASONS for the worldwide fascination with Mary Shelley's first novel are blazingly obvious, but *Frankenstein* also raises difficult questions. Whose curiosity is not aroused by a creature made but not born, fashioned out of the limbs of the dead? The more difficult question is why does Victor Frankenstein reject a creature committed to humanity, reason, and the return of kindness for kindness, who seeks a peaceful vegetarian life in the jungles of South America? The answer lies in the creature's looks. During their long conversation on the Mer de Glace, after the creature has told Frankenstein the pathetic story of his life, his education, and the wrongs he has suffered, after he has demanded that Victor make him a bride so that he can live peacefully and "in my dying moments . . . not curse my creator," Victor considers:

> *His words had a strange effect upon me. I compassionated him, and sometimes felt a wish to console him; but when I looked upon him, when I saw the filthy mass that moved and talked, my heart sickened and my feelings were those of horror and hatred.*

Mary Shelley's novel arouses in the reader a desire for Victor's experience—for the sight of the creature *and* for the disgust he feels, heartsick though he is, because human eyes perversely long to see sights like the creature's face, "wrinkled into contortions too horrible for human eyes to behold." This desire for the pleasures of disgust and horror lies behind the history of Gothic art of which *Frankenstein* is a legitimate child. The urge to gratify it led generations of directors, playwrights, and screenwriters to silence the creature, thereby making him simpler, stranger, contemptible.

If the creature's moral capacity is simplified in early plays and films by his muteness, Victor Frankenstein's is simplified by his portrayal as presumptuous, competing hubristically with God. This, too, is a crucial deviation from Shelley's novel. There, although Frankenstein regrets having made the creature, his qualms are ambiguous and ultimately retracted. Frankenstein spends his final moments exhorting Walton's sailors to *keep going* toward the North Pole, to fulfill their captain's ambition, even if they die in the effort. The sailors decline. His last words are more ambiguous but come down on the side of presumption:

> *Farewell, Walton! Seek happiness in tranquility, and avoid ambition, even if it be only the apparently innocent one of distinguishing yourself in science and discoveries. Yet why do I say this? I have myself been blasted in these hopes, yet another may succeed.*

After Frankenstein dies, the creature appears to say farewell before becoming his maker's companion in death.

1823: Thomas P. Cooke in *Presumption!*
or, The Fate of Frankenstein

1826: Richard John Smith in
Frankenstein; or, The Man and the Monster!

The title page of the 1818 edition gives us the keys to both creature and creator and shows how they are bound together. The subtitle, *The Modern Prometheus*, tells us that we should take seriously Frankenstein's claim that his intention—to create "a new species [that] would bless me as its creator and source"—is benevolent and not merely egotistical. Prometheus, one of the Titans, steals a spark in a stalk of fennel from the gods on Mount Olympus to give fire to humankind. That gift and the punishment Zeus inflicts on him, to be chained to a rock, with his liver being eaten by an eagle every day and regenerating itself every night, have made him, to Christians, a prefiguration of Jesus. *Frankenstein*'s first readers would have seen the novel's epigraph immediately following the subtitle. Originally from Book X of *Paradise Lost*, it is uttered by Adam as he laments his fall: "Did I request thee, Maker, from my clay / To mould me man? Did I solicit thee / From darkness to promote me?" Even the title page emphasizes the novel's double focus, shifting from Victor, the modern Prometheus, to the creature, into whose mouth Shelley has put the most eloquent version of the child's cry, "I didn't *ask* to be born!" They are father and child, God and Adam, Pygmalion and Galatea—but one of them has a terrible disability. Mary Shelley consistently identifies that disability as the creature's loathsome appearance. Frankenstein's physical attributes are never described.

Beneath the attractive-repulsive eye appeal in *Frankenstein*, beneath the identities of parent and child, lie a deeper disgust and a stronger pull: the horror of the creature's body and the pull of identification itself. The creature's body is made from those of the dead, and his touch is death; the readiest refuge from the fear of death is to tell oneself that this is, after all, fiction. And yet to speak of "the creature" rather than "the monster," "the demon," or "the wretch" reminds us that we are ourselves creatures. We were not made as he was, but the biological mysteries of sperm and egg (or their more complicated corollaries) are just as peculiar as the never-explained process by which Frankenstein infuses the spark of life into his creature's "yellow, watery, but speculative eyes." Both dis-

gust with the creature's touch and the pull of identification are stronger in the novel than in most of the theatrical or cinematic adaptations because there is more room to give expression to these tropes in the more intimate experience of reading or listening to a novel. The passages describing Victor's work and those in which the creature reports on reading about his own making are among the most compelling. Even more so is the creature's account of his intellectual development and self-education, which leads the reader to feel deeply for him. But the identification of reader with creature is only one direction in which identities slide in *Frankenstein*'s history: in her 1831 introduction, for instance, Shelley speaks of the novel as "my hideous progeny," identifying herself as the maker of monsters. In James Whale's 1935 *Bride of Frankenstein*, however, Elsa Lanchester plays both Mary Shelley and the female creature, implicitly making *her* the monstrous one.

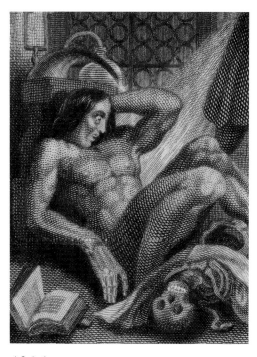

1831: The creature in the frontispiece of the third edition

Most famously, the slippage between Frankenstein and his unnamed creature has made the man and the monster universally synonymous. "For Mary Shelley," one preeminent scholar tells us, "it was not enough that the book should speak to our fears: the fears were to be 'mysterious,' that is, unconscious and inexplicable sources of psychic disturbance. It is a novel (*the* novel, some would say) about doubling, shadow selves, split personalities."[1] That doubling speaks not only to our fears but also to the fantasy, rooted in babyhood and elaborated in adolescence, of a relationship that surpasses language or the division of bodies. Frankenstein and the creature are tied to each other more tightly than any real-life relationship allows, and their constant pursuit of or flight from each other structures the novel. The creature knows Frankenstein's movements so well that he seems to see through Victor's eyes. For his part, Victor resists the relationship with all his might, until, with the death of Elizabeth Lavenza, his fiancée, he resolves to pursue and destroy his creation. With a few notable exceptions, such as the 2011 stage version directed by Danny Boyle, in which two actors alternated in the parts of creature and creator, this pairing is destroyed when the tale is

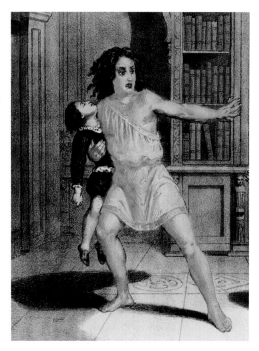

1861: François Ravel in *Le Monstre et le magicien*

1884: The creature in a cheap reprint edition

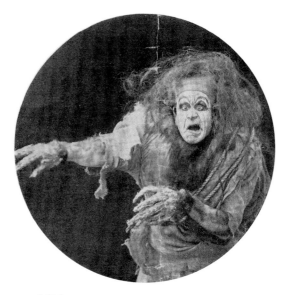

1910: Charles Ogle in *Frankenstein*

enacted. The act of reading is more closely linked to the imagination, which enables a deeper identification with the monster than is possible on stage or screen. The dramatic mandate to *show* whatever is most important means that the creature, however embodied, must be inhumanly wondrous.

Our greedy-eyed world has made the sight of the mysterious monster the most important element of the novel's popularity: the 1823 production, in which a blue-skinned Thomas Cooke lent his graceful and athletic form to the character, identified on the playbill as "———," led straight to a second edition of the novel. The 1931 film, directed by James Whale and starring Boris Karloff as the monster— identified in the credits as "?"—constitutes a new work altogether, cruder than Shelley's but more powerful, giving it the significance of a myth. The Internet Movie Database now lists 208 films and television shows with *Frankenstein* in the title, a number not to be taken as comprehensive.

The subject of this book is *Frankenstein* as it has been seen and shown, with particular attention to Mary Shelley's life and the culture that made it possible for her to write it. Early chapters focus on her milieu and the circumstances of the novel's composition. Later ones explore the creature's portrayal on stage and screen as well as the representation of the creature and the story he shares with Victor Frankenstein in comics, graphic novels, book illustrations, and posters. These will be investigated with a double aim: first, to see some of the reasons why Shelley's novel has such continuing fascination (one of the landmark critical texts devoted to it is titled *The Endurance of Frankenstein*); and second, to explore its particularly *visual* power to fire the imagination for so many generations of readers.

Before James Whale's 1931 *Frankenstein*, before the Edison Studios' 1910 *Frankenstein*, even before Mary Shelley's 1818 *Frankenstein*, readers had long been entranced by the most important sources for the book's visual power, and these are our starting points. We begin with the Gothic strand of European culture, a constant spooky presence in paintings, prints, chapbooks, ballad sheets, and (above all) novels of the period.

The Morgan has been fortunate enough to borrow for this exhibition some of the great British paintings in the Gothic style, including Henry Fuseli's *Nightmare,* and it has obtained reproductions of works in related genres for this publication.

Alongside the Gothic and sometimes indistinguishable from it, dependent as they both are on corpses, skeletons, and a fascination with the bizarre, is the practice of science and medicine in the eighteenth and early nineteenth centuries. Victor Frankenstein, with a bent for alchemy, is a reluctant scientist. Mary Shelley, though, had the galvanic experiments of her time and stories about Erasmus Darwin in mind when she wrote. She found inspiration in the conversation of her scientifically minded husband and her own knowledge of how the bodies of hanged convicts supplied anatomy classrooms with cadavers. This scientific legacy in prints and paintings is also shown in these pages.

Mary Wollstonecraft Godwin, as she was named at birth, was fated to be both rational and haunted. Her history and early life could easily fit into a Gothic novel: her mother, the pioneering feminist thinker Mary Wollstonecraft, died of puerperal fever ten days after giving birth to her second daughter, and the child was brought up visiting her mother's grave. Her father, William Godwin, was a pioneering philosopher and a novelist, a founder of the genre that became the detective thriller. At the time of Mary Godwin's birth, in 1797, the British government was driven by fears of a revolution like those that had taken place in France and the United States, and British society was thick with spies reporting on its subjects, a surveillance state not unlike the United States during the tenure of J. Edgar Hoover.

William Godwin was part of the opposition to this rule of fear. He knew what it was to have to watch his words, both written and spoken; he knew, too, what it was to be haunted by debt, as would his children. When Mary Godwin grew up to fall in love with a married poet from a rich family, she would have felt the monstrous shame inflicted by her culture. Before she was eighteen she had already lost a daughter of her own. Percy Bysshe Shelley had his own troubles: when he

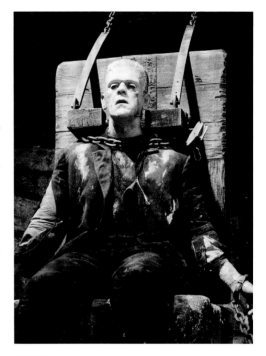

1935: Boris Karloff in *The Bride of Frankenstein*

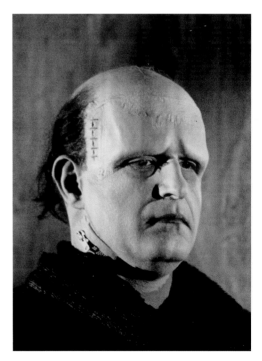

1974: Peter Boyle in *Young Frankenstein*

1983: The creature in a wood engraving by Barry Moser

met Mary Godwin, his hastily made marriage to the former Harriet Westbrook, a sweet and lovely young woman by no means his intellectual peer, was breaking down. Shelley's radical political views, partly taken from the works of William Godwin, and his tenaciously held atheism led to his withdrawal of his 1813 poem *Queen Mab* from public circulation to avoid a blasphemy suit; the publisher had already refused to put his name on the book. Nonetheless, Shelley lost custody of his two children in 1817, the court regarding him as unfit because of his politics. The effect of this political and familial turmoil is perceptible in *Frankenstein,* and while the visual record of Mary Shelley's early life is thin, I have summarized it here as the ghostly commencement of the ever-growing cultural legacy of the novel she wrote when she was eighteen and nineteen years old. Much of the novel's manuscript has survived, and readers will be able to closely examine its images. They will see manuscripts of other writers, too, such as Lord Byron's apocalyptic poem "Darkness," inspired by the same dreary weather that kept the little party of Byron, Mary Godwin, Percy Bysshe Shelley, Mary's stepsister, Claire Clairmont, and Byron's doctor, John Polidori, indoors during that "wet, ungenial summer" by the shores of Lake Geneva, where *Frankenstein* was conceived. There is also an illustrated account of the novel's composition and of Mary Shelley's life, which is just as tragic—and in its early days almost as improbable—as *Frankenstein.*

Although it is hoped that this book may prove useful to scholars or to teachers of the novel, it is by no means a scholarly work. The outsize proportions of *Frankenstein*'s themes—life, death, parenthood, monstrosity, the meaning of human identity, just to start with—have created an enormous body of scholarship. Marshall Brown gives a thumbnail sketch of the criticism:

> Critics have found [Frankenstein] *a more or less direct representation of Shelley's biography, a reckoning with the ideas of her parents, a fable of the role of women, or of the unconscious, or of family or social structures, or of political turmoil, or scientific discovery, of colonialism, economic theory, capitalist enterprise, or literary production.*[2]

More examples might easily be adduced. To take a statistical approach, for example, a search under "Frankenstein" in the JSTOR database of academic books and articles returns 13,716 results in 70 subjects—from African American Studies to Zoology (taking in Sociology, Paleontology, Middle East Studies, and Labor and Employment Studies along the way).[3] This total number reflects the extent to which *Frankenstein* has saturated our culture rather than the degree to which it has been studied; but one of its most assiduous scholars, Charles Robinson, found that the novel is one of the most frequently assigned texts in the American college

classroom. And with 5,536 results in Language and Litera-ture, 789 in Film Studies, 1,243 in Education, and 1,547 in History, we can infer that *Frankenstein* is not only alive, it is unkillable. The present work was inspired by the fact that despite this extraordinary attention, there hadn't been a book focusing on how *Frankenstein* has been *seen*.

Its occasion, which also has been observed by other insti-tutions and publications, is the two-hundredth anniversary of the novel's publication, which took place New Year's Day, 1818. The round-numbered anniversary seems both significant and irrelevant: the elapse of two hundred years proves the novel's enduring power. Readers' longing to see the creature has not abated since 1818; it is hard to think of another book so universally loved, or of a sadder portrayal of the failure of human understanding. While much has changed since Mary Shelley's time, our present teaches us, as hers did then, that the strangest things may come true; and that the arts, all of them, even under a government hostile to them, can help us to understand our own natures, human and monster at once.

1994: Robert De Niro in *Frankenstein*

NOTES

1. Crook 2000, p. 59.
2. Brown 2003, p. 146.
3. This search undertaken 5 April 2017.

◖ NOTE TO THE READER

This volume is organized around the illustrations. We have called it a visual history of *Fran-kenstein* because artwork plays an important part in the production and reception of the novel. Literary documents are reproduced here with the intention of making them as legible as possible. The pictorial content proceeds in chronological order, beginning with biographical information about the author and concluding with an account of *Frankenstein* in contempo-rary culture. In accordance with that concept, we include dates in the headings, and we have placed the descriptive notes and technical data in a separate section, pages 318–25. We have also supplemented the narrative by inserting illustrations of some objects not included in the exhibition. All quotations from *Frankenstein* in this volume are taken from Marilyn Butler's Oxford World's Classics recension of the 1818 edition.

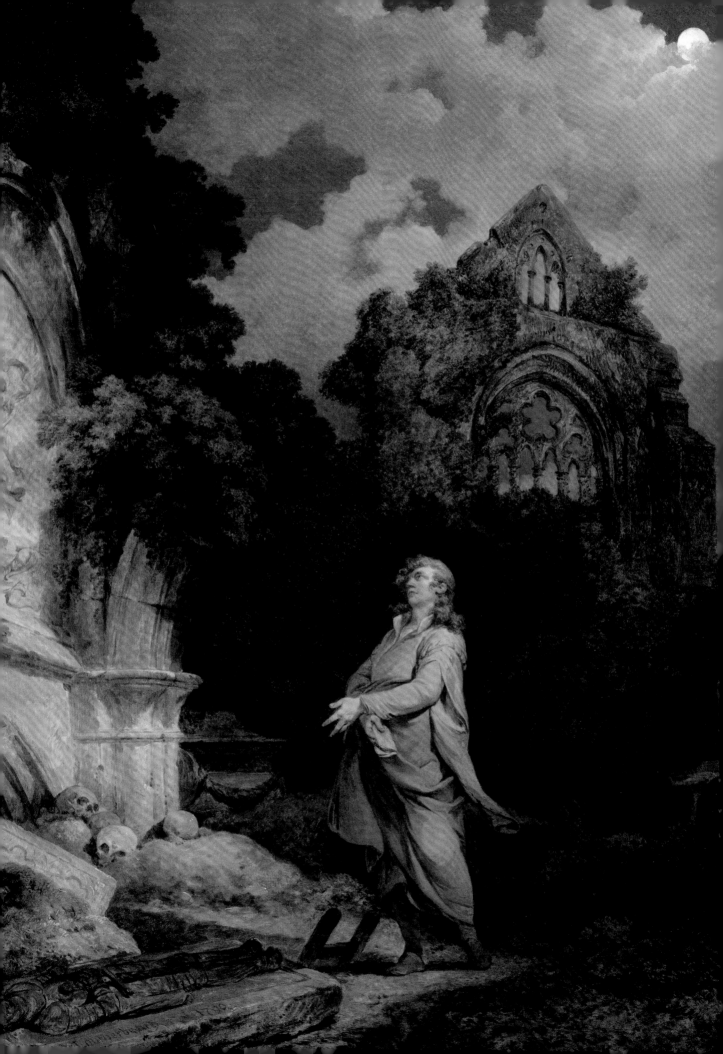

CHAPTER 1
THE GOTHIC BACKGROUND

THE WORD *Gothic* has a long history, signifying first a group of Germanic tribes who invaded the territories of other Europeans, perhaps most famously in the first sack of Rome, 24 August 410. The earliest sense connotes destructiveness, disorder, a wanton love of violence, from which broader meanings proliferated: particularly in regard to architecture, *Gothic* indicates pointed, towering, fanciful and irregular structures by contrast to the straight, symmetrical lines of Greece and Rome.

By the early eighteenth century in Britain, any sort of art that evoked the unnatural side of nature, the ghostly parts of life, might be called Gothic. The opening scene of Shakespeare's *Macbeth*, first performed 1606—in which witches on a blasted heath stir their unholy concoction —already shows a fully formed sense of the Gothic. But if we want to date the Gothic as a kind of narrative rather than a style, 1765 makes sense, when Horace Walpole added to the second edition of his *Castle of Otranto* the subtitle *A Gothic Story.* Opening with the sickly heir to the supposed prince of Otranto being crushed to death by a gigantic black helmet, the tale is full of Gothic features: a bleeding statue, an anchorite reduced to a living skeleton, and an enormous ghostly knight who wields a fifty-foot sword to put all to rights.

Other features of Gothic tales readily suggest themselves; the strength and persistence of these conventions is a hallmark of the style. Their geography: forests, caves, moonlit beaches, mountain passes, and howling moors (insofar as these are distinguishable from blasted heaths) are all natural places to set a Gothic story. Special favor was given to the Celtic nations and Britain's closest Catholic neighbors, France and Italy. (A strong anti-Catholic strain erupts regularly.) Built spaces are equally predictable: for living characters, castles, abbeys, ruinous mansions, underground tribunals of the Inquisition, private chapels, hermits' huts, and grottoes abound. But the Gothic locus par excellence is any home of the dead: graveyards, crypts, mausoleums, ossuaries, and gallows. Inhabitants of both kinds of places include possessed monks, women who only appear to be nuns, genuine and disguised hermits, highwaymen and banditti armed to the teeth, demons, and occasionally Satan himself. Wills, mysterious portraits, secrets half-uttered by a dying parent are the narrative spools from which plots about legitimacy and inheritance unwind, often at great length, twisted and knotted to the end.

The fifty-odd years between the publication of *Otranto* and that of *Frankenstein* were an eventful and violent period of British history. During that time, to mention only the major conflicts, Britain lost the thirteen American colonies after eight years of war; annexed Ireland,

after a series of bloody uprisings; greatly expanded its hold on India through the private armies of the East India Company; and, above all, fought with France in both the Revolutionary and Napoleonic periods. The French Revolution alone, which terrified the British government and led to harsh legal crackdowns on the freedoms of speech and association, might be taken as an explanation for the Gothic vogue, with its combined features of death, dismemberment, ghostly apparitions, *and* thrilling escape from the real world. (Since Napoleon's wars were global, it is no surprise that the rest of Europe was also mad for the Gothic, with Germany falling for it hardest.) There is rarely a clear causal relation between history and art, but where art is possible, every time and place creates the culture it needs. Britain of the 1990s had Sinead O'Connor, Tracy Emin, and Alexander McQueen; the 1790s had Ann Radcliffe, Monk Lewis, Henry Fuseli, and a plethora of skeletons.

Despite the power of the Gothic conventions, two quite different branches of style prevailed during the British Romantic period, ramifying just before Mary Godwin's birth: the school of Ann Radcliffe (1764-1823), most famously exemplified by her *Mysteries of Udolpho* (1794), in which apparently supernatural threats to the heroine's life or virginity are pursued through sublime or beautiful landscapes, resolved by rational explanations, and concluded with a wedding; and the horror Gothic, embodied by Matthew Gregory Lewis (1775-1818) and his novel *The Monk* (1796), in which bad things happen to good people (women, especially) and are neither redressed nor redeemed, though the malefactors are punished: the eponymous monk, for example, having sold his soul to Satan, is punished with myriads of insects drinking blood from his wounds while eagles tear his flesh and "dig out his eyeballs with their crooked beaks."[1]

Frankenstein, although far less gory, falls squarely within the second branch. Nora Crook outlined its points of correspondence with the tradition:

> The mouldering abbey is transformed into Victor's laboratory, with Victor as cloistered monk/student. A buried incest motif underlies Victor's betrothal to his "more than sister" Elizabeth. The towering spectre becomes an artificial man eight feet high, the secret tribunal becomes the secret ballot of the Geneva magistracy. The villain's pursuit of the maiden becomes the mutual pursuit of Victor and his Creature. It has a fatal portrait (Caroline Frankenstein's) and sublime landscapes (the Alps and Arctic wastes). The Creature, an Undead patched from corpses, is explicitly compared to a vampire and a mummy. The embargoed secret is that of human life itself.[2]

Frankenstein also, of course, exceeds these traditional plot points. While other novels featured demons (as in Charlotte Dacre's *Zofloya; or, The Moor,* 1806) or characters driven by unnatural obsessions (Charles Brockden Brown's 1798 *Wieland,* for instance, a favorite of Percy Bysshe Shelley), the star-crossed pair of monstrous creature and ghoulish creator is Mary Shelley's unique contribution to literature.

While the novel was the primary vehicle for the Gothic mode, the style was available to practitioners of other arts as well. From the 1760s onward, British painters favored subjects

from the medieval (and earlier) history of the British Isles. Some of the most famous exemplars of Gothic paintings—Henry Fuseli's *Nightmare* (1781) and *Three Witches* (ca. 1782)—are shown in this chapter, along with parodies, for the Gothic was parodied as soon as it was taken seriously. Here, in addition to prints and paintings, some outstanding examples of book illustration and design may be seen, from the high to the low end of the Romantic-era market. The Gothic as a whole, like its exemplar *Frankenstein*, evokes in the reader the wish to see with one's own eyes haunted, uncanny scenes from the nighttime side of nature.

Philippe-Jacques de Loutherbourg, A Philosopher in a Moonlit Churchyard, 1790

D E LOUTHERBOURG's style is the Gothic sublime, with every element—the moonlight, the ruins, the skulls, the philosopher's long, windblown hair—contributing to induce haunted wonder in the viewer. The young philosopher has just finished reading an incantation or a prayer. Standing before an open grave in the ruins of Tintern Abbey (a tourist destination well before the 1798 publication of Wordsworth's poem), he faces a bas-relief of Jesus leaving the tomb. Both his imploring expression and the open crypt imply an attempt to raise the dead. This kind of scene was de Loutherbourg's stock in trade, whether he

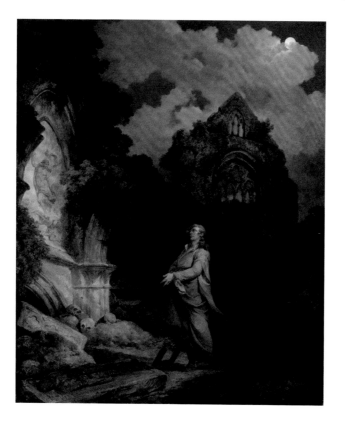

was painting or producing for the Drury Lane Theatre the most impressive stage sets and special effects London had ever seen, or later, when he built a miniature mechanical theater showing a shipwreck and scenes from Milton. De Loutherbourg's 1790 painting of the philosopher may not have been produced wholly from the imagination: long interested in the occult, he had four years previously engaged in a brief partnership with the notorious magician Count Cagliostro.

Charles Reuben Ryley, watercolor illustration for *The Monk*, ca. 1796

IN THIS SCENE from *The Monk*, young Rosario, companion of Ambrosio (the title character) reveals himself to be a woman named Matilda, in love with Ambrosio. Ambrosio condemns her to expulsion from the abbey, but the sight of her breast as she threatens to kill herself fills him with lust: "a raging fire shot through every limb; the blood boiled in his veins, and a thousand wild wishes bewildered his imagination."[3] There are good reasons why *Frankenstein* is taught more often than *The Monk*, but the driving force of the horror Gothic, a force shared by the works of Fuseli, Mary Shelley, and Matthew Gregory Lewis, is the pursuit of fear to its limit, where "there is no ordinary world to wake up in."[4] No one took it quite so far as Lewis, however: Matilda is not just intent on seducing Ambrosio, she has been created by Satan to steal the monk's soul. The first edition of the novel sold out quickly, and when Lewis, by that time known to his friends as "Monk," added his name and credential as a member of Parliament to the second edition, readers and journalists were appalled—both that a politician (only a slightly more dignified trade than it is now) should write something so scabrous and that large chunks of it were plagiarized from German horror novels. Lewis made significant cuts in a fourth edition of 1798, though piracies of the earlier ones stayed on the market. He remained identified with the novel for the rest of his life.

Franz Joseph Manskirch,
Interior of a Gothic Crypt, 1799

MANSKIRCH's scene could be taken straight from one of Ann Radcliffe's novels—*The Italian*, for instance, set partially in the subterranean courtrooms of the Inquisition. Both architectural and decorative details identify it as Gothic: the pointed doors, the high vaulted ceiling that dwarfs the visitors; the armor on the walls and sepulchral statue whose posture threatens an imminent rise from the dead. All of this is spooky in its own right, although mitigated by the cohort of early tourists (the *Oxford English Dictionary* notes the earliest occurrence of this word in 1780) who remind us that later we will go home and have a cup of tea. Manskirch's is an example of what was called a transparent or protean print, a specialty product designed to surprise the viewer: the parts of the paper on which the flames of the hanging lamp and the guide's torch are shown are colored and waxed for translucence. When held up to a light they glow a pellucid crimson, giving the viewer the sense of staring straight into a mystery. Unfortunately, this effect cannot be reproduced here.

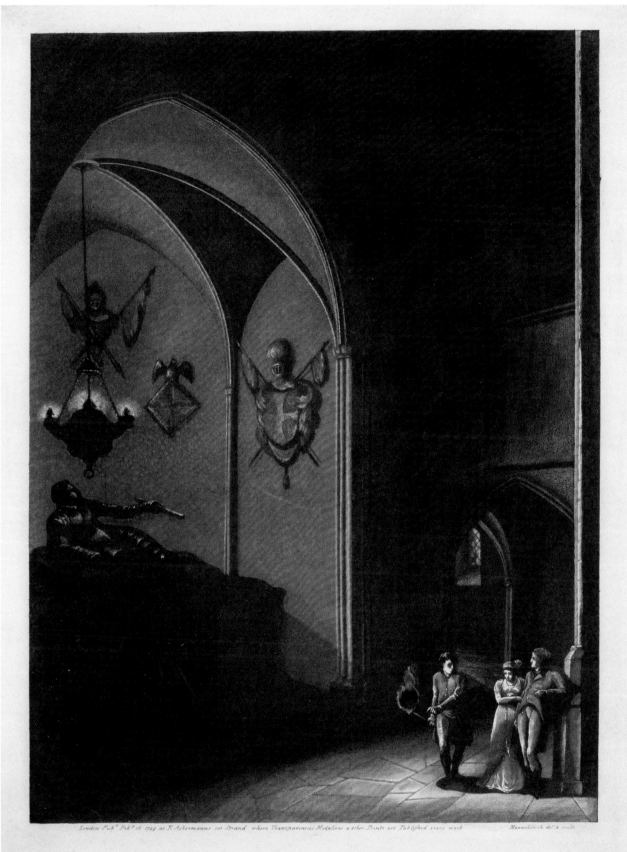

London Pub.ᵈ Feb.ʳ 16 1799 at R. Ackermanns 101 Strand where Transparencies Medallions & other Prints are Published every week Manneskirsch del.ᵗ & sculp.

N.º 18

John Hamilton Mortimer, Death on a Pale Horse, ca. 1775

"AND I LOOKED, and behold a pale horse; and his name that sat on him was Death, and Hell followed with him" (Revelations 6:8). When Mortimer, a dissolute yet productive painter and engraver, set out around 1775 to illustrate this passage, he followed a long line of artists attracted to the Four Horsemen of the Apocalypse, of whom Death on a Pale Horse is the last. In 1498 Albrecht Dürer set the standard in a woodcut showing all four horsemen. Dürer's figure of Death is a tiny, weak old man with a maniac's face. Mortimer makes his a skeleton and gives him the crown that in the biblical text belongs to the first horseman as well as a great deal of gleeful energy. Like the ghost in Bone's *Incantation Scene* (pp. 34–35), and like Lady Diana Beauclerk's skeletons (pp. 38–39), this Death is funny, cartoonlike in the Looney Tunes sense of the word. This comic strain was stronger in Gothic art than in literature; the immediacy of the visual evokes nervous laughter more quickly than narrative does. Mortimer's apocalyptic figures revive medieval traditions as Thomas Rowlandson's *Dance of Death* would do explicitly in 1815.

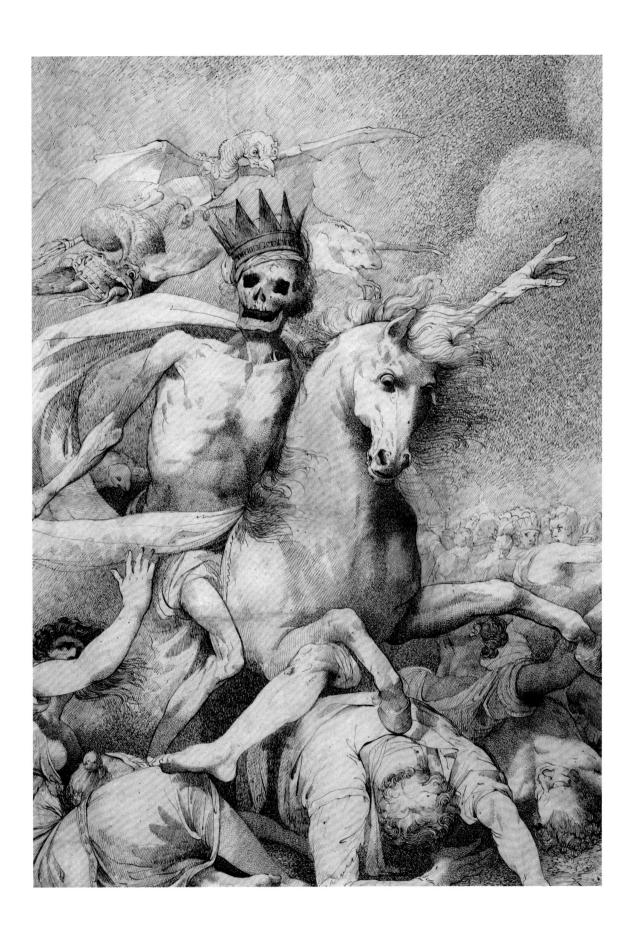

John Hamilton Mortimer, *Jealous Monster*, ca. 1778

I N 1778 Mortimer etched a series of monsters engaged in distinctly human activities and caught up in human emotions—"Successful Monster," "Winged Monster," "Musical Monster," and eleven others, including "Jealous Monster." While there is no reason to see these creatures as direct forebears of Frankenstein's creature, the interpenetration of the human and the monstrous is worth noticing. To see the whole series is to enter a mindset in which the monstrous slips easily into the human—the opposite of that produced by Goya's *Caprichos*, in which people constantly reveal themselves as horrific.

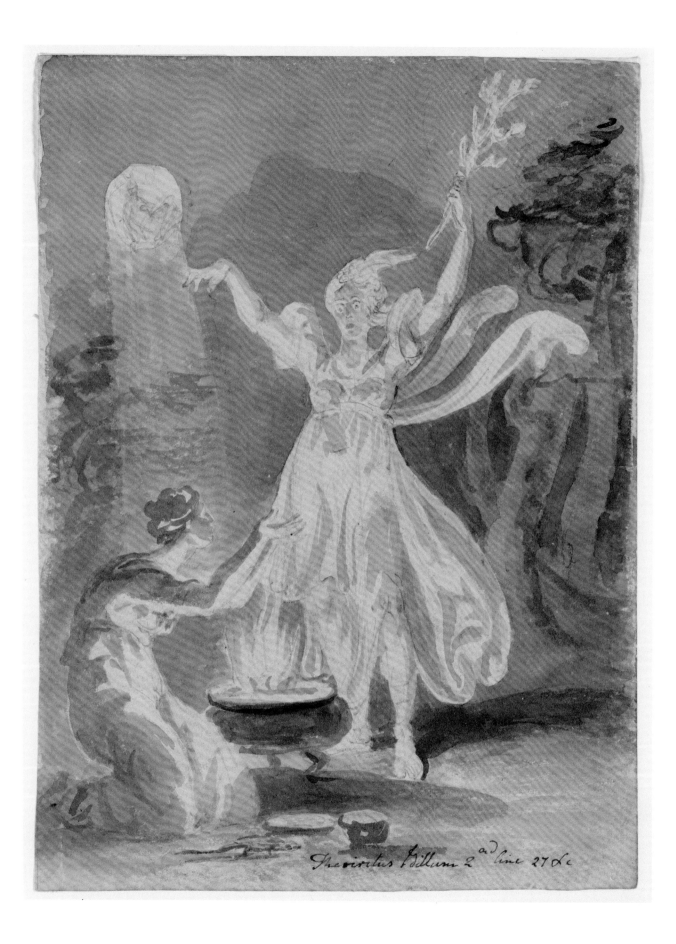

Theocritus Idillium 2ad line 27 &c

William Lock, *The Sorceress*, ca. 1784

THE PERSISTENCE of Gothic conventions collapses history, denying real change and allowing artists working in the mode to span centuries easily. The women of *The Sorceress* are in many ways similar to those of Henry Pierce Bone's *Incantation,* but Lock's source, "Theocritus Idillum 2nd line 27 &c."—the second Idyll attributed to Theocritus—dates to classical antiquity. This drawing shows Simaetha, a young woman unusually free of patriarchal guidance, burning ritual items in a cauldron. Her spell, occupying most of the poem, aims to win back Delphis, a young athlete with whom she has fallen into a briefly requited, now spurned, love. The second figure, despite her ghostly appearance, seems to be Simaetha's servant, Thestylis, who will soon gather the ashes of her mistress's sacrifices to smear on Delphis's lintel. For a later example of the Gothic foreshortening of history, recall the illustration of Victor Frankenstein leaving home in the first illustrated edition of *Frankenstein,* 1831 (or see p. 192): even though the novel is set in the 1790s, young Frankenstein wears Renaissance costume.

Bertie Greatheed, *Alphonso Appeared in the Center of the Ruins*, 1796

THE *Castle of Otranto*, Horace Walpole's genre-founding contribution to the literary Gothic, was published in 1764. But his obsession with the mode had begun more than a decade before. Walpole made his house, Strawberry Hill, a cynosure of the Gothic style in its architecture, landscaping, decoration, and collections of medieval (and faux medieval) artifacts. In 1796, the Della Cruscan poet Bertie Greatheed (1759-1826) showed Walpole four illustrations of *Otranto* by his fifteen-year-old son, also named Bertie (1781-1804). Soon after, Walpole wrote to the father that such works produced in boyhood were "indubitable indications of real genius."[5] This one portrays the gigantic ghost of Alfonso, who puts the inheritance of Otranto to rights. Separate appearances in the novel of an enormous helmet and a sword needing fifty men to lift it indicate Walpole's keen sense of the outsize—a sense that may have been inspired by Jonathan Swift's *Gulliver's Travels* (1726) with its Brobdingnagians or, additionally, Edmund Burke's influential treatise *On the Sublime and the Beautiful* (1757), which discusses (among much else) how vast landscapes produce a sense of the sublime.[6] All three works should be understood as part of the literary culture from which *Frankenstein* arose and part of the ground from which the creature is raised—"about eight feet in height, and proportionably large."

Henry Pierce Bone, Incantation Scene

BONE was an enamel portraitist, but here he turned to watercolor, a medium offering greater translucence. Like de Loutherbourg's philosopher, these women approach the dead by an incantation, and unlike him, by igniting a fire on a stone altar. The wand of the elder tells us she is a witch; her bare, aged breast and grotesque expression tell us that she lacks the philosopher's dignity. (If Victor Frankenstein had been in the hands of a less imaginative writer, he, too, might have intoned incantations; and Mary Shelley shows him, at first, in thrall to alchemy.) The younger woman, meanwhile, may be threatened from the left by a bat and a viper—typical Gothic creatures. In the foreground, skulls and bones of cows or sheep assert the reality of nonliterary death. But the most striking aspect of the painting is the contrast between the darkness behind the women and the glowing, almost white light emitted by the ghost they have called up. Here is the death that readers, and viewers, of Gothic works longed for—bright, frightening, lively, blazing against darkness. We can infer that the deceased was a knight because he carries a shield and a spear. There seems to be a story here, but Bone left no information as to what it was. The scene is its own primary gratification, as we are shown what so rarely happens in real life—the successful conjuring of a ghost.

❡ See illustration on pages 34–35.

Lady Diana Beauclerk, illustration for *Leonora*, 1796

THE ELDEST CHILD of the duke of Marlborough, Lady Diana Beauclerk was born into wealth but had to support her family because of her profligate second husband. Her lifelong practice of painting and drawing became a profession, and she not only produced paintings and designs for illustration, but also, later in her career, designs for Josiah Wedgwood's pottery. Horace Walpole venerated her work and devoted a room at Strawberry Hill to her illustrations for his play *The Mysterious Mother*. Lady Diana's illustrations for Gottfried Bürger's ballad *Leonora* were more lucrative. The ballad tells the story of a young woman's fiancé, missing in battle during the Seven Years' War (1756–63), who returns late one night to give her a horseback ride that ends at his grave. Both the ballad and Lady Diana's illustrations were extremely popular. Percy Bysshe Shelley, when a boy, was one of those enchanted with this edition and sent a copy to his first love, Harriet Grove. This final image shows Leonora near the end of her ride, with a welcoming party of skeletons to meet her and her fiancé.

❰ See illustration on pages 38–39.

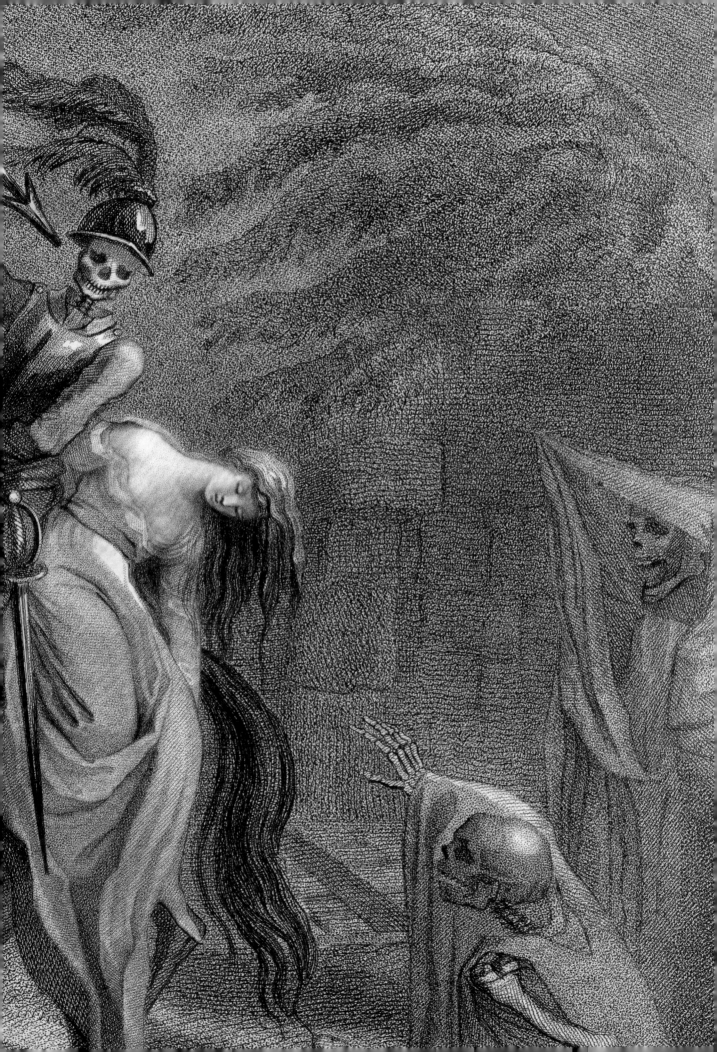

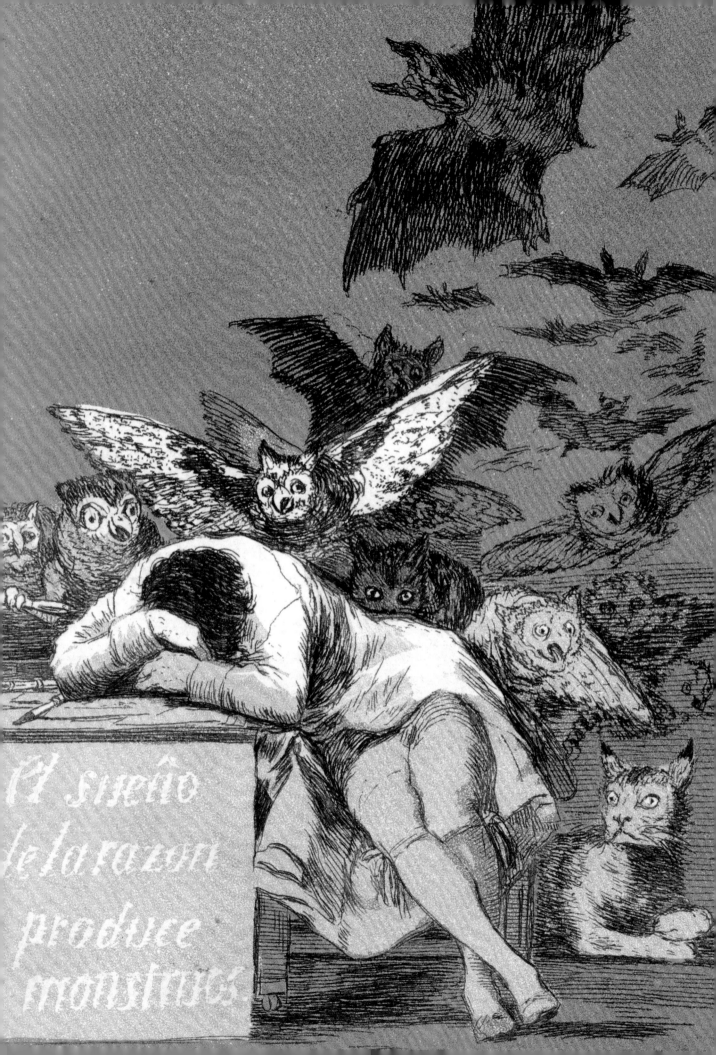

El sueño de la razon produce monstruos.

Francisco de Goya y Lucientes, *El Sueño de la razon produce monstruos,* from *Los Caprichos,* 1799

I**T IS UNLIKELY** that Mary Shelley knew Goya's book of satiric prints, the *Caprichos,* but the motto of this, the most famous of them, might have described *Frankenstein.*[7] *El Sueño de la razon produce monstruos,* "The sleep of reason creates monsters," was probably intended as the frontispiece of Goya's volume. His gloss on the text brings it close to Enlightenment theories of art: "The imagination abandoned by reason produces impossible monsters; united with her, she is the mother of the arts and the origin of their wonders."[8] *Los Caprichos,* a series of eighty prints in aquatint and etching, was Goya's first major project after a serious illness in 1792, from which he emerged with much-diminished hearing and a far darker outlook on life. They are also a response to the failed promise of the French Revolution and to the corruption of the Spanish church. The *Caprichos* take as their subjects priests, young girls, witches, prostitutes, and the upper strata of Spanish society arrayed in grotesque positions, committing strange and unsavory acts. They resemble today's *New Yorker* cartoons in being subtitled with a single line, usually far more ambiguous than this one. After only seventeen copies of the volume containing the prints had been sold, Goya was denounced to the Spanish Inquisition. He was rescued by the king (to whom he was a court painter), who accepted the copperplates as a gift, thereby forestalling the religious authorities.

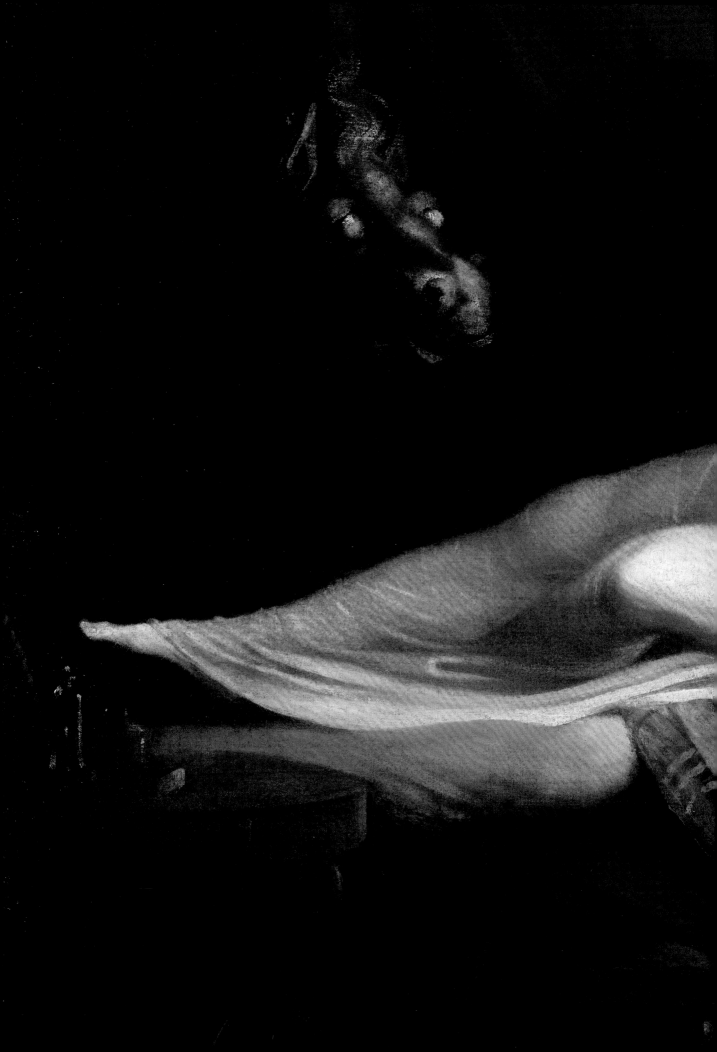

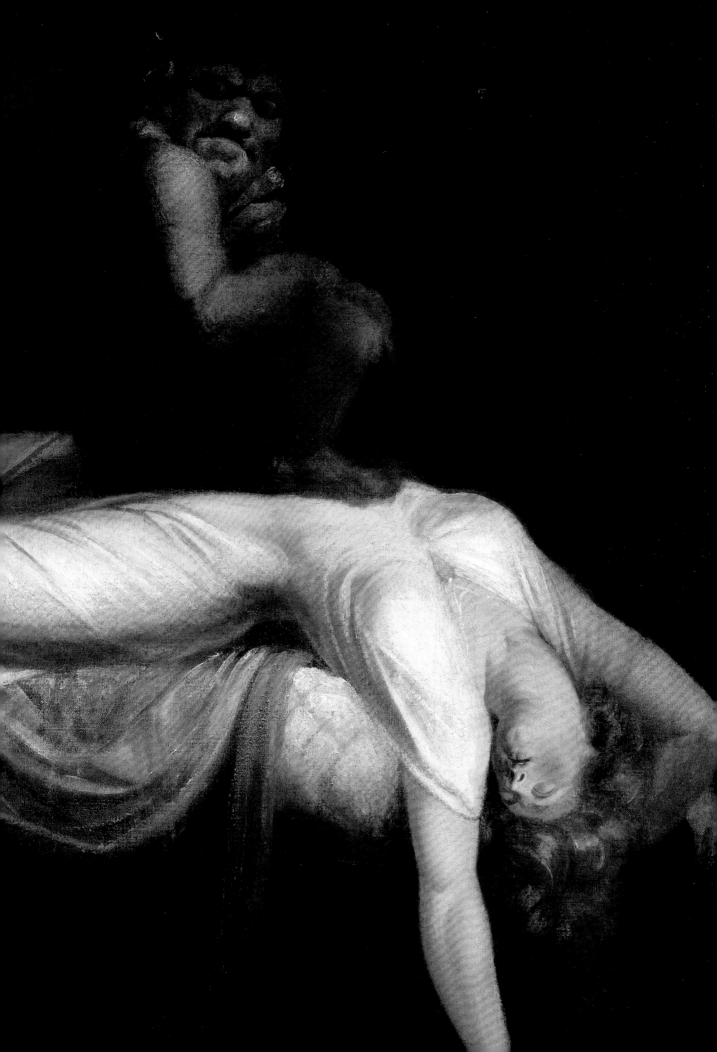

Henry Fuseli, *The Nightmare*, 1781

No PAINTING more fully exemplifies the British Gothic than *The Nightmare*, first exhibited in 1782. It sealed the reputation of Fuseli, a Swiss immigrant long active in England, as his generation's preeminent painter of visionary scenes. The subject of the painting is a young woman in a gauzy white gown, unconscious and prone on a couch. Her upside-down face registers only syncope. Her left arm touches the floor, while her right is tucked uncomfortably under her head. A pug-nosed demon, or incubus, sits on her chest—the nightmare of Samuel Johnson's definition: "a morbid oppression in the night, resembling the pressure of weight upon the breast."[9] The demon's ears, like carvings by Grinling Gibbons, throw a horned shadow on the red velvet curtain. At the left, a comic horse—an equine Peeping Tom with glowing blanks for eyes—watches. Only the imp has pupils, slits like a cat's, and they face different directions. Mary Shelley would have had a complex relationship with even the thought of Henry Fuseli: according to her father's memoir of her pioneering feminist mother, Fuseli was the first man to inspire passion in Mary Wollstonecraft's heart—a passion he (and his wife) spurned. Would the daughter, one wonders, have thought of her mother on seeing this depiction of a woman entirely without agency? It has been suggested that the painting is the direct inspiration for the creature's threat in *Frankenstein*, "I shall be with you on your wedding-night."[10] Whether or not this is the case, the image of an unconscious woman stretched out on a bed is central to the Frankenstein films, not-too-subtly threatening rape.

❦ See illustration on pages 42-43.

Henry Fuseli, *The Three Witches*, ca. 1782

FUSELI was steeped in English as well as German literature and first made his living in Britain as a literary critic and translator. Hugely ambitious, he was celebrated not just for visionary paintings but for his deeply (and sometimes maliciously) imagined work in the lucrative market for literary scenes, becoming known as "Shakespeare's painter." Shown here is his earliest of three versions of the witches from *Macbeth*, illustrating a moment of Banquo's conversation with them: "You seem to understand me, / By each at once her choppy finger laying / upon her skinny lips" (I.3.43–45; *choppy* here meaning "cleft, full of cracks"). The repetitive composition also brings to mind the witches' next lines, in which together they cry "Hail, hail, hail" to the future king, Macbeth. Banquo mocks their hairy faces, the bane of old women everywhere. Fuseli seizes a chance to mock his old friend and painting master, Jakob Johann Bodmer, by giving the middle witch Bodmer's face. In the two later versions, he added a death's head moth at life size, evidence of his passion for entomology as well as a reminder of Macbeth's future.

❦ See illustration on pages 46–47.

Thomas Rowlandson,
The Covent Garden Night Mare, 1784

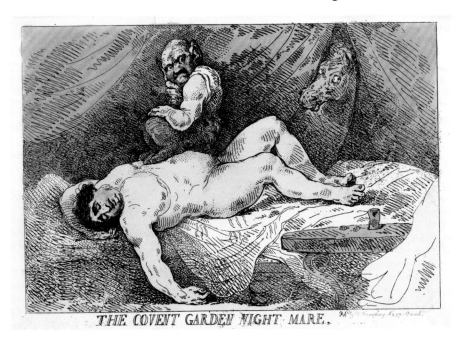

THE COVENT GARDEN NIGHT MARE.

THE LATE eighteenth century was the great era of the satiric print in Britain. Whether plain or colored (by hand), prints were a hugely important source of political education and savage pleasure to the British people. In London, portfolios of prints could be rented for an evening's amusement, and the area around print shop windows was crowded with readers. Thus, when *The Nightmare* was such a success, it was quickly reproduced in large numbers. The painting, "somewhere between the sublime and the ridiculous," as one art historian has called it, was ripe for satire, and so famous that "it became the first ever contemporary work to form the basis of an entire subgenre of 'mock Sublime' in English political caricature."[11] Here, Rowlandson swapped out the lissome woman for the roly-poly leader of the Whig opposition, Charles James Fox (1749–1806), otherwise sticking close to Fuseli's composition. Fox's genial ursine face, his corpulence, and his charisma all made him a favorite subject for satirists such as Rowlandson and James Gillray; this shows him soon after he had lost the 1784 election.

James Gillray, *Wierd-Sisters, Ministers of Darkness, Minions of the Moon*, 1791

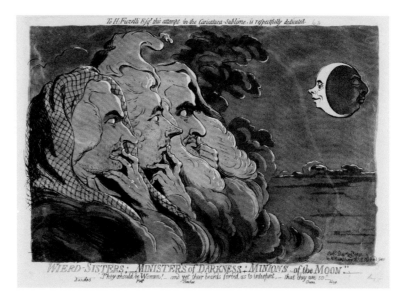

GILLRAY, the best British caricaturist along with Thomas Rowlandson, turned to Fuseli's Shakespeare paintings six times in his career. This "attempt in the caricatura-sublime" is dedicated to him. Although it has been suggested that the dedication is mocking, Gillray nonetheless distilled much of the power of Fuseli's original, enough that one may read it straight, as well. Certainly the image registers genuine anxiety about the state of England in 1791.[12] The three witches are the three most powerful politicians at the time—William Pitt, Lord Thurlow, and Lord Dundas—who were joined in an unstable government. They are supposedly minions of Queen Charlotte, seen here as the bright side of the moon, while her mad husband, George III, is in the dark. The inscriptions identifying these personages are in the hand of Horace Walpole himself. The *Morning Chronicle* saluted the print as Gillray's "Chef d'Oeuvre," saying it "exhibited more genius and skill than any jeu d'esprit of the kind. . . ."[13] No one was safe from Gillray's pen; his caricatures of George III and Napoleon rival Fuseli's caricature of Jakob Bodmer in the original painting.

Title page, *The Modern Minerva*, 1810

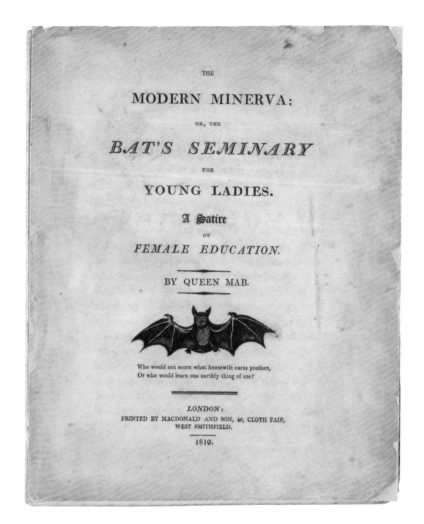

The *Modern Minerva* shows the Gothic mode fully suitable for satire: despite the bat on the title, this poem sends up, in rollicking anapests, young ladies' boarding schools that taught the accomplishments (dancing, drawing, deportment, and so on) rather than solid education and old-fashioned virtue— "But what are the Virtues compar'd with the Graces?"[14] Miss Bat changes her name to "Madame Chauvesouris" (in French a bat is a *chauve-souris*, a "bald mouse") and seeks lucre in sophistication and overenrollment while foisting the teaching onto her poor cousins, the weasel and the mouse.

Frontispiece for *Tales of Terror,* 1801

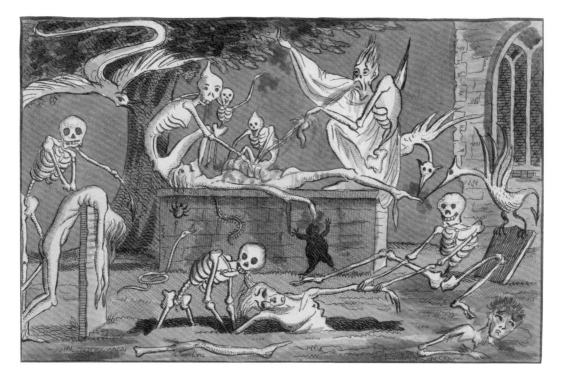

I n *Tales of Terror* we see the fine line between the earnest and parodic Gothic trampled into the gory mud. Monk Lewis is at the heart of the matter. In 1800 Lewis published with John Bell a collection of poetry entitled *Tales of Wonder* with contribu‑ tions of his own and others, including the young Walter Scott and Robert Southey. He had planned to call it *Tales of Terror,* and whoever edited this second work may have known that. In any case, this book was intended as a parody, as may be inferred from the frontispiece showing a graveyard jumping like a disco, with skeletons disemboweling the new corpses, thorn‑beaked birds hunting for dinner, random body parts groaning in the dirt, and what looks like a black pudding sprung to life. (Less fun versions omit the blood, added liberally by the colorist of this copy.) Nonetheless it seems perfectly in tune with Lewis's version of the Gothic, an impression his publishers encouraged by designing and producing *Tales of Terror* as an exact match for the earlier book, and selling them as a set.

SAINT EDMOND'S EVE.

Oh! did you observe the black Canon pass,

 And did you observe his frown?

He goeth to say the midnight mass,

 In holy St. Edmond's town.

He goeth to sing the burial chaunt,

 And to lay the wandering sprite,

Whose shadowy, restless form doth haunt,

 The Abbey's drear aisle this night.

It saith it will not its wailings cease,

 'Till that holy man come near,

'Till he pour o'er its grave the prayer of peace,

 And sprinkle the hallowed tear.

F

Percy Bysshe Shelley, *Original Poetry,* by Victor and Cazire, 1810

A S THE ADORED ELDEST CHILD of a wealthy Sussex family, Percy Bysshe Shelley knew *Tales of Terror* well. At age eighteen, he set about his first volume of poetry, a collaboration with his favorite sister, Elizabeth (1794–1831). They called it *Original Poetry by Victor and Cazire,* the brother being "Victor" and the sister "Cazire" after a character in Charlotte Dacre's Gothic novel *Confessions of the Nun of St. Omer.* The result is a collection of highly conventional poetry, mostly lyrics (eleven of the seventeen poems have the word *song* in the title), a conversation poem, and a couple of Gothic ballads. Sir Timothy Shelley, their father, would later foot the bill for Shelley's printing costs at Oxford and may have done the same earlier. Those printers, C. and W. Phillips, asked the London publisher Joseph Stockdale to distribute *Victor and Cazire* in the metropolis. Unfortunately for Shelley, Stockdale was better read than the Phillipses and quickly recognized the longest poem, here titled "Saint Edmond's Eve," as an outright plagiarism from *Tales of Terror,* where it is called "The Black Canon of Elmham; or, St. Edmond's Eve." Unkindly, and probably untruthfully, Shelley played the innocent when Stockdale confronted him, blaming Elizabeth and demanding that Stockdale destroy the rest of the print run. The book was long lost, with a copy rediscovered only in the late nineteenth century and only three other copies surfacing since then.

Frontispieces for *Wolfstein,* ca. 1820–22, and *The Foundling of the Lake,* 1810

THE CRAZE for the Gothic ran up and down the literary marketplace, and chapbooks—cheap little paperbound things of 16, 24, or 32 pages—were within the reach of all but the most destitute. They usually included a frontispiece of the most harrowing scene, colored for those who could afford it, plain for those who couldn't. Frequently, narratives were pirated from longer novels and chopped down to the most exciting bits. In *Wolfstein* (above) we see such an example: Percy Bysshe Shelley's third book, *St. Irvyne; or, The Rosicrucian* (1811), has been ripped off as *Wolfstein* in what the bookseller James Burmester calls "a remarkably blatant plagiarism."[18] Turnabout is fair play, one cannot help thinking. But while Shelley's honor—or his class position, much the same thing— forced him to withdraw *Victor and Cazire* from publication, that *Wolfstein* was a copy went unnoticed (at least in print) until the early twenty-first century when Burmester discovered it. The daisy chain doesn't begin with St. Irvyne, though, as there is evidence that Shelley himself was, again, cribbing from earlier works.[19] The other chapbook shown here, *The Foundling of the Lake* (below), reminds us with its claim to being "an original romance" that audiences were hungry not just for the conventions of the Gothic but for innovation and novelty, as well they might be, with so many plagiarisms flooding the market.

THE GOTHIC BACKGROUND 55

James Gillray, *Tales of Wonder!*

Books were expensive in the Romantic era, and reading aloud was a common way to share a novel. Gillray's 1802 print, though a scathing portrayal of silly readers, reminds us of the setting that would have made a frightening story more frightening: the light from candles; the circle of warmth from a fireplace; the relative darkness of the world outside. Their feathers cannot keep these women from shivering. Young Mary Godwin might have sat in just such circles, either at home in London or with her friend Isabel Baxter, with whom she spent two long visits in Dundee. Unlike these women, Godwin—by then united, though not yet married, to Percy Bysshe Shelley—once sat up listening to Monk Lewis himself tell ghost stories. In August 1816, weeks after she had begun work on what became *Frankenstein,* Godwin and Shelley spent an evening at the Villa Diodati with Byron's houseguest, Lewis, who told no fewer than five ghost stories. Godwin carefully recorded them and, years later, published them in *Essays, Letters from Abroad, Translations, and Fragments* (1839), though now they may be read in her published journals just as she wrote them on the spot.[17]

◀ See illustration on pages 58–59.

NOTES

1. Lewis 1796, p. 420.

2. Crook 2000, p. 58.

3. Lewis 1796, p. 87.

4. Doody 1977, p. 553.

5. Walpole 1796, Vol. 3, p. 430.

6. In full: *A Philosophical Inquiry into the Origin of Our Ideas of the Sublime and Beautiful.*

7. Goya's name does not appear in her collected letters, nor those of P. B. Shelley, Claire Clairmont, or George Gordon Byron.

8. Goya 1799, pl. 43.

9. Quoted in Frayling 2006, p. 15.

10. Frayling 2006, p. 19.

11. Frayling 2006, pp. 14–15.

12. Donald 1996, p. 73.

13. Quoted in Myrone 2006, p. 131.

14. Queen Mab 1810, p. 10.

15. James Burmester, e-mail, 13 October 2016.

16. See, for example, Peck 1925.

17. Shelley 1987, pp. 126–28.

J. Gillray, inv & f.ᵗ

TALES of WON

Publish'd Feb.ry 1st 1802. by H. Humphrey. 27. St James's Street. London.

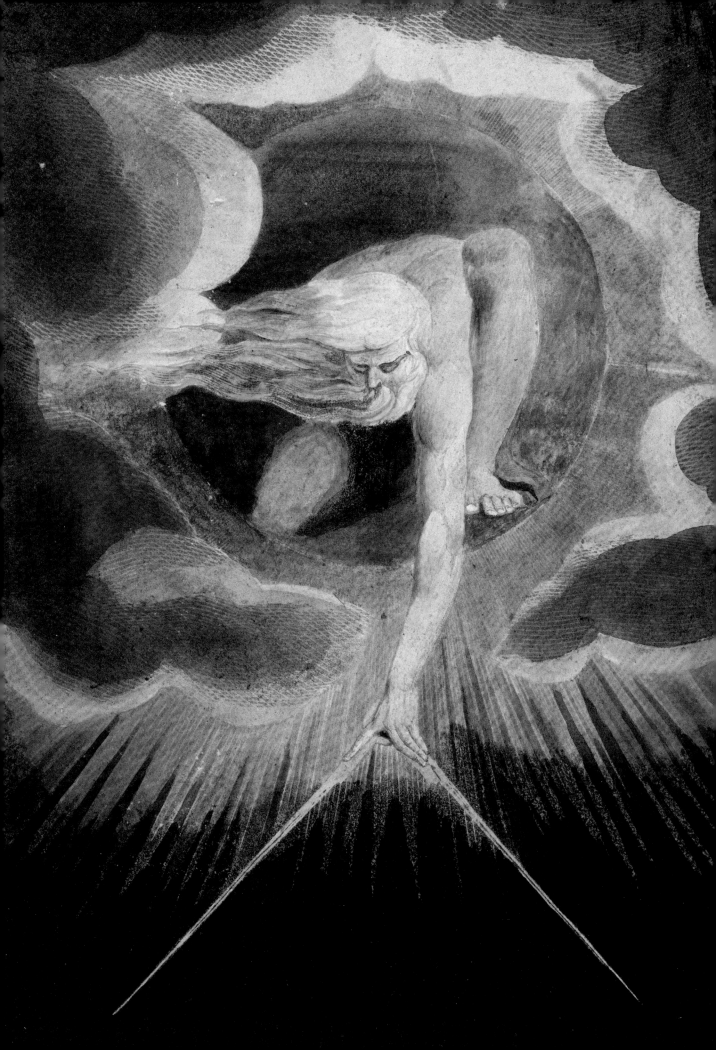

CHAPTER 2

THE SPARK OF BEING:
SCIENCE IN FRANKENSTEIN

MARY WOLLSTONECRAFT GODWIN was born in the midst of a great age of scientific and technological discovery. Industrial inventors such as Matthew Boul-ton, James Watt, and Josiah Wedgwood had already changed the landscape of England with the steam engine and new model factories. They and others of the Lunar So-ciety of Birmingham, including the natural philosopher Erasmus Darwin (grandfather of Charles), the scientist and Unitarian leader Joseph Priestley, and the chemist Thomas Bed-does fostered a culture of exploration and experimentation. Many of them were published by the Unitarian Joseph Johnson, Mary Wollstonecraft's mentor and William Godwin's friend. In London, the Royal Institution was founded in 1799 to promote scientific knowledge, mak-ing a home for giants of English science, such as Humphry Davy (who isolated, among other elements, sodium, calcium, potassium, and boron and who invented the miners' safety lamp), Michael Faraday (inventor of the electric generator and theorist of electromagnetism), and Joseph Banks (the botanist, explorer, and president of the Royal Society). Through prizes, competitions, publication, classes, and lecture series, the Royal Institution, the Royal Society, and other knowledge-promoting bodies encouraged young men to pursue scientific studies. (On this level the target audience was entirely male, though the astronomer Caroline Her-schel, "the celebrated comet-searcher," as Frances Burney called her, won a gold medal from the Astronomical Society.)

Besides offering rewards to those working in scientific circles, London and the smaller cities of Britain had a thriving circuit of lectures and experimental demonstrations for the general public, including women and children. It was not confined to science: in the winter of 1811–12, for instance, Mary Godwin attended Coleridge's lectures on Shakespeare with her whole family except her nine-year-old half brother. A few of the scientific demonstrations of these years have become part of the *Frankenstein* legend—anatomical dissections, for instance, though these were mostly for medical students. (Percy Bysshe Shelley may have observed one when visiting St. Bartholomew's with his cousin Charles Grove, a medical student.) At the Royal College of Surgeons in 1803 Giovanni Aldini, carrying on the work of his uncle, Luigi Galvani, applied electricity to the corpse of a murderer, making the body twitch and pound the table. One reporter wrote that "Vitality might have been fully restored, if many ulterior circumstances, had not rendered this—*inappropriate.*"[1]

There is not much electricity in *Frankenstein*. The 1818 edition contains a single brief but important passage set during Victor Frankenstein's education. After an ancient oak has been blasted by lightning, his father gives him a few lessons: "He constructed a small electrical machine and exhibited a few experiments; he also made a kite, with a wire and string, which drew down that fluid from the clouds." In the more conservative 1831 edition, Shelley shifts the responsibility for this lesson to an unnamed visitor, "a man of great research in natural philosophy" who omits the Ben Franklin experiment and explains "a theory which he had formed on the subject of electricity and galvanism." Later, crucially, Victor Frankenstein describes the moments just before the creature's animation: "I collected the instruments of life around me, that I might infuse a spark of being into the lifeless thing that lay at my feet." From such acorns many movies grow.

There are further references and half references to electricity in the 1831 edition's introduction recounting how *Frankenstein* came to be written. There Mary Shelley recalls Percy Bysshe Shelley and Lord Byron discussing an experiment of Erasmus Darwin's with a piece of vermicelli, desiccated and lifeless "till by some extraordinary means it began to move." She mentions galvanism, and describes a dream in which "I saw the hideous phantasm of a man stretched out and then, on the working of some powerful engine, show signs of life. . . . " None of this language, however, is present in the *text* of the novel. We are so accustomed to thinking of *Frankenstein* as an electrically powered story that it's worth remembering that the only electrical term used to describe the creature's making is the aforementioned "spark of being," and that sparks came from fire long before they came from wires. And yet the creation scene of the 1931 James Whale film, with the creature bound to the table, helpless as any maiden in a nightmare, a sacrifice to the lightning gods, delivers a gratification far more dramatic and satisfying than the novel's creation scenes. There the pleasure comes from Frankenstein's haunting the charnel house, the dissecting room (after class), and the graveyard and, ultimately, from the description of the creature's body.

Mary Shelley's absolute refusal to name "the secret of life" poses a narrative problem for illustrated versions of the story or theatrical productions, both of which have to show *something* of the creature's birth. And the answer of electricity was mooted early on: an 1825 periodical version, "The Monster Made by Man; or, The Punishment of Presumption," shown on p. 88, shows an electrostatic generator in the laboratory. But the theatrical productions during Shelley's lifetime—they began in 1823—largely stayed with the science most often referred to in the novel: chemistry. When Victor Frankenstein spurns the alchemists, he turns to their direct descendants, and "chemistry, in the most comprehensive sense of the term, became nearly my sole occupation." In making the first creature Victor calls his equipment merely "the instruments of life," but after his destruction of the creature's intended bride, he sets himself to "cleaning and arranging my chemical apparatus." Chemistry was the favored science of Percy Bysshe Shelley, and Mary Shelley would have heard stories about his messy experiments in

his rooms at Oxford. During the writing of *Frankenstein* she read Humphry Davy's *Elements of Chemical Philosophy*.[2] Chemistry makes eminent sense as Frankenstein's primary study because its object is transformation. The transformative moment that leads to the creature, however, occurs in Victor's mind, and it is entirely metaphorical. During his studies of causation in "the change from life to death, and death to life," he is struck: "a sudden light broke in upon me—a light so brilliant and wondrous, yet so simple, that . . . I became dizzy with the immensity of the prospect which it illustrated. . . . " We have returned to Henry Bone's incantation scene, in which bright light is the most important element of a Gothic moment. At the crucial moment, the chemist in *Frankenstein* reverts to the alchemist.

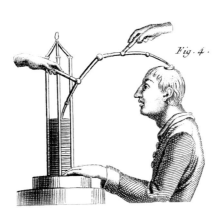

William Blake, frontispiece in Europe, 1794

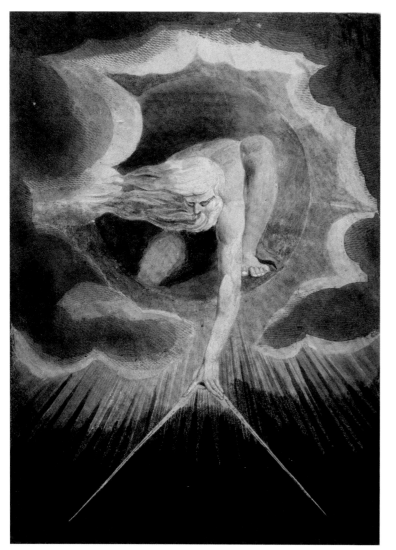

IN THE FRONTISPIECE to his poem *Europe*, the poet and artist William Blake portrayed the white-bearded Urizen, "your reason." He is meant to remind one of God's work in Genesis, dividing day from night and earth from water. In Blake's world, division—the power to split—is both original sin and the source of creation. For him, scientific characters like Urizen and Isaac Newton, whom he also portrayed wielding a powerful compass, were the enemies of art. And yet this image, which became known by the portentous but tamer nickname "The Ancient of Days," was one of the most popular of Blake's lifetime. No powerful image is ever wholly in its creator's control; and just as Mary Shelley's characters lurched on to careers she never dreamed of, Blake's image of Newton found a later avatar as a huge bronze statue in the courtyard of the British Library, hinged and bolted, strapped to its seat, a cousin to Frankenstein's creature. Shelley—who would have known Blake's commercial engravings, certainly in the book he illustrated for her mother, *Original Stories from Real Life*—might have found in his work a motto that would have changed *Frankenstein* profoundly: "Opposition is true Friendship."[3]

Joseph Wright, An Experiment on a Bird in the Air Pump, 1768

JOSEPH WRIGHT (1734-1797) became known as "Wright of Derby" (pronounced Darby) because there was already another painter by that name exhibiting in London, where our Wright had considerable success. Yet life in the provinces—in portraits, landscapes, and what he called "night pieces"—furnished most of his subject matter. Wright's circle of friends included Erasmus Darwin and others of Birmingham's Lunar Society who kept him abreast of the latest scientific research. Here we see a possibly fatal experiment, conducted in a private home, on a bird in a glass bell. The scene is sociable, civilized; every subject's individuality is conveyed in his or her response to the demonstration. But the long-haired philosopher's intensity, the wonderfully bright light, the full moon, and the dark background all come from the Gothic sphere. The fear and pity on the little girl's face take us to still a third aspect of the culture from which *Frankenstein* sprang, and back to the Lunar Society: compassion for suffering was also part of that world, made most famous by the poet Anna Letitia Aikin's petition to Joseph Priestley (one of the discoverers of oxygen) to spare a trapped mouse— "Let not thy strong oppressive force / A free-born mouse detain."[4] The high drama and compelling characterizations made this Wright's most famous painting; it was soon made into a mezzotint by the engraver Valentine Green and published by Joseph Boydell, one of the giants of the trade, for a hefty 15 shillings.

❧ See illustration on pages 66–67.

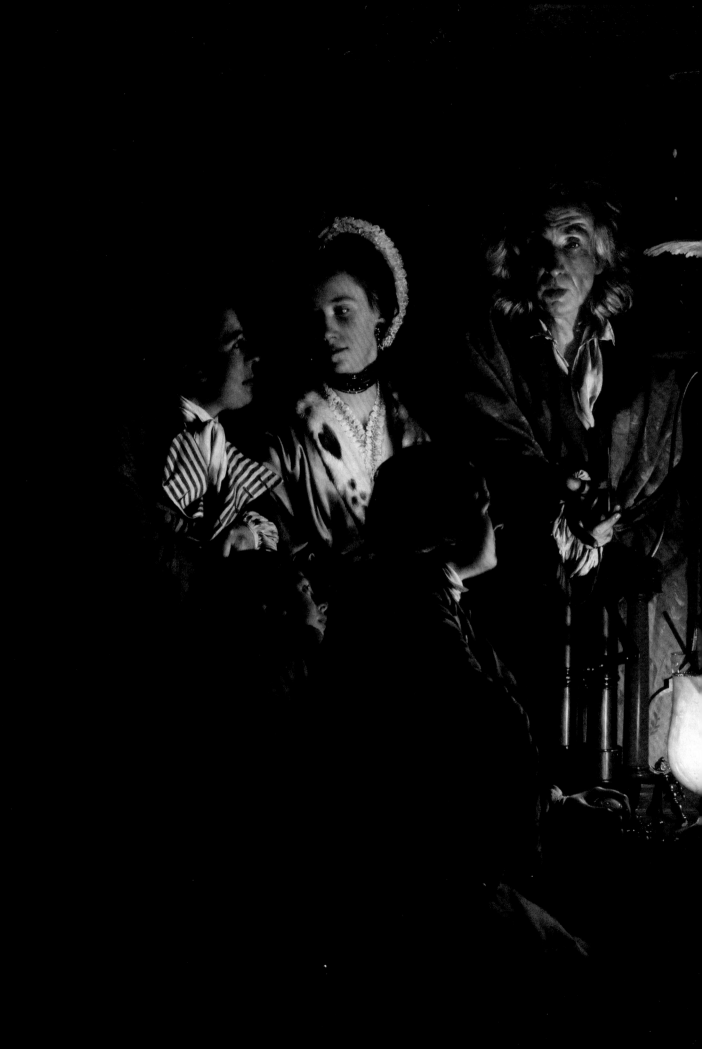

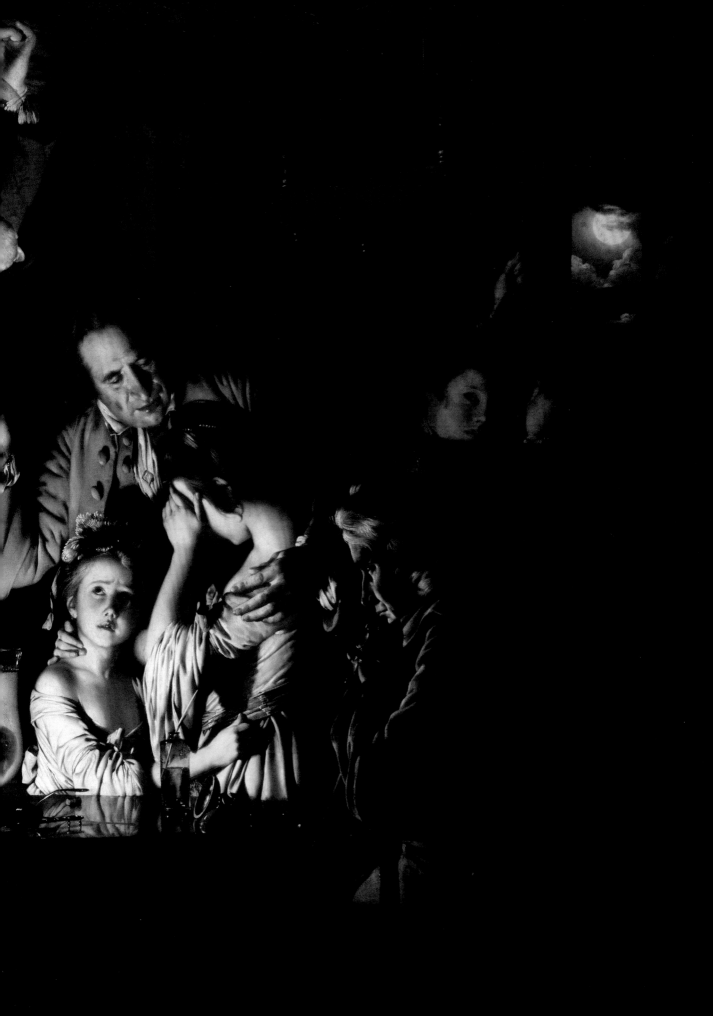

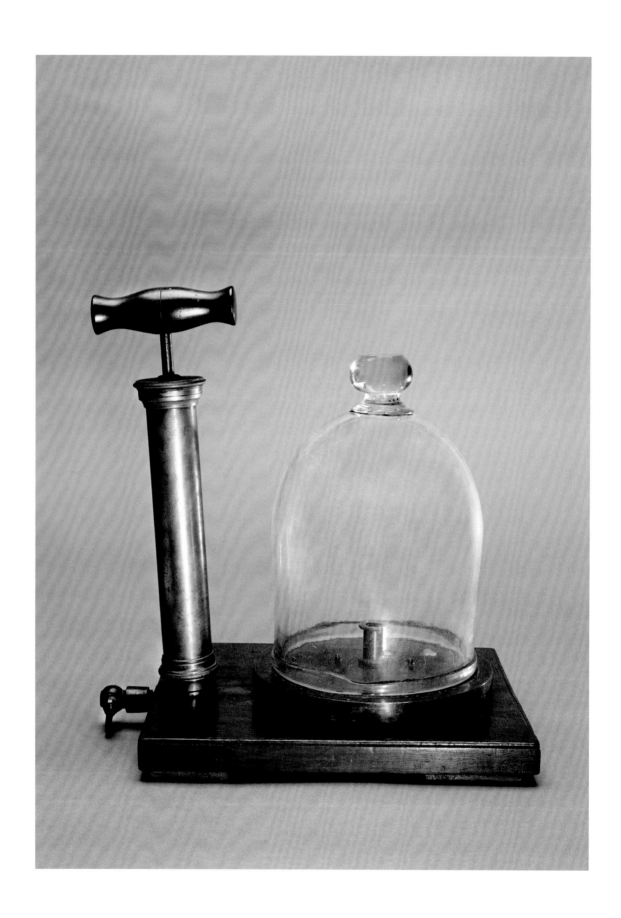

Vacuum pump with bell jar, ca. 1800–1850

THE AIR PUMP is also known as a vacuum pump, logically, since its function was to extract air from an attached bell jar or other glass receptacle, creating a near vacuum. This one is simpler than the double-barreled pump shown in Wright's painting. Invented in 1650 by the German scientist Otto von Guericke, the air pump was first manufactured in England for Robert Boyle, the Anglo-Irish scientist. (People of Guericke and Boyle's time would have used the term *natural philosopher*, or simply *philosopher*. The term *scientist* as we use it now became current in the decades just after *Frankenstein* was published.) Any breathing creature inside the receptacle from which the air was pumped would quickly lose consciousness and die of oxygen deprivation. Many shared Anna Letitia Aikin's compassion, and at least one scientist, James Boswell's friend James Ferguson, considered experiments on living creatures "too shocking to any spectator who has the least degree of humanity."[5] Nonetheless, the air pump was a popular piece of equipment for demonstrating pneumatics: Joseph Priestley, in his early days as a schoolmaster, taught his senior students how to use his and encouraged them to conduct demonstrations for their families with it.

Gabriel Jacques de Saint-Aubin, The Lesson of the Chemist Sage at the Hôtel des Monnaies, 1779

BALTHAZAR GEORGES SAGE (1740–1824), professor of mineralogy and metallurgy at the École des Mines de Paris, studied the chemical aspects of minerals; his experiments at the Hôtel des Monnaies attracted large crowds. We see here a quite different scientific culture from that depicted by Wright: the group lacks individuation, and we know which figure is Sage only because he holds up a glowing beaker, possibly containing phosphorous. Saint-Aubin devoted almost equal attention to the decorations on the ceiling, an allegory of the reign of Louis xv and the luster brought to it by the scientific work below. In 1778, the year previous to this drawing, Sage tried to isolate the "raw gold" he believed to inhere in plants. A talented administrator as well as showman, Sage amassed a large collection of mineral specimens, but his refusal to give up exploded theories left him consistently demolished in arguments with Lavoisier and others. Sage lost his place after the Revolution, though he regained some stature during the Directory. *The Dictionary of Scientific Biography* gives him this mordant envoi: "He died in his eighty-fifth year, an unregenerate royalist, a scientific fossil, and a pathetic hangover of the *ancien régime*."[6]

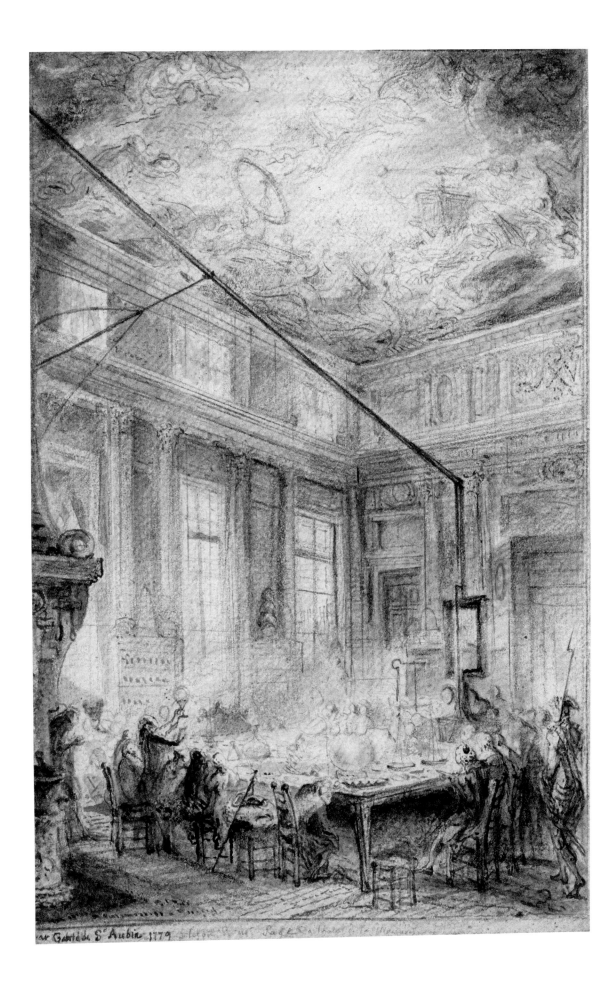

par Gabriel de St Aubin 1779

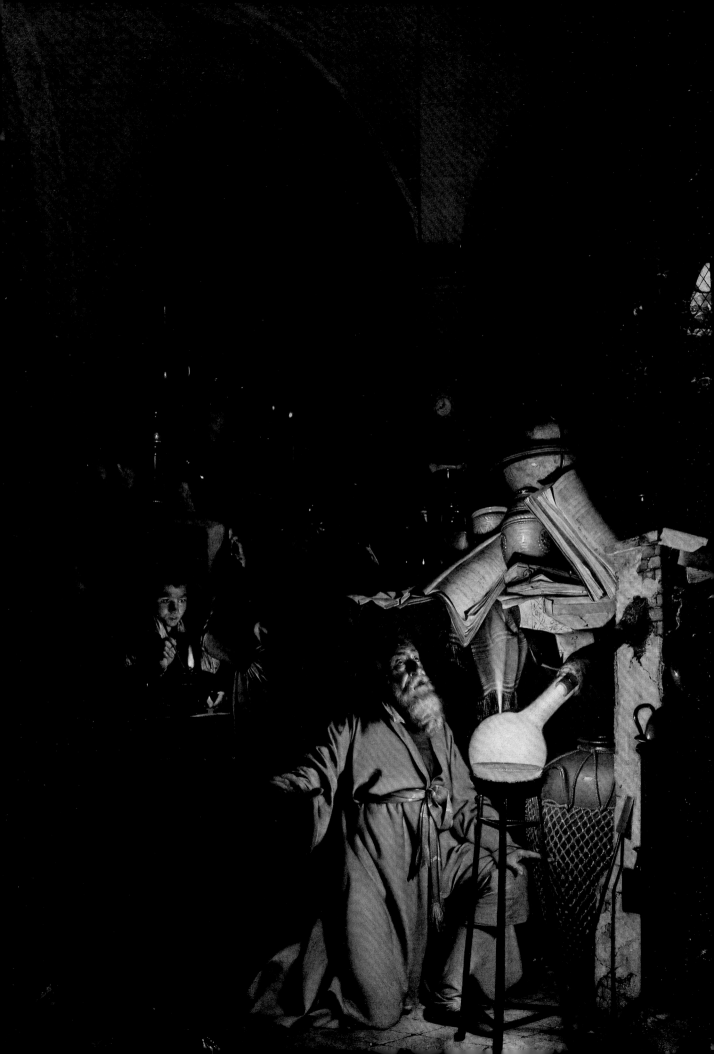

Joseph Wright, *The Alchymist, in Search of the Philosopher's Stone, Discovers Phosphorus, and Prays for the Successful Conclusion of His Operation*, 1771, reworked and dated 1795

WRIGHT died the day before Mary Godwin was born. His work seems to have been made to illustrate *Frankenstein*, except that where Victor conceals the secret of life, the aim of Wright's night pieces is revelation. But even when his subject is a scientific demonstration, such as the *Experiment on a Bird in the Air Pump* or *The Philosopher Lecturing on the Orrery* (1766), the surrounding darkness also imparts a powerful sense of mystery. His painting of the German alchemist Hennig Brand (1630–1710) shows a moment in the emergence of chemistry from the secretive world of alchemy. In 1669, it is said, Brand discovered phosphorus after boiling down hundreds of gallons of urine that had been allowed to putrefy, a key step in alchemy and one that features obliquely in *Frankenstein*. The first sign of the element's appearance would have been the bright light in the round glass bottle. (*Phosphorus* means "the morning star" in Greek.) Wright worked from a sketch supplied by his friend, the cartographer Peter Perez Burdett, and information provided by Dr. Matthew Turner, whose lectures had interested Joseph Priestley in the subject of chemistry.[7] Whereas Wright's title emphasizes the alchemist's piety, the painting more strikingly portrays his astonishment, while the assistant's pointing finger underscores the singularity of the moment.

Henry Fuseli, frontispiece in Erasmus Darwin, *The Temple of Nature,* 1803

THE POLYMATH Darwin linked many figures in the scientific and artistic worlds of his day, and his works of scientific poetry propelled Britain into the future. Trained as a physician (Wright of Derby was among his patients), he was a key member of the Lunar Society. His genre was the scientific poem, setting forth ideas in verse with prose notes for the technical aspects. *Loves of the Plants* (1789) and *Botanic Garden* (1791) promoted Linnaean botany in Britain, while *Zoonomia* (1794) theorized a view of the origin of life that anticipated the work of his grandson, Charles. One of Darwin's last works, *The Temple of Nature* (1803), published posthumously, combines an explanation of life on earth with the development of human society. Despite Henry Fuseli's illustrations invoking mythological traditions—we see here the three-breasted goddess Nature approached by her fearful votary—the work was attacked in *The Anti-Jacobin,* along with William Godwin's *Enquiry Concerning Political Justice,* as materialist and atheist. This poem is the source of the famous misunderstanding in Mary Shelley's introduction to the 1831 edition of *Frankenstein* in which she recalled P. B. Shelley and Byron discussing Darwin's experiment on a long-dry piece of vermicelli, which is brought to life. In fact, what Darwin described is "vorticella, or wheel animal . . . capable of continuing alive for many months though kept in a dry state," but which, placed in water, "assumes the form of a lively maggot" and starts looking for food.[8]

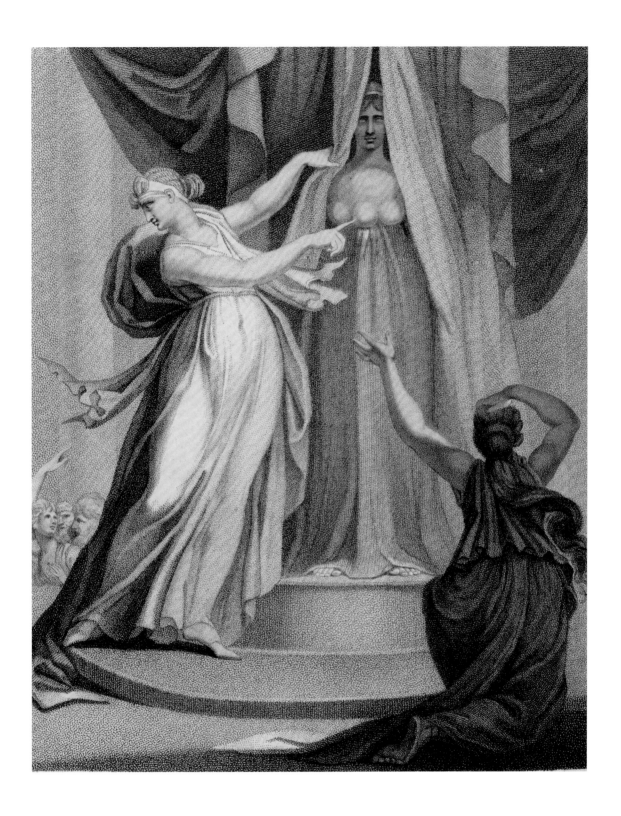

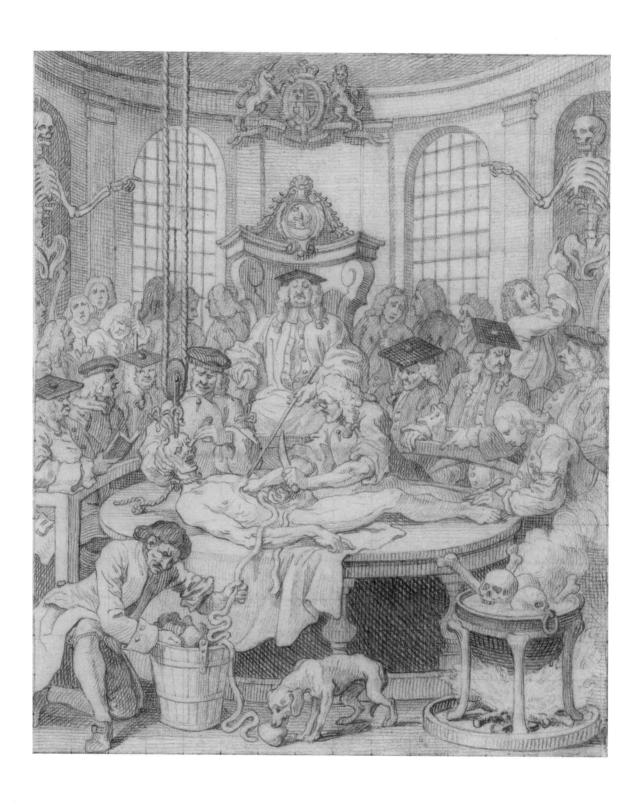

William Hogarth,
The Reward of Cruelty, ca. 1751

I N *The Four Stages of Cruelty* (1751), William Hogarth designed a series of prints to dissuade his viewers, especially the poor, from everyday sadism. He imagined a progression of atrocities in which his antihero Tom Nero, named for the notorious Roman emperor, goes from bad to worse, ending up on the gibbet and finally the dissection table, shown here. As a boy, Tom tortures a dog; in the second print, he graduates to beating a horse while another driver runs over a child; in the third, he reaches the perfection of cruelty, murdering the servant girl he has impregnated. Here we see the reward of cruelty: Nero's face suffering even after death, the anatomists' knives, the disgusting detail of intestines, and the hungry dog. Like Wright's experiment with an air pump, this technical demonstration has an audience, but it consists of students and members of the Company of Surgeons, overseen by the skeletons of other criminals. When Hogarth made this drawing, the Company of Surgeons was the only body licensed to receive corpses for dissection, and they were allowed only six a year. But the death penalty was being applied ever more frequently for ever-smaller crimes, and a 1752 act of Parliament allowed judges to direct dissection, the final invasion of privacy, as a particular punishment for murder.

William Austin, Anatomist Overtaken by the Watch, 1773

WHILE the Company of Surgeons was licensed to receive bodies, private schools of surgery, such as the one run by William Hunter (1718–1793), had to look elsewhere. In 1826, 592 bodies were dissected by London medical students.[9] Given that only 1,242 people were hanged in London between 1703 and 1772, it is clear that there was a shortage of specimens.[10] The solution was provided by body snatchers, resurrection men—less fancifully, grave robbers. From the mid-eighteenth century to 1832, exhumation was all too reasonable a fear in London, especially in quiet graveyards like St. Pancras, where Mary Godwin's mother was buried; young Mary may well have seen there emptied graves of the recently dead.[11] William Hunter, the toothpick of a man scarpering off in this print, was a celebrated man-midwife (male obstetricians were thus called after they began taking over the craft from women) and an even more celebrated surgeon. He taught anatomy according to the European method, by which each student or pair of students worked on a corpse. It is unlikely that Hunter was personally involved in grave robbing in 1773, when he was well established, though in another copy of this print the identification of the dead woman as "Miss Watts" implies an untold story. The European method provoked an even greater demand for bodies, and as the nineteenth century continued, the price they commanded rose sharply. In 1832 an especially cruel solution to the problem was found, when bodies of those who died in workhouses were given to medical schools unless speedily claimed by their families.

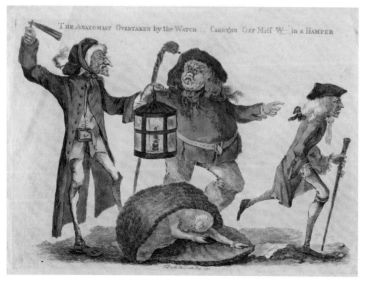

Surgical kit, ca. 1790

Frankenstein fudges the details of Victor Frankenstein's labor, but he would have needed something like this case of surgeon's instruments, which includes lancets, scissors, drills, a saw for amputations, tourniquets (more useful on subjects with beating hearts), and trephines for cutting out circular sections of the skull. This kit was made by the firm of William Hasledine Pepys (1748–1805), a London cutler whose son of the same name followed him into the business. (They were distant relatives of the famous diarist Samuel Pepys.) In addition to being a leading producer of surgical and then scientific instruments, the younger William Pepys (1775–1856) conducted research in electrical technology and made several large batteries; he was also a proprietor of the Royal Institution from 1800 to 1846. Victor Frankenstein could have learned much from him. In this kit, the trephine points to both the future and the past: it was invented by John Woodall (1570–1643), the first surgeon general of the East India Company, as an improvement on the instruments used for trepanning, the an-

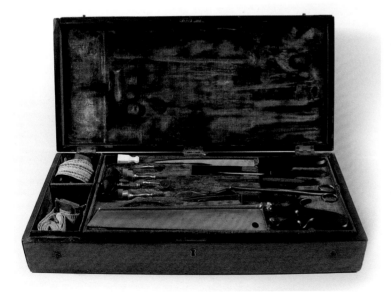

cient practice of boring holes into skulls. Woodall was not a modern man of science in that—like Frankenstein—he saw alchemy as an important part of the surgeon's education. But his textbook for sea surgeons, published in 1617, was the first to direct the use of lemon juice against scurvy, and the design for his trephine was used for three centuries.

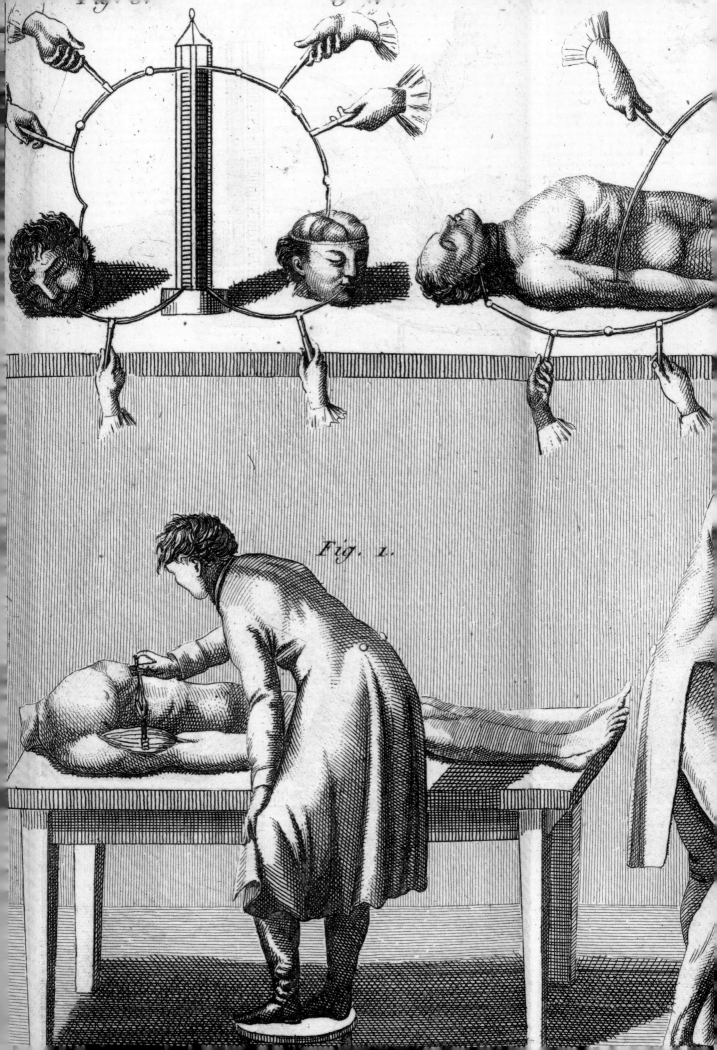

Fig. 1.

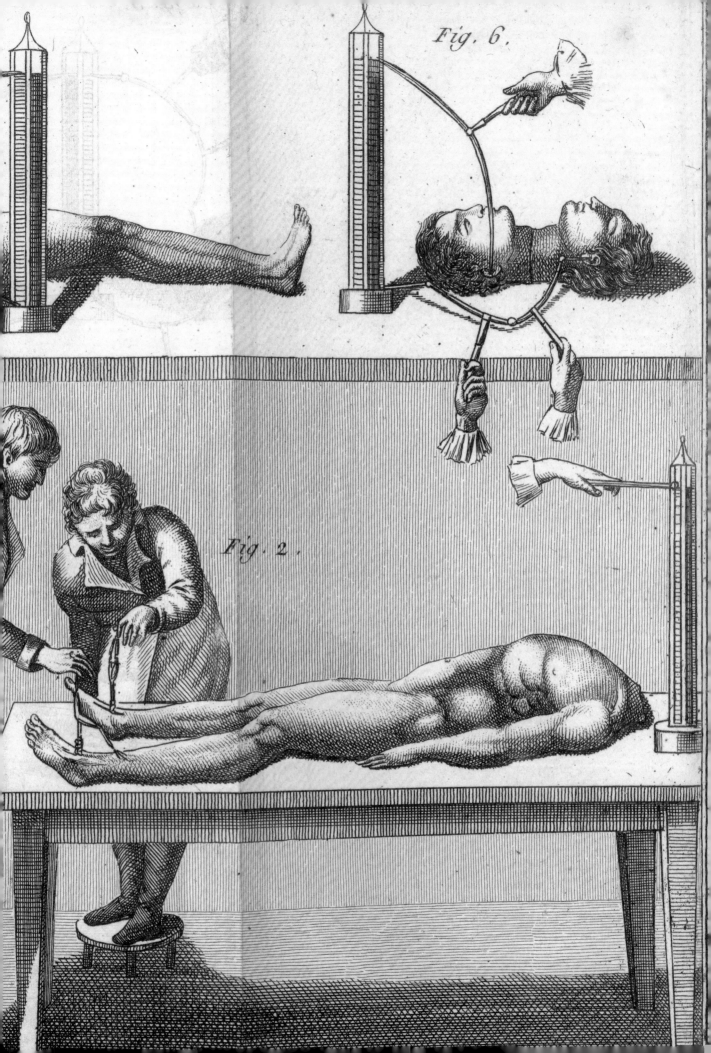

Fig. 6

Fig. 2

Anatomical experiments of Giovanni Aldini

GIOVANNI ALDINI (1762–1834), a Bolognese professor of physics, popularized and extended the discoveries of his uncle Luigi Galvani (1737–1798) in the realm of "animal electricity." Observing frogs' legs react to electrical charges, Galvani believed he had found a distinct form of electricity, a fluid inherent in animal life.[12] In this belief, Galvani and Aldini's primary opponent was Alessandro Volta (1745–1827). The relative importance of Galvani and Volta in the history of science is indicated by the fact that the volt is the primary measure of electricity, while "being galvanized," though still a useful idiom, is mostly metaphorical. While Volta saw in Galvani's observation a "truly astonishing experiment," he came to believe, after "countless trials on diverse unlucky creatures" that there was no separate animal electricity, only electricity. He published his conclusion in an open letter to Aldini early in 1793. Concurrently, Volta had been investigating how electricity could be produced by disks of different types of metal interspersed with cardboard; these towers of disks were called piles, the etymon for battery in a number of languages. Volta, favored and honored by Napoleon later in his career, would prevail in scientific history, but this did not stop Aldini, who continued to demonstrate the electric conductivity of bodies—not just frogs—in France and England as well as in Italy. This print illustrates one of Aldini's most famous trials, in which the recently hanged corpse of George Forster, murderer of his wife and child, was subjected to the most powerful charges Aldini could muster. The results frightened the audience into something close to the belief that Forster might be brought back to life.

◀ See illustration on pages 80–81.

Professor Ure galvanizing the corpse of the murderer Clydesdale

IN HIS CAPACITY of professor of natural philosophy at Anderson's Institution in Edinburgh, Andrew Ure gave popular evening lectures to audiences from all ranks of society. Ure was known as a cantankerous man and a "highly competent practical chemist"; electricity was not his area.[13] In 1818, however, he had the idea of repeating Aldini's experiment, with two variations: first, he would apply electricity directly to the nerves of the corpse, and second, he would use a stronger battery than had been available to Aldini.[14] He obtained permission to try out his techniques on the corpse of the murderer Matthew Clydesdale, which was rushed from the scaffold to the operating theater, where the battery was brought into "a state of intense action." With the lungs, Ure reported, his success was "truly wonderful. Full, nay, laborious breathing instantly commenced." On Clydesdale's face, "rage, horror, despair, anguish, and ghastly smiles, united their hideous expression . . . surpassing far the wildest representations of a Fuseli or a Kean."[15] (Edmund Kean was one of the great actors of the era.) It is unlikely that James Whale was reading the *Quarterly Journal of Science, Literature, and the Arts* for 1819 prior to filming *Frankenstein* in 1931, and Clydesdale's dead face is more expressive than the makeup allowed Boris Karloff's to be; but there is an uncanny foretelling of Whale's version of the story in this vignette, with the direct use of electrical current. At the time, although Ure reported the story to the local newspapers, only one ran it.

❦ See illustration on pages 84–85.

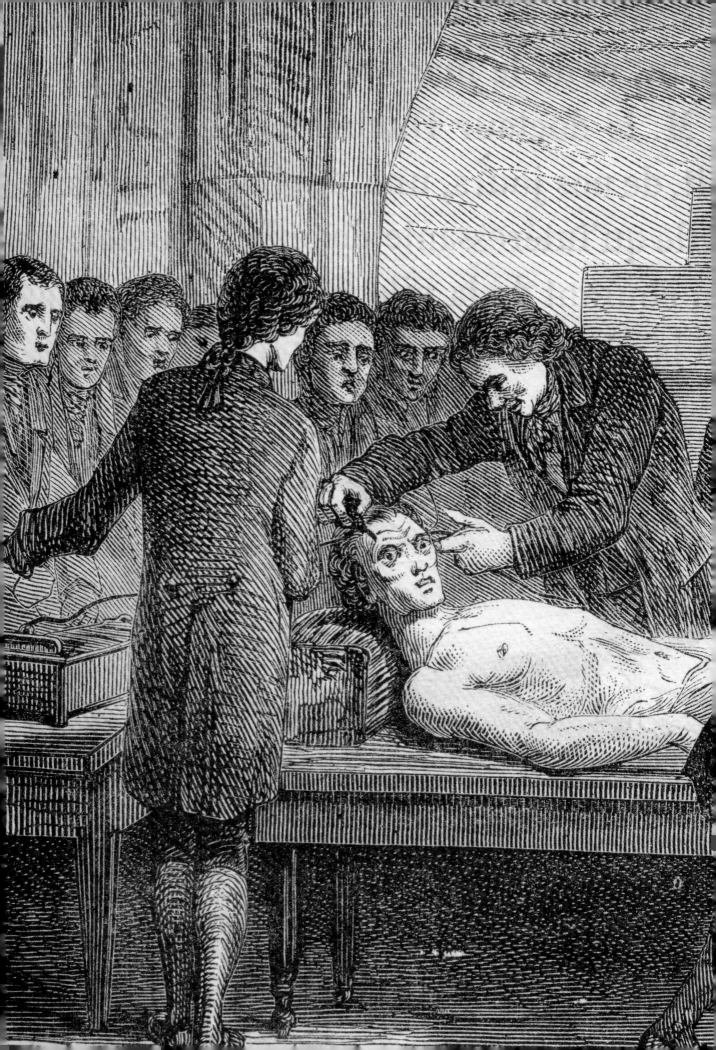

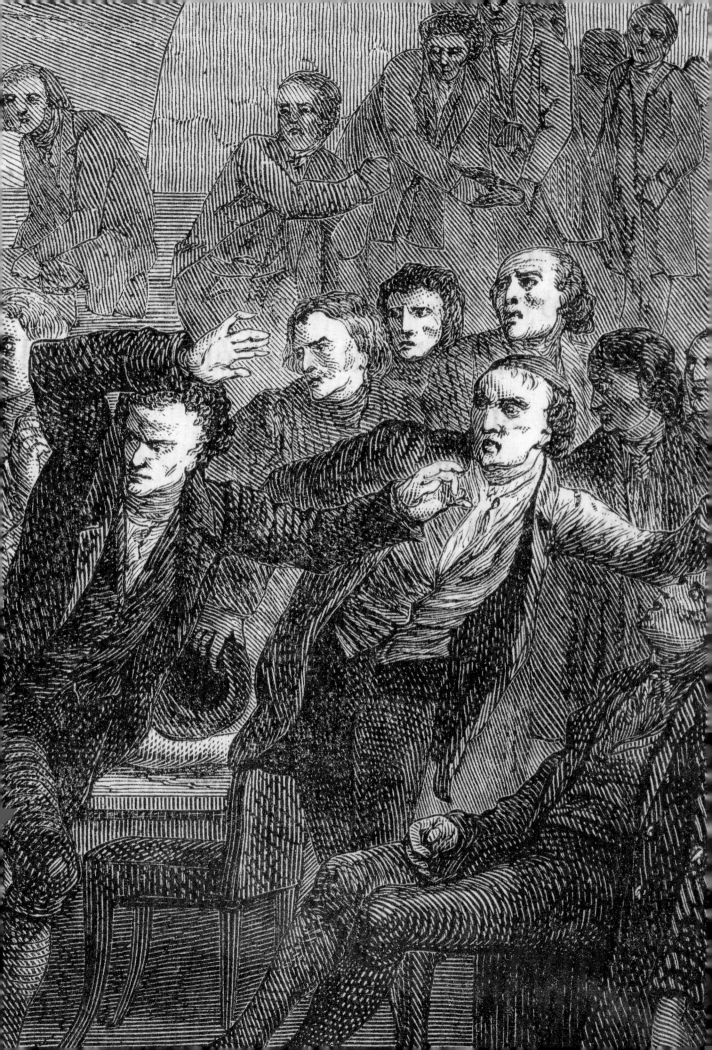

Voltaic pile, ca. 1805

COPPER AND ZINC disks sandwiching cardboard disks wet with saltwater, connected by a metal rod, produce an electric current. This is the operating principle of the voltaic pile illustrated here and in the depiction of Aldini's experiments on pp. 80–81. The first of its kind—a chemical rather than a mechanical means of generating electricity—it was soon superseded by the trough battery because it was inefficient and did not hold a charge for long. Alessandro Volta may have given his name to voltage, but this, his invention of about 1800, was quickly superseded by more powerful devices. A giant battery in the basement of the Royal Institution supplied the power for the blindingly bright carbon arc lamp invented by Humphry Davy (1778–1829).

Trough battery, ca. 1832

THIS TROUGH BATTERY, similar to the one used to such effect on Matthew Clydesdale, once belonged to Joseph Henry, professor of natural philosophy at the College of New Jersey (later Princeton University) and the first secretary of the newly founded Smithsonian Institution. It illustrates what Benjamin Franklin was thinking of when he coined the term *battery:* Like the row of large guns or cannon making up a battery, these early devices worked only when their components were ranged together in a group. We can't imagine Boris Karloff's creature running on a battery; but the makeup artist Jack Pierce imagined the electrodes at his neck, inevitably mistaken for bolts, as "inlets for electricity," the creature's life force.[16]

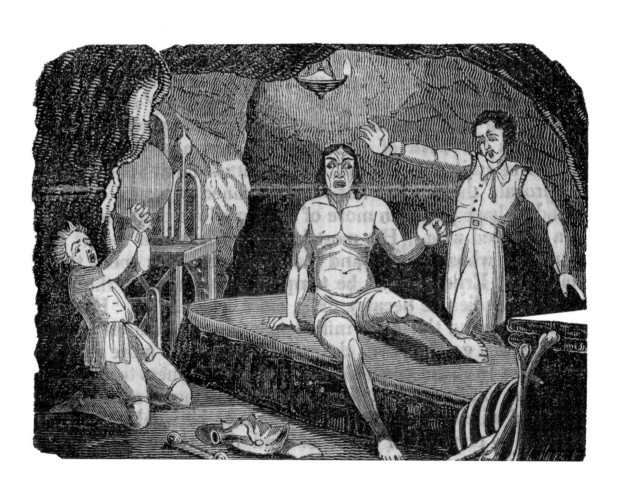

Frontispiece, Endless Entertainment; or, Comic, Terrific, and Legendary Tales, 1825

I N 1823 Richard Brinsley Peake's *Presumption!, or, The Fate of Frankenstein,* the first theatrical adaptation of the novel, appeared on the London stage. Its enormous success made it part of the nineteenth-century repertory and inspired many copycat dramas. This 1825 issue of *Endless Entertainment* is, thus, an early derivative of Peake's derivative: a tale entitled "The Monster Made by Man; or, The Punishment of Presumption." The story, compressed to thirteen pages, owes relatively little either to the play or the novel; one has the sense that the writer knew the major points of the play (monster, avalanche) but perhaps had not seen it. Thus, the creature is made of clay, not flesh, and its ability to speak has been restored. Its first words are "I am the punishment of thy presumption." By the end, the Frankenstein character has gone mad; the creature, "now the most rational of the two," gently guides him down a mountain, several times preventing his creator from attempting suicide. As in the play, they die together in an avalanche. The "spirited cut" shown here, like the story, is an independently imagined version of the creation scene. For the first time we see a slab with the creature sitting up on it and for the first time we see equipment: in the foreground, a broken beaker and something that may be a glass rod; to the right, broken bones, and in the left background an electrostatic generator. After the celebrated electrifications of corpses, it was only a matter of time before someone switched on the creature.

Laboratory scene in
The Bride of Frankenstein, 1935

THE GENERATOR in *Endless Entertainment* of 1825 is puny next to the equipment that went into the laboratory when *Frankenstein* was filmed for the second time in 1931. This image shows the laboratory reassembled for *The Bride of Frankenstein* in 1935. The designers of these horror classics did not build a "workshop of filthy creation," as Victor Frankenstein calls his laboratory in the novel, but a spotless, unworldly place, its

coziest aspect the high stone walls. Kenneth Strickfaden, a Hollywood electrician who became a specialist in producing the appearance of science, threw everything he had at the laboratory. It featured Tesla coils, retorts, glass bells that might be electrostatic generators or vacuum tubes, and equipment so purely imaginary that its purpose can only be guessed at. In tribute to Whale and Strickfaden, Mel Brooks reused many of the same pseudoscientific props in *Young Frankenstein*.

NOTES

1. Such experiments were occasionally carried out later, such as the one in Edinburgh in 1818 shown on pages 84–85.

2. Shelley 1987, p.143 ff., 28 October 1816 and later.

3. Blake 1790, pl. 20.

4. Barbauld 1773.

5. Quoted in Nicolson 1968, Vol. 1, p. 60. Much of this comment derives from Nicolson's research.

6. Guerlac 1976, p. 67.

7. Powers 2017, pp. 12, 14–15.

8. Darwin 1803, p. 7 of the Additional Notes, "Spontaneous vitality of microscopic animals" (separately paged from the poem).

9. Richardson 1987, p. 54.

10. Linebaugh 1992, p. 91.

11. Richardson 1987, p. xiii.

12. Heilbron 1976, p. 76; further quotations from the same source, p. 77.

13. Cardwell 2004.

14. Ure 1819, pp. 284–85.

15. Ure 1819, pp. 289, 290.

16. Interview with Pierce quoted in Jacobs 2011, p. 93.

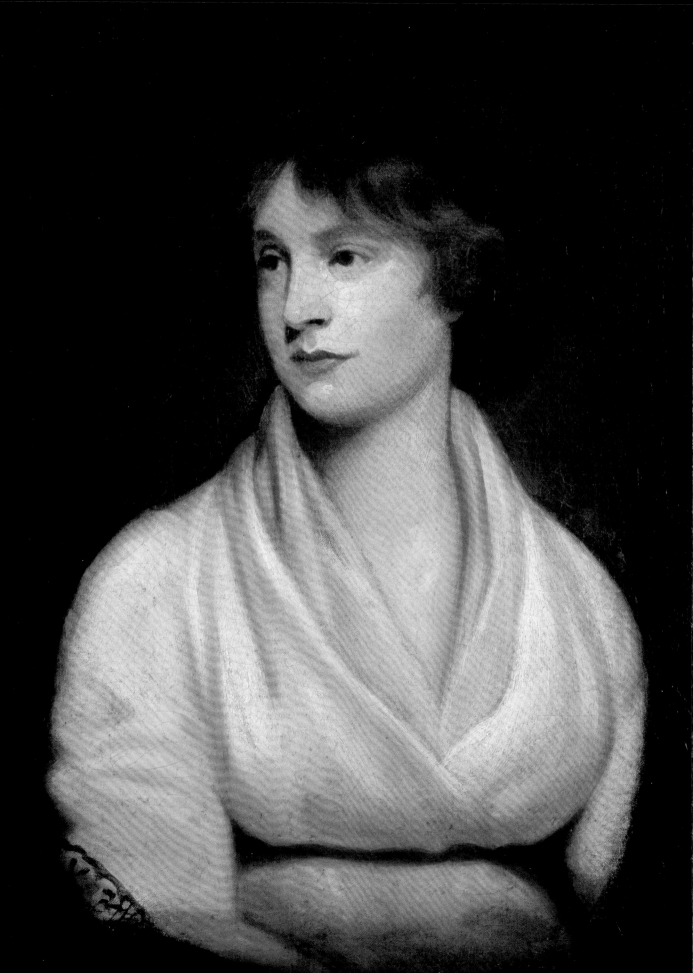

CHAPTER 3

ROMANTIC CHILDHOODS

O N 30 AUGUST 1797, Mary Wollstonecraft, now surnamed Godwin, aged thirty-eight, gave birth to a girl. She had expected a boy and intended to name him for the man who had, that March, become her husband, the philosopher and novelist William Godwin. Ten days later, she was dead of puerperal fever, leaving her husband grieving and her infant daughter, Mary Wollstonecraft Godwin, with little but a name. Her older daughter, three-year-old Fanny Imlay, the offspring of a previous relationship, was effectively orphaned since her biological father, Gilbert Imlay, had abandoned her, though William Godwin would raise the child and give her his name. It was a difficult beginning for the future author of *Frankenstein*, harder for her father and sister, and worst of all for her mother.

That mother, Mary Wollstonecraft, had streaked through life, traveling widely and publishing furiously. Raised by an abusive father and a passive mother, she sought independence young and worked as a companion, governess, and schoolmistress. By her early thirties, with the help of her publisher and mentor, Joseph Johnson, she had made herself a writer. Wollstonecraft wrote for everyone: beginning with translations, she wrote children's books, educational theory, novels, a travelogue, a history of the French Revolution, and in 1790, *A Vindication of the Rights of Men*, the first response to Edmund Burke's defense of the toppled French monarchy. Her most famous work, *A Vindication of the Rights of Woman*, its agenda nowhere near fulfillment today, came out in 1792. It eviscerates writers who have "rendered women objects of pity, bordering on contempt," redefines the concept of modesty (used then and now to disenfranchise women), promotes a rational education for boys and girls, and exhorts women to free themselves of "that pitiful cunning which disgracefully characterizes the female mind."[1] The first *Vindication* had made her name; the second was immediately recognized as epoch-making.

In November 1791 Wollstonecraft and Godwin met at a dinner given by Joseph Johnson. Godwin had come to meet the radical writer Thomas Paine, and found that Wollstonecraft talked too much. She, for her part, was painfully in love with Henry Fuseli, who was married and faithful. At the end of 1792, she went to Paris to see the revolution for herself and to write its history.

Wollstonecraft befriended the literati of Paris, followed the frightening political news as the Terror commenced, and took a lover. She fell in love with Gilbert Imlay, "perhaps best regarded as an early example of the American con man," a land speculator who, despite lip service against slavery, had also been involved in that trade.[2] Wollstonecraft became pregnant in August 1793. They did not marry, although Imlay declared her his spouse to afford her

the protection available to Americans; Britain and France were now at war. Their daughter, Frances, known as Fanny, was born in May 1794.

Imlay proved untrue, and Wollstonecraft despaired. After her first suicide attempt, by an overdose of laudanum, Imlay sent her to Scandinavia to try to recover property stolen by the Norwegian captain of his ship. She took Fanny and a maid and wrote him witty, sad, mordant missives. These became *Letters Written During a Short Residence in Sweden, Norway, and Denmark*—a book, as Godwin famously wrote, "calculated to make a man in love with its author."[3] Back in London, Wollstonecraft again tried to kill herself over the faithless Imlay but was rescued from the Thames. In 1796 she became reacquainted with Godwin, and they fell in love. When Wollstonecraft again found herself pregnant, they married.

After her death, William Godwin was briefly unmoored, but his friends rallied and helped him look after the girls. An advocate of total candor, Godwin found solace in writing a frank and loving memoir of Wollstonecraft that included his emotional reeducation at her hands but also her suicide attempts and her sexual life. It ruined her reputation and did his no good either.

He was, however, still one of the most celebrated writers in Britain, having shone through in 1793 with *An Enquiry Concerning Political Justice,* which urged that individual thought should be free and predicted that institutions hindering it—government, marriage, organized religion—would become unnecessary as human minds were improved by learning and rational argument. In 1794 he had published *Caleb Williams,* a suspenseful novel dramatizing the ideas of *Political Justice.*

Although Godwin searched systematically for a new wife to help with Fanny and Mary, he married a woman who happened to move next door and who, recognizing the philosopher—his portrait in mezzotint was available at print sellers—admired him extravagantly. They married in 1801. Mary Jane Clairmont brought two children of her own to the union, Jane and Charles (themselves, though they didn't know it, fathered by two different men). In 1803 she bore William Godwin the younger. Their household thus sheltered five children, no two of whom had the same two parents. Although many of Godwin's friends found Mary Jane Godwin unbearable—Charles Lamb called her the "bad baby" because of her ill-managed outbursts—the couple loved each other greatly and the marriage endured.

In 1805, the Godwins founded a children's bookshop and publishing company, the Juvenile Library. Despite loans and gifts from friends and a fair degree of success at selling books (among their best sellers was Charles and Mary Lamb's *Tales from Shakespeare*), their financial situation grew ever more precarious. The family lived over the shop at 41 Skinner Street, where Godwin had a separate study, the children had the schoolroom on the third floor, and Mary Wollstonecraft's portrait hung over the fireplace in the parlor.

Young Mary Godwin grew up visiting Wollstonecraft's grave, reading her books, and looking at the portrait. As she grew older, her relations with her stepmother grew so tense that

she was sent for long visits to the Baxters, family friends in Dundee, whence she traveled in the countryside with much delight. Here she began, she remembered in 1831, to conceive of her "true compositions, the airy flights of my imagination" that would free her voice from its "common-place style." At home or away, standards for the Godwin ménage were high: years after *Frankenstein* had been published, Jane, now Claire, Clairmont wrote to a friend that "in our family if you cannot write an epic poem or a novel that by its originality knocks all other novels on the head, you are a despicable creature not worth acknowledging."[4] She exaggerated, but Mary's parentage, in particular, raised great expectations.

Mary Godwin's girlhood was, thus, compassed by a number of the themes of British Romanticism: the early rapture and disappointment of the French Revolution, premature death, the need to measure up to greatness, and a bond with nature. The only thing missing as she reached adolescence was passion, which erupted when she met and fell in love with her father's new disciple, a married poet named Percy Bysshe Shelley. Their elopement at dawn on 28 July 1814, accompanied by Jane Clairmont, is one of the great scenes of English literary legend. Their journey to the Continent was underfunded, and they returned the cheapest way possible, on boats down the Rhine, where they may or may not have noticed a Castle Frankenstein. On their return in September, Mary Godwin was pregnant.

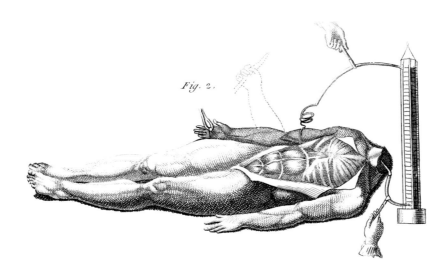

Fig. 2.

George Dawe after James Northcote, portrait of William Godwin, 1802

GODWIN's fur collar and Roman profile give him the dignity he craved; his portrait's having been engraved means that he was famous enough for it to be reproduced and sold in print shops. Yet after Britain went to war with France, his political positions became extremely unpopular, as the country grew more conservative and more fearful of spies. Godwin, ordained as a Dissenting minister, retained his sense of moral urgency, but he, too, changed with the times and eventually published two new and less demanding editions of *Political Justice.* When Shelley first wrote him in 1812, the young poet expected to meet the radical of 1793. Nonetheless Shelley and his first wife, Harriet, soon became close to the whole Godwin-Clairmont household—with the exception of Mary, away on an extended visit in Scotland.

Mary Wollstonecraft, letter to Catharine Macaulay, 1790

ALTHOUGH, at a hyperbolic moment, Mary Wollstonecraft called herself "the first of a new genus," she was aware of and grateful to the professional women writers who preceded her. One of these was Catharine Macaulay (1731-1791), a Whig historian whose marriage to a much younger man, William Graham, had damaged her reputation. A month before she wrote this letter, Wollstonecraft had published an appreciative review of Macaulay's *Letters on Education*. Both writers intervened in the furious pamphlet war during the early days of the French Revolution—on the insurrectionist side, of course. Wollstonecraft's contribution was *A Vindication of the Rights of Men*, aimed at the conservative Edmund Burke, and it made her name. Her letter closes with a compliment that must have been gratifying: "I respect Mrs. Macaulay Graham because she contends for laurels whilst most of her sex only seek for flowers."

John Keenan,
portrait of Mary Wollstonecraft, 1804

A PORTRAIT of Wollstonecraft, painted by John Opie when she was pregnant with Mary, hung over the fireplace in the parlor of the Godwin-Clairmont household. John Keenan painted this copy for Aaron Burr, whom the Godwins befriended when, in 1807, he came to England in political disgrace. Burr had raised his daughter Theodosia on Wollstonecraft's precepts and called Mary, Fanny, and Jane "les goddesses." Wollstonecraft remained a central figure in the household even in death, and Mary Godwin and P. B. Shelley first declared their love for each other in 1814 at her grave in St. Pancras churchyard. During their elopement soon after, Wollstonecraft's novel *Mary* and her *Letters Written During a Short Residence in Sweden, Norway, and Denmark* formed part of their reading.

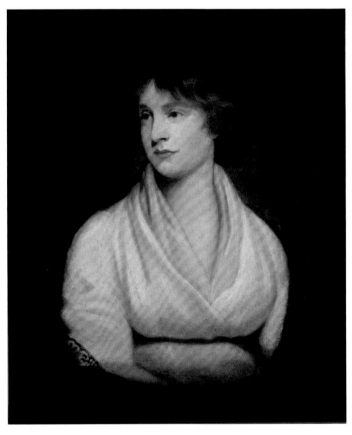

Translated by Wollstonecraft, illustrated by Blake, 1791

JOSEPH JOHNSON, the publisher of the children's book from which this illustration is drawn, was also the organ of the Unitarians at a time when the liberal Dissenting sect was a major voice in Britain's political life. ("Dissenting" indicates a Protestant sect—e.g., Methodists, Baptists, Quakers—espousing different beliefs than the state-sponsored Church of England.) Johnson also published many medical and scientific works and employed artists such as William Blake and Henry Fuseli, the latter a particular friend. Johnson was a mentor, friend, and publisher to Mary Wollstonecraft from her earliest days as a writer, offering her work not just on books but writing reviews and essays for his liberal journal, *The Analytical Review*—where her review of Catharine Macaulay's *Letters on Education* appeared. Wollstonecraft's translation of Christian Gotthilf Salzmann's *Elements of Morality* for Johnson is one of two books in her oeuvre to have been illustrated by Blake.

Pl. 4. Vol. I.

What will become of me!

Published by J. Johnson Oct.^r 1. 1790.

Wollstonecraft, *Original Stories from Real Life*, illustrated by Blake, 1796

Original Stories from Real Life is Wollstonecraft's second Blake-illustrated book, although the illustrations weren't added until she had become one of Johnson's star writers. The stories feature a benevolent governess, Mrs. Mason, who instructs two young girls in morality and (among other things) effective time management. These lessons draw on her experience in Ireland teaching the older daughters of a viscount. The girls' mother was a model for the vain, idle creatures Wollstonecraft would castigate in *A Vindication of the Rights of Woman*, but she loved the eldest daughter, Margaret King, later the Countess of Mount Cashell. Lady Mount Cashell had taken her governess's teaching very much to heart; she hated her arranged marriage and life as an aristocrat. While traveling in Europe in 1803, she fell in love with an Irish agriculturalist and settled in Pisa. In need of an alias, she called herself Mrs. Mason, remembering her mentor, and under this name befriended the Shelleys and Claire Clairmont when they met in Italy in 1819.

P. 94

Be calm, my child, remember that you must do all the good you can the present day

Blake in & sc

Published by J. Johnson, Sept.ʳ 1 1791.

Frontispiece, Dramas for Children, 1817

MARY JANE GODWIN loosely translated these little dramas for children as the "editor of Tabart's Popular Stories." Although they share a moral mission with Wollstonecraft's *Original Stories from Real Life,* it is hard to believe any child could derive much pleasure from them. The girl hanging her head in the frontispiece has been brought to tears of shame by the fault of curiosity, her reproved state representative of all the protagonists of this book by its close. Not all of the books Mary Jane Godwin worked on were so relentless; she was also responsible for the first English translation of *The Swiss Family Robinson.* The book's advertisement directs readers to the Skinner Street address where the Juvenile Library—a bookshop, not a lending library—was located.

Mary Shelley, Mounseer Nongtongpaw, 1808

Mounseer Nongtongpaw is the earliest evidence we have of Mary Godwin's involvement in the Juvenile Library. When William Godwin sought to commission a new version of Charles Dibdin's 1796 comic song *Mounseer Nongtongpaw*, he sent his ten-year-old daughter's prose paraphrase to an unknown correspondent to use as a guide. Dibdin, a popular and prolific composer, wrote for an adult theater audience. Children needed something more direct and vigorous, and to make a picture book, the song needed to be longer. While it was once thought that Mary Godwin added extra stanzas, it is now believed that William Godwin's correspondent and the writer are one and the same.[5] All of the girls, Jane, Fanny, and Mary, helped out in the shop, though none seems to have relished the work. Indeed the prospect of a life in the shop may have been one reason that P. B. Shelley proved so attractive to Mary Godwin.[6]

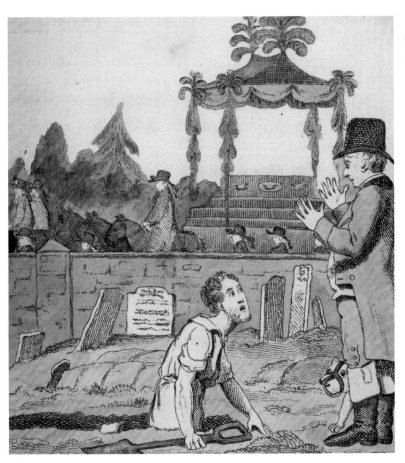

Portrait of Percy Bysshe Shelley as a boy

THOUGH this portrait bears little resemblance to those of the adult Shelley, its authenticity is attested to by a note on the back written soon after his death by his friend, the poet and journalist Leigh Hunt: *Genoa, October 17, 1822 / This miniature was given to me by my poor dear / friend Shelley in the presence of Lord Byron. / Leigh Hunt.* This boy meets conventional expectations of how a young poet should look—the sensitive eyes and fair hair, the ingenuous gaze, the girlish collar—but from Shelley's early adventures in plagiarism we know that innocence was not a significant part of his psyche. His sincerity and self-confidence were never in doubt, however, as he plunged into publishing. *Zastrozzi,* his first novel, appeared in 1810 when he was seventeen, demonstrating to the English literary world what his friends and family already knew: that the angelic-looking poet, steeped in the bloodiest Gothic romances of the Monk Lewis school, was now producing his own.

P.B.Shelley

Percy Bysshe Shelley, "A Cat in Distress," ca. 1810

P ERCY BYSSHE SHELLEY's first female collaborator was his sister Elizabeth; their work on *Victor and Cazire* (1810) was glimpsed in Chapter 1. This is their earliest surviving coproduction, although several years elapsed between P. B. Shelley's composition of the poem and its presentation here: a note on the verso claims it was written when Shelley was 10, around 1802. The paper is watermarked 1809. The hand and the painting were held by family history to be Elizabeth's. We see Shelley already mocking the status quo and promoting the cause of the hungry, though it is only a cat—"As I am a sinner / It wants for some dinner / To stuff out its own little belly." Shelley continued to

take young women under his wing with Harriet Westbrook, his sisters' school friend. Seeing her in need of rescue from an overbearing father, he promised to care for her, and they eloped in the summer of 1811. Harriet Westbrook, a pretty schoolgirl of average intelligence and conventional upbringing, was sixteen and he, by now a weathered radical, estranged from his rich family, was nineteen. For him, the marriage was largely over by 1814, when he met William Godwin's daughter.

Jane Clairmont, travel journal, 1814, transcribed ca. 1870

WHEN Percy Bysshe Shelley, Mary Godwin, and Jane Clairmont eloped to France in July 1814, they packed like bookish teenagers. Mary Godwin brought all her early letters and papers, which she inadvertently left in Paris, to the dismay of biographers ever since. They had little money and no changes of clothes. Shelley forgot his watch but remembered his three-volume pocket Shakespeare.[7] All kept journals recording the miseries of their journey (rats, dirt, rain, dreadful food, unhelpful drivers, sprained ankles) and the rewards, as well, for instance, an al fresco reading of *As You Like It:* "Shelley said poetry read in a room never came so near the soul as if read in a beautiful spot, in the wide open air and under the wide open Heaven." Ascending toward Switzerland, Clairmont wrote: "We were so happy . . . Shelley in an ecstacy declared how great was his joy—How great is my rapture he said, I a fiery man with my heart full of Youth, and with my Beloved at my side, I behold these lordly immesurable Alps."[8]

Journal of Cl. Clairmont written in the year 1814.

August. 1814

We took a walk in the Eg— and climbed one of the highest of the hills— As we descended a most violent storm of rain came on, and we were wet through. The sky was entirely black and the rain poured in torrents. One long strip of red light alone marked where the sun had set. I said, "look there how the Sun in parting, has bequeathed a lingering look to the Heavens, he has left desolate." I thought this a most beautiful thought. When we reached the valley it was a very pretty sight to look on the lights from the cottages reflected in a small clear stream that flowed a bank beneath them. We went to bed directly as our clothes must be dried in the night. They are the only ones we have got with us.

Monday 15th August. Rise at four. Misty Morning and the wind bleak & cold. A peasant takes us in his cart to Sugencourt, where we

NOTES

1. Wollstonecraft 1792, p. 288.

2. Verhoeven 2006.

3. Godwin 1798, p. 123.

4. Clairmont 1995, Vol. 1, p. 295.

5. Moskal 1996, p. 398.

6. Seymour 2000, p. 94.

7. So Claire Clairmont thought at the time; in fact he had sold it in Paris.

8. Clairmont 1970, pp. 346, 349.

CHAPTER 4

THE SUMMER OF 1816

B Y THE SPRING of 1816, Jane Clairmont was calling herself Claire. Steeped in Woll-stonecraftian and Godwinian politics as deeply as her traveling companions of 1814, she was a more articulate feminist than Mary Shelley would ever be and had unloosed herself from "the trammels of custom & opinion."[1] The year and a half after their return from France had been difficult: she and Mary Godwin shared shabby lodgings, often alone, while Mary endured her first pregnancy, cared for the baby girl, who lived only a few weeks, and mourned for her. P. B. Shelley was on the run from debt collectors, frantically raising funds, and pressed by William Godwin for a handsome share of whatever might come his way. All of the families of their connections (including Harriet Shelley's Westbrook kin) were angry at them. The cooped-up stepsisters got on so badly that in May 1815, as soon as he could afford it, Shelley paid for Clairmont to go to Devon for a bit to give Mary a break.

Miserable in exile, Clairmont saw with envy how Mary's partnership with Shelley gave purpose to life. After visiting her brother in Ireland, she returned to London looking for a poet, or a purpose, for herself. She wrote to Byron to ask for help breaking into the theater. George Gordon Byron, Lord Byron, was one of the most popular and certainly the handsomest poet in London. He, too, was in crisis, as his ill-matched marriage publicly fell apart, and he was on the board of the Drury Lane Theatre, in a position to help Clairmont. She had genuine musical gifts, including a lovely voice, but her offer to sleep with Byron before they'd even met suggests that seduction may have been a stronger motive. In any case, Byron was not hard to seduce, though he never claimed to love her. Clairmont felt quite differently and tried to win his esteem and affection through her connections with the Shelleys and the Godwins. To that end, without any encouragement, she decided to follow Byron, who was bound for Switzerland after formally separating from his wife. She made no secret of her determination, and Byron told her that at least she had better not come alone, expecting to fling herself on his protection. In early May 1816, Claire Clairmont, Mary Godwin, and P. B. Shelley again set out for the Continent, now with baby William. Shelley had been advised by his doctor to find a warmer climate, and they were already thinking of a permanent home in Italy. Clairmont begged for Switzerland and explained why: she may already have been pregnant and was much relieved when Shelley, as she wrote to Byron, "yielded to my pressing solicitations," adding, "in five or six days I shall be at Geneva."[2]

The Shelley-Godwin-Clairmont party got there first. They spent a fortnight waiting for Byron in Geneva, a city that struck them as prissy and rule-bound. Avoiding English tour-

ists, they studied and played with little William in the hotel garden or perhaps on the grassy expanse of the Plainpalais, a public park that would appear in *Frankenstein*. In the evenings, P. B. Shelley and Mary Godwin left William with his recently hired nurse and went out to row and drift on Lake Geneva with Mont Blanc looming across the water.

By early June, Byron had arrived with his physician and traveling companion, John William Polidori, and rented the Villa Diodati, northeast along Lake Geneva in Cologny, a quiet town offering more privacy than Geneva. The larger party took the Maison Chappuis, a lakeshore cottage five minutes' walk downhill from Diodati. Byron was writing the third canto of *Childe Harold*, the narrative poem that had already made him famous. The others had come with less workaday plans and great hopes for outdoor excursions. P. B. Shelley loved boating; he and Byron bought a small sailboat together and went out as often as possible. There were violent storms and relentless rain, however, the effect of the 1815 explosion of an East Indian volcano, Mount Tambora. The party was often pent indoors. Byron wanted little to do with Claire alone, although, as he wrote to his friend Douglas Kinnaird, "if a girl of eighteen comes prancing to you at all hours of the night—there is but one way. . . . "[3] As a group, they were welcome to visit Diodati, and Byron and P. B. Shelley struck up a friendship on their own. When they were all together, the men did most of the talking while the women listened, genuinely rapt.

Sometimes they would read aloud. There was a volume of ghost stories on hand, *Fantasmagoriana*, German tales translated into French, with titles like "The Dead Bride," "The Fatal Hour," "The Death's Head," and "The Black Chamber." Beyond that book, we don't know much for certain about the famous mid-June evening that produced Mary Godwin's first novel. There would have been a fire in the fireplace, the candles lit, rain beating on the windowpanes. We might imagine that Shelley and Mary Godwin share a little sofa, she reading with her best French accent as Byron lounges on a red and white chintz armchair, his leg hanging over its arm, Polidori fidgeting on a wooden side chair with nowhere to put his empty wineglass. One imagines Claire Clairmont in the shadows, if she was there at all—none of the accounts mentions her.

"'We will each write a ghost story,' said Lord Byron; and his proposition was acceded to." This is how Mary Shelley described it in the introduction she added to *Frankenstein* in 1831, long after Byron, P. B. Shelley, and Polidori were dead. The eighteen-year-old threw herself into the contest, trying to come up with something to rival the stories in *Fantasmagoriana*, "to curdle the blood, and quicken the beatings of the heart." She tried over many days, almost despairing, when at last the idea came to her one night, in something she does not call a dream: "I saw—with shut eyes, but acute mental vision—I saw the pale student of unhallowed arts kneeling beside the thing he had put together."

More was at stake for her than triumph in the Diodati drawing room. Other forces bore on the young writer to produce something wonderful: she had cast her lot with a poet she

idolized who was "very anxious that I should prove myself worthy of my parentage, and enrol myself on the page of fame." Her partnership with Shelley had made her a parent, with the fears and duties that state entails; it had painfully shifted her relationship with her own parent, exposing her to Godwin's cold and peremptory demands for money from Shelley, money that was not readily available and that came very dear. And that partnership had, as she was coming to learn, rendered her vulnerable to slander and shame. In these circumstances, the contest that would prove her an author and adult took on great importance. Perhaps we shouldn't wonder that a writer as young as Mary Shelley would, under such extreme pressures, have produced a diamond with a story so multifaceted that we still turn it over and over.

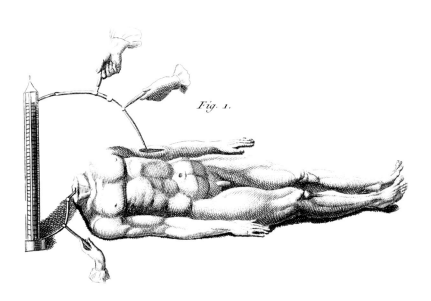

Fig. 1.

Shelley explains himself to Godwin

THE DEATH of P. B. Shelley's grandfather in January
1815 and the poet's subsequent inheritance improved his
financial situation, but it meant that Godwin's demands for
money were even more pressing. Godwin still refused to talk
to his daughter or to Shelley. Seeing them on the street, he
remarked that Shelley was "so beautiful it was a pity he was
so wicked."⁴ In this letter of May 1816, Shelley tries to make
amends without betraying his integrity: while he thinks well of

[handwritten letter, largely illegible]

... forgive me. — burn those letters which contain
the records of my ... & ... that however
what you ... call ... & ... separate
us, I shall always feel towards you as the
most affectionate of friends. —

P.B. Shelley.

Address — Post Restante, Geneva.

*This ... written in great haste, expecting
every moment to hear that the Pacquet sails.*

Godwin, "perhaps better than of any other person whom Eng-
land contains," he finds it unfortunate that the "least excellent"
part of Godwin's character should have been that with which
Shelley had to deal. At the same time, he will no longer bear a
situation in which the prejudice against his relationship with
Mary Godwin does not permit him to "live on equal terms with
my fellow beings." While he will always feel toward Godwin as
to the most affectionate of friends, he is leaving England, per-
haps forever, and taking Mary to Geneva.

William Shelley, 1819

WILLIAM GODWIN SHELLEY was four months old when his parents traveled with him to Switzerland. His nicknames—Blue Eyes, Willmouse—show how they doted on him. During their time in Cologny, Polidori, hearing of an illness in the neighborhood, took the baby to be vaccinated, possibly saving his life. In January 1817, just before William's first birthday, his mother described him: "Blue Eyes gets dearer & sweeter every day—he jumps about like a little squir-

rel—and stares at the baby with his great eyes."[5] The baby was Claire Clairmont's daughter by Byron, named Alba by her mother; her father changed it to Allegra Biron, the shift of vowel indicating her illegiti-macy. Both children fell prey to diseases endemic to Italy, William dying of malaria at three and a half, and Allegra of typhus at five. She was bur-ied at Harrow, Byron's school, while William was buried in the Protestant Cemetery in Rome. When P. B. Shelley had to be interred in 1822, they looked for William's body to move it near his father's, but it was not to be found.

Mary Shelley, a lock of hair for Thomas Jefferson Hogg

RETURNING from their first trip to the Continent in September 1814, Mary Godwin and P. B. Shelley were in many kinds of trouble—penniless, expecting a child, nearly disowned by their families. For the poet, one bright spot was a reconciliation with his suggestible friend Thomas Jefferson Hogg, his collaborator on *The Necessity of Atheism,* the pamphlet that got them expelled from Oxford. They had fallen out late in 1811 when Hogg tried to seduce Harriet Westbrook Shelley (now cruelly abandoned, though Shelley didn't see it that way). Later the two men made it up, to some degree, and in 1814 Hogg, with Shelley's encouragement, cast his eye toward Shelley's new love. Hogg was habitually attracted to women attached to P. B. Shelley: previously he had believed himself in love with Shelley's sister Elizabeth, sight unseen. By January 1815 Mary Godwin was seven months pregnant with her first child. She told Hogg in the letter accompanying this lock of hair that he would have to wait for her, as she said, for "phisical reasons," as would Shelley. And she was trying to arouse in herself some love for Hogg: "My affection for you although it is not now exactly as you would wish will I think dayly become more so . . . this dear Hogg will give time for that love to spring up which you deserve and will one day have." So far as we know, and fortunately for all, nothing, at least nothing physical, took place.

The Plainpalais in 1817

A GOOD DEAL of blood, both fictional and real, has nourished the turf of Plainpalais, a public park in Geneva with a wide lawn. In *A History of a Six Weeks' Tour*, Mary Shelley's first published work, she was grateful for the Genevan republic, established by a revolution in 1794, which cannot be rendered vain by "the chicanery of statesmen, nor even the great conspiracy of kings."[6] She noted coolly that the Genevan magistrates were executed at Plainpalais during that revolution, and that their successors avoided the place. For the rest of the city, including the Shelley-Godwin-Clairmont party when they were there in 1816, it is an inviting playground. In *Frankenstein*, traces of Mary Shelley's time in Geneva are perceptible: Victor Frankenstein's brother, little William, a blond, blue-eyed boy, has a favorite playmate named Louisa Biron; William's murder at Plainpalais is the first the creature commits, and when the creature frames the servant girl Justine Moritz, it is here that she is hanged. Today a statue of the creature, cast in 2013–14 and known as Frankie, stands on the expanse.

❧ See illustration on pages 116–17.

The Mer de Glace in 1781

THE Mer de Glace is a valley glacier, a flowing mass of ice that looks, in P. B. Shelley's description, "as if frost had suddenly bound up the waves and whirlpools of a mighty torrent." The Sea of Ice was a tourist destination as soon as there were tourists and remains one today, though considerably shrunk by global warming. The small building shown in this print is Blair's Hospital, built by an Englishman in 1779 not for medical purposes but to offer refreshments for climbers; it has been followed by an unbroken chain of other such businesses. The Shelley-Godwin-Clairmont party visited the Mer de Glace on 24 July 1816, a little more than a month after Mary Godwin had begun work on *Frankenstein.* They, too, were struck by its sublime and uncanny beauty. And they, too, like the visitors here, added a domestic note to the scene by picnicking on the grass.

❦ See illustration on pages 120–21.

View of Geneva and the Villa Diodati, 1803

T HE Villa Diodati, shown in this print from a short distance, is still (as of this writing) a private residence, and visitors can only look at it. The best view is from the adjacent "Pré Byron," Byron's meadow. Maison Chappuis, the residence of the Shelleys and Claire Clairmont, possibly the lower building seen here, lay at the foot of the hill but has been demolished. Thomas Moore's 1830 life of Byron incorporated Mary Shelley's recollections: after a late breakfast, Byron would stroll down to "Shelley's cottage" for an excursion in the boat the two men shared. Byron dined alone at 5:00 and would sometimes return for a second outing on the lake in the evening. When the weather was bad, however, Moore tells us, "the inmates of the cottage passed their evenings at Diodati, and when the rain rendered it inconvenient for them to return home, remained there to sleep. 'We often,' says one, who was not the least ornamental of the party [i.e., Mary Shelley], 'sat up in conversation till the morning light. There was never any lack of subjects, and, grave or gay, we were always interested.'"[7]

George Gordon Byron, "Darkness," 1816

THOMAS MOORE's description of Byron's life in Cologny makes it sound as if Byron did nothing but boat, chat, and eat alone during his days at Diodati. In fact, he was quietly upholding his reputation (nearly a secret one) as the hardest-working poet in the business. Between April and July of 1816 Byron wrote the 1,110-line third canto of *Childe Harold's Pilgrimage*, describing in it the trip he took with Shelley around Lake Geneva. He also produced a number of lyric poems, among them "Prometheus," "The Dream," and "Darkness," an apocalyptic poem inspired by the dreadful weather. The neat hand in which the only extant copy of "Darkness" is written does not resemble Byron's energetic scratching, because it is Claire Clairmont's. A fair copy—the clear, legible copy for the printer, as free of errors and revisions as possible—still meant a *handwritten* piece of work: neatness counted for much in literary transmission. Byron, whose sexism was unfettered and unrepentant, employed both Mary Godwin and Claire Clairmont to make fair copies of his work that summer, including *Childe Harold*. Neither seems to have minded. Years later Mary Shelley mentioned Byron's "letterless scrawl" as one she had learned to read with ease.[8]

Darkness.

I had a dream which was not all a dream.

The bright Sun was extinguished, and the Stars

Did wander darkling in the eternal space,

Rayless, and pathless, and the icy Earth

Swung blind and blackening in the moonless air;

Morn came, and went, — and came, and brought no day,

And Men forgot their passions in the dread

Of this their desolation — and all hearts

Were chilled into a selfish prayer for light:

And they did live by watchfires — and the thrones,

The palaces of crowned kings, — the huts,

The habitations of all things which dwell,

Were burnt for beacons, — cities were consumed,

The ghost story competition described in *The Vampyre,* 1819

xiv *Extract of a Letter from Geneva.*

well acquainted with the *agrémens de la Société*, and who has collected them round herself at her mansion. It was chiefly here, I find, that the gentleman who travelled with Lord Byron, as physician, sought for society. He used almost every day to cross the lake by himself, in one of their flat-bottomed boats, and return after passing the evening with his friends, about eleven or twelve at night, often whilst the storms were raging in the circling summits of the mountains around. As he became intimate, from long acquaintance, with several of the families in this neighbourhood, I have gathered from their accounts some excellent traits of his lordship's character, which I will relate to you at some future opportunity.

Among other particulars mentioned, was the outline of a ghost story by Lord Byron. It appears that one evening Lord B., Mr. P. B. Shelly, two ladies and the gentleman before alluded to, after having perused a German work, entitled Phantasmagoriana, began

IT IS HARD to give "Poor Polidori," as Mary Shelley called him, his due. As the only other person at Diodati to complete his story, and as the writer of the first full tale of vampires, he has earned a place in literary history. The publication of *The Vampyre,* however, is shrouded in malodorous gloom: either Polidori tried to pass it off as Byron's; or Henry Colburn, a major publisher, did the same thing and, worse, did so in a way that robbed Polidori of the copyright. "The Vampyre" appeared in Colburn's *New Monthly Magazine* in April 1819, attributed to Byron. It was accompanied by the anonymous "Extract of a Letter from Geneva," shown here. The "Extract" tells for the first time in print the story of the contest and

relating ghost stories ; when his lordship hav-
ing recited the beginning of Christabel, then
unpublished, the whole took so strong a hold of
Mr. Shelly's mind, that he suddenly started up
and ran out of the room. The physician and
Lord Byron followed, and discovered him lean-
ing against a mantle-piece, with cold drops of
perspiration trickling down his face. After
having given him something to refresh
him, upon enquiring into the cause of his
alarm, they found that his wild imagination
having pictured to him the bosom of one of
the ladies with eyes (which was reported of
a lady in the neighbourhood where he lived)
he was obliged to leave the room in order to
destroy the impression. It was afterwards
proposed, in the course of conversation, that
each of the company present should write a
tale depending upon some supernatural agency,
which was undertaken by Lord B., the phy-
sician, and one of the ladies before mentioned.
I obtained the outline of each of these stories
as a great favour, and herewith forward them

adds details of life at Diodati, including an unpleasant and
dubious anecdote of P. B. Shelley. Although Polidori sought
an injunction against Colburn, another publisher, Sherwood,
Neely, and Jones (probably in collusion with Colburn), had
copyrighted both the story and the "Extract" in late March.
Soon after they published both texts as a book, which sold
briskly. Polidori's biographer believes that he may have ham-
strung himself by selling the manuscript too cheaply.[9] De-
spite an industrious writing career after this episode, Polidori
did not escape self-sabotage, and in 1821, after a three-week
trawl through the gambling dens of Brighton, killed himself
with prussic acid.

Percy Bysshe Shelley describes the Mer de Glace, 1816

PERCY BYSSHE SHELLEY and Mary Godwin wrote long letters home in 1814 and 1816, almost certainly with an eye toward publication in their collaborative *History of a Six Weeks' Tour Through a Part of France, Switzerland, Germany, and Holland, with Letters Descriptive of a Sail Round the Lake of Geneva and of the Glaciers of Chamouni*—the book is not much longer than the title. Mary Godwin wrote to her half sister, Fanny Imlay Godwin, perhaps as a sop for having left her behind. Shelley addressed

his friend Thomas Love Peacock, living (on an annuity from Shelley) in Marlow, Buckinghamshire. Peacock was writing the comic novels for which he is now chiefly remembered, including *Nightmare Abbey* (1818), in which he sent up his friend Shelley as the philosophical Scythrop Glowry. Peacock was also an enthusiastic hiker in northern Wales, the area of the British Isles perhaps most like Switzerland, and Shelley would have known that he would take pleasure in his descriptions of the Alps.

History of a Six Weeks' Tour, 1817

The author of *Frankenstein* and P. B. Shelley described the Mer de Glace with quite different purposes. The letter to Peacock, previously shown in manuscript, was imported almost without change into the *History of a Six Weeks' Tour*. For Shelley, the constantly moving glacier—it flows at a rate of about 90 meters a year—was an occasion for philosophy and analogy: "In these regions every thing changes, and is in motion. . . . One would think that Mont Blanc, like the god of the Stoics, was a vast animal, and that the frozen blood for ever circulated through his stony veins."[10] For Mary Shelley, the sublimity of the place offers a moment of irony, as Victor Frankenstein, though deep in mourning for Justine Moritz and little William, both killed by the creature, is roused by the "vast river of ice" and the "icy and glittering peaks" of the surrounding mountains to address their ghosts. "My heart, which was before sorrowful, now swelled with something like joy; I exclaimed—'Wandering spirits, if indeed ye wander, and do not rest in your narrow beds, allow me this faint happiness.'" Victor is answered—not by William and Justine but by their murderer, and the Mer de Glace is the stage on which the creature tells his sad and angry story.

164

Chamouni, July 25th.

We have returned from visiting th glacier of Montanvert, or as it is called the Sea of Ice, a scene in truth of dizzying wonder. The path that wind to it along the side of a mountain, now clothed with pines, now intersected with snowy hollows, is wide and steep The cabin of Montanvert is thre leagues from Chamouni, half of whic distance is performed on mules, not s sure footed, but that on the first da the one which I rode fell in what th guides call a *mauvais pas*, so that I na rowly escaped being precipitated dow the mountain. We passed over a ho low covered with snow, down whic vast stones are accustomed to roll. On

NOTES

1. Clairmont 1995, Vol. 1, p. 110, to Byron, 12 January 1818.

2. Clairmont 1995, Vol. 1, p. 43, to Byron, 6 May 1816.

3. Byron 1976, p. 162, 20 January 1817.

4. Shelley 1987, entry for 23 March 1815, p. 72.

5. Shelley 1980, Vol. 1, p. 28, to PBS, 17 January 1817.

6. Shelley 1817, p. 102.

7. Thomas Moore, *Letters and Journals of Lord Byron*, London, 1830, Vol. 1, pp. 498–99, quoted in Shelley 1987, p. 108.

8. Shelley 1980, Vol. 1, p. 495, to John Howard Payne, 29 June [1825].

9. Stott 2013, pp. 239–45.

10. Shelley 1817, pp. 166, 167.

165

had fallen the preceding day, a little time after we had returned: our guides desired us to pass quickly, for it is said that sometimes the least sound will accelerate their descent. We arrived at Montanvert, however, safe.

On all sides precipitous mountains, the abodes of unrelenting frost, surround this vale: their sides are banked up with ice and snow, broken, heaped high, and exhibiting terrific chasms. The summits are sharp and naked pinnacles, whose overhanging steepness will not even permit snow to rest upon them. Lines of dazzling ice occupy here and there their perpendicular rifts, and shine through the driving vapours with inexpressible brilliance: they

CHAPTER 5

FRANKENSTEIN IN HER TIME

*F*RANKENSTEIN inevitably provokes the questions: How could a novice writer come up with such a tale? And a *girl?* Many books have been filled with answers to these questions, some more convincing than others. Mary Shelley made constant use of her experience on the Continent and of the journals she and P. B. Shelley kept. Other sources are less direct: Victor's consent to the creature's demand for a mate, for instance, has a strong scent of the Godwinian belief that correct moral reasoning should overcome even the strongest emotions. Or consider the dream that Mary Shelley created for Victor just after he had made the creature: he embraces his fiancée, Elizabeth Lavenza, only to have her body turn to his mother's corpse as he kisses her. This condenses love, death, and guilt, and the power of such feelings may have had a source in Mary Shelley's knowledge that her birth caused her mother's death. Equally, tragic events in the life of her family soon after the party's return to England left legacies of remorse and sorrow for all concerned.

Fanny Godwin, born Imlay, was more strongly attached to William and Mary Jane Godwin than were the other children although, as the only child without a biological parent active in her rearing, the attachment was not mutual. Her last letter to Mary Godwin pressed for money that P. B. Shelley had promised but was unable to give to William Godwin. She felt herself mocked by her younger, more glamorous sister—"I understand from Mamma that I am your laughing stock—and the constant beacon of your satire," she wrote to her in Geneva.[1] In October 1816, having written suicide notes to Godwin and to P. B. Shelley, Fanny Godwin traveled to Swansea, Wales, where she knew no one, and took a room at an inn under an assumed name. There, wearing a pair of Mary Wollstonecraft's stays (the functional equivalent of a brassiere), she killed herself with an overdose of laudanum. Two months later, the body of pregnant Harriet Shelley was pulled out of the Serpentine, a lake in Hyde Park, where it had been for more than a week. She left a miserable suicide note. In composing *Frankenstein,* Mary Shelley (as she became shortly after Harriet Shelley's death) might have called on the feelings evoked by these events.

There are, too, less personal sources. The scientific ones have been described. Mary Shelley dipped deep into the pool of poetry from Coleridge, P. B. Shelley, Milton, and Wordsworth, to name only the most prominent, both by quotation and in the quality of her attention to the natural world. Other sources are merely speculative: the Castle Frankenstein, for instance, that she, P. B. Shelley, and Claire Clairmont passed as they traveled down the Rhine in 1814. On 2 September, their boat passed the castle, and the couple took a rare walk without Claire

Clairmont into the neighborhood. There they may have heard the story of Johann Konrad Dippel, an early-eighteenth-century alchemist said to have tried to create artificial life with a concoction called Dippel's Oil. Claiming to have been born at the Castle Frankenstein, he sometimes signed with that name. No evidence exists for Mary Shelley's having known any of this, however, and the story amounts to a good deal of speculation about an afternoon walk.

An earlier source may be a 1790 novel by François-Félix Nogaret entitled *Le miroir des événemens actuels, ou la belle au plus offrant* (The Mirror of Current Events, or, The Belle to the Highest Bidder). Nogaret, a supporter of the French Revolution, tells the story of a young woman who rounds up six inventors, one named Frankenstein. The maker of the best invention will get her hand in marriage, "and by extension . . . advance technology in a war-torn economy."[2] Frankenstein produces a male automaton that plays the flute, and his closest competitor, Nicatos, a female automaton that speaks, moves, and brings gifts. The heroine marries the latter inventor, and her sister marries Frankenstein. The coincidence seems irresistible: how could this tale not be a source? But Nogaret, too, got the name of Frankenstein from the Konrad Dippel story. If Shelley knew about Dippel, she might not have needed to know Nogaret. But perhaps she did know the book. It may have entered William Godwin's library from books Mary Wollstonecraft brought back from France, or from one of the London booksellers who served the polyglot city. Again, though, there is no evidence. All of this merely gestures toward some of the materials that may have come to hand as Mary Shelley, working on the novel, reached into her mind's attic. Other materials are discussed in the comments below relating to the creature's reading list.

The important point is that *Frankenstein* is a novel, not a stitched-together collection of sources. The composition of a novel is a state of conscious, focused gestation. The novelist carries the work around with her, thinking about it, adding to it, tinkering with it as she goes through the day, and has then to throw herself as deeply as possible into another world when she comes to the physical labor of composition. Because this imaginative immersion requires nerve, many writers find they need to avoid delay and return often to their work. And despite the terrible deaths of Fanny Godwin and Harriet Shelley, despite her less than ideal situation in the spa town of Bath, where all three travelers settled to conceal Claire Clairmont's pregnancy from the Godwins, despite the first trimester of another pregnancy of her own, Mary Shelley wrote with perseverance and speed, completing a draft of the whole novel by April 1817.[3] Her first reader—and editor—was P. B. Shelley, who offered emendations and suggestions, which she usually took. Even as she was reading proofs of *Frankenstein,* the couple was also working on the more fully collaborative *History of a Six Weeks' Tour,* which beat *Frankenstein* as her first published work by less than two months.

Frankenstein has always been Mary Shelley's most famous work. It made her name, and the second and third editions of the novel in 1823 and 1831 were her only major publications to carry that name. After P. B. Shelley's death in 1822, when Sir Timothy Shelley, her implacable

father-in-law, was trying his hardest to keep the Shelley name out of the public eye, she was identified in most of her published works simply as "the author of *Frankenstein*." That was enough. In 1831, she revised the novel, making Elizabeth Lavenza an orphan rather than Victor's cousin, improving some awkward moments, expanding the characterization of Clerval, and giving Frankenstein an even worse conscience than he has in the 1818 edition. These revisions are not so significant that we need to think of the later edition as a different book. It breathes a little more slowly, but the most thrilling passages—those of the creature's making; his account of his education; the conversations between him and Victor; and the closing scenes—are intact. The best way to connect with *Frankenstein* is to open a copy and read.

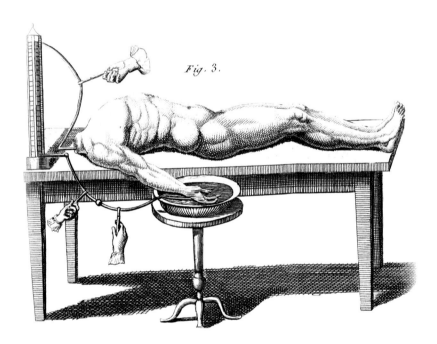

Fig. 3.

occupation. The leaves of that year
were withered before my work drew
near a close; and now every day shewed
me more plainly how well I had suc
ceeded. But my enthusiasm was
checked by my own anxiety and I appeared
rather like one doomed by slavery
to toil in the mines or any other
unwholsome trade than an artist
occupied in his favourite employment
Every night a slow fever oppressed
me and I became nervous to a
most painful degree; a disease I regretted the more because I had
hitherto enjoyed excellent health &
had always
boasted of the firmness of my nerves. But I
believed that exercise and amusement
would soon drive away these sym
ptoms and I promised myself both
of these when my creation should be
completed. I had then determined to
go to Geneva as soon as this should be
done and in the midst of my
family find eve

It was on a dreary night of November
that I beheld ~~the frame or~~ my man compleated; ~~And~~
with an anxiety that almost amount
ed to agony I collected instruments of life
around me and ~~endeavoured~~ that I might infuse a
spark of being into the lifeless thing
that lay at my feet. It was already
one in the morning, the rain pattered
dismally against the window panes, &
my candle was nearly burnt out, when
by the glimmer of the half extinguish
ed light I saw the dull yellow eye of
the creature open — It breathed hard,
and a convulsive motion agitated
its limbs.

~~But how~~ How can I describe my
emotion at this catastrophe, or how deli
neate the wretch whom with such
infinite pains and care I had endeavoured
to form. His limbs were in proportion
and I had selected his features *beautiful*
as ~~Handsome Handsome~~. *Beautiful* Handsome; great God! His
yellow ~~dun~~ skin scarcely covered the work of
muscles and arteries beneath; his hair *& a lustrous black*
was flowing and his teeth of a pearly white
ness but these luxuriances only ~~formed~~
formed a more horrid contrast with
his watery eyes that seemed almost of
the same colour as the dun white
sockets in which they were set,

A dark and stormy night

LUCKILY for posterity, Mary Shelley's career began just when manuscripts ceased to be merely tools for printers and began to be valued as literary artifacts by scholars and collectors. Most of the *Frankenstein* manuscript is preserved at the Bodleian Library of the University of Oxford. On the right-hand page is the scene that Mary Shelley initially imagined (according to her introduction in the 1831 edition): the dreary night in November when the creature awakes. On the left side, you can see her avoid a detour, when Victor thinks about going home: "I had determined to go to Geneva as soon as this should be done." This passage would have clogged the action, and she was right to cut it. P. B. Shelley's editorial suggestions here are few, and they make the prose more lush. To Mary Shelley's description of the creature's hair as "flowing" he adds "of a lustrous black," and where she uses the more conventional "handsome" to indicate what Victor had hoped for the creature, he suggests "beautiful."

◀ See illustration on pages 136–37.

Victor meets the monster on the Mer de Glace

THE SCENES on the Mer de Glace are the moral heart of *Frankenstein*. The creature has already caused two deaths, one directly (Victor's youngest brother, William) and one indirectly (Justine Moritz, the servant whom the creature frames by planting on her a miniature that William wore at the time of his death). On these leaves we see the work of both Shelleys: on the top left, Mary Shelley quotes from her husband's poem "Mutability," which strikes a theme as old as human consciousness—"Nought endures but mutability." The passage echoes the specific observation, which both Shelleys make, about the constant motion of the Mer de Glace. The page at right has, at top, a canceled description (moved elsewhere) of the hut in which Victor and the creature converse. Below, Mary Shelley continues her description of the Sea of Ice, with P. B. Shelley revising slightly for more precision. Victor is filled with joy at the beauty and grandeur of the scene. Notice that he almost commits the ne plus ultra Romantic gesture of clasping his hands—"I clas," Mary Shelley wrote, then thought better of the cliché. In any case, Victor's joy is given him only to be snatched away in the next sentence when he comes face to face with the creature.

❦ See illustration on pages 140–41.

scene that that wind may convey to
us

We rest, a dream has power to poison sleep
We rise one wandering thought pollutes
the day

We feel conceive, or reason — laugh or weep
Embrace fond woe or cast our cares
away

It is the same — for be it joy or sorrow
The path of its departure still is free
mans yesterday may ne'er be like his morrow
nought may endure but mutability.

It was noon when I arrived at the
top of the scanty mountain. For some time I
sat upon the rock that overlooks
the sea of ice. a mist covered both
that and the surrounding mountains
Presently a breeze dissipated the mist
and I descended on the glacier. This surface
is very uneven
rising like the waves of a troubled sea
descending low, & interspersed by rifts
that sink deep — The width in width of the
ice is a large league, but I was
nearly two hours in crossing it — The oppo-
site & mountain is a bare perpendicu-
lar rock. — From that side where I now
stood Montanvert was exactly opposite
at the distance of a league and above

100
130
 40
75 5

130
75

I should listen to the daemon — my
feelings were against it but the
misery he expressed had already
moved my compassion and I thought
the least justice I could shew would
be to listen to to his tale.

We entered the hut — the monster
lighted a fire and sitting by it he
began this.

it rose Mont Blanc in awful majesty. I re-
mained in a recess of the rock gazing on
this wonderful & stupendous scene — My heart
which was tranquil now
before swelled with something like
joy I as I exclaimed — Wandering spirits,
if indeed ye wander and do not rest in
your narrow bed, allow me this faint
happiness or take me as your compa-
nion away from the joys of life." As I
said this I suddenly beheld the
figure of a man at some distance advancing
towards me with superhuman speed —
among
He bounded over the crevices in the
ice by which I had walked with caution
his stature also as he approached seem
ed to exceed that of man — I was
troubled — a mist covered my eyes and
I felt a faint — The cold breeze
of the mountains quickly restored me.
But I perceived as the shape came nearer

sea or
the vast
river of
wound among
its dependant
mountains whose
al summits
s over its
bes. Their
& glittering
les shone
sun light
the clouds.

155

158

You accuse me of murder and yet ~~th~~
you would with a ~~s~~ satisfied conscience
destroy ~~thy~~ thine own creature – oh praise the eter
nal justice of man! – Yet I ask you
not to spare me, listen and then, if
you ^can and if you^ will, destroy the work of your han[ds]

"Why" cried I," do you ~~ever~~ call to my
remembrance ~~those~~ circumstances ^of which^
I shudder to reflect ^that I have been the^ ~~ever the occasion~~ –
miserable origin & author
cursed be the ~~night & during which you~~
day in which you first saw light, curse
(although I curse myself) be the hands
that formed you! You have made
me wretched beyond ^You have left me no power to cons!^
whether I am just to you or no. ~~from your~~ sight
thus I relieve me ~~your, creature~~
he replied & ~~he~~ places his abhorred hands before
my eyes – ~~which flings from me with violence~~
~~he replied~~ from the sight of one whom
you abhor. – still you can listen to me
and grant me your compassion – By the
the virtues I once possessed I demand th[is]
of you – ~~to~~ Hear my ~~whole~~ tale – It is
long and strange ~~but~~ and the temperature
of this place is not fitting to your
fine sensations; come to hut on ~~the~~ the mountain
~~foot~~ – The sun is yet high in the

heavens — before it descend to its lowest 159
side itself behind the mountains and 62
illuminate another world you will have
heard my story and can decide. And
on you it rests whether I quit for ever
the habitations of man & lead an
harmless life or become the scourge
of your fellow creatures & the author
of your own speedy ruin.
As he said this he led the way
across the ice — I followed — my heart was
full and I did not answer him but
as I proceeded
when I weighed the various arguments
which he had used, I felt determined at
least to listen to his tale — I was partly urged
by curiosity, and compassion confirmed
me — As I was not — I had hitherto supposed
properly sought him to be the murderer of my brother
confirmed and I wished to find this either confirmed
or denied. For the first time also I felt
this opinion what the duties of a creator towards his
creature were and that I ought to
render him happy before I complained
of his wickedness. These motives urged me
to comply with his request — We crossed
the ice therefore, and ascended the
opposite rock — The air was cold and
the rain began again to descend — we
entered the hut — the fiend with an
air of exultation I with a heavy

The creature tells his story

VICTOR FRANKENSTEIN makes a being by hand. His first reaction is revulsion—the opposite of what a new parent is supposed to feel. Now, though, the creature's power to disgust seems outweighed by his power to kill, and on the left page we see Victor's guilt and anger center on the instruments of creation: "Cursed (though I curse myself) be the hands that made you!" The creature places his own hands over Victor's eyes, relieving him of an abhorrent sight by an even more abhorrent touch. Even as they play at this hostile peekaboo, the antagonists embark on a deeply serious conversation. The creature tells the story of his brief life, a tale of education, rejection, and hatred, culminating in his demand for a female companion. Victor, softened by compassion, accedes after a long bout of Godwinian reasoning. The second page shows that reasoning begin, with Victor agreeing to hear the creature's story—again using a Godwinian appeal to the sense of what is owed: "For the first time I felt what the duties of a creator towards his creature were, and that I ought to render him happy before I complained of his wickedness."

◀ See illustration on pages 142-43.

The creature's consciousness

"How like an angel came I down! / How bright are all things here!" wrote Thomas Traherne (ca. 1637–1674) in a poem that, except for its Christianity, evokes the creature's early wonder at the strange and beautiful world that he instinctively feels to be his. Yet their experiences would soon diverge: Traherne had parents and teachers, while the creature has to rear himself. Like a nonfictional infant, he experiences all his senses at once and tries to understand his world even when his own body is still disjointed and mysterious. Mary Shelley grew up in the Godwin household surrounded by Enlightenment ideas of child development. These theories—John Locke's chief among them—saw infants as blank slates, material creatures formed by their surroundings, bodily experiences, and social interactions. Beyond this knowledge, she also had her son William, five months old when she began writing, and it is easy to imagine her looking at him long and hard to understand his world. Factual accounts of parentless children—the Wild Boy of Aveyron, for instance—were popular in the eighteenth century, and other novels presented innocent, truth-telling figures, such as the kitschy-noble "Indian" chief in Robert Bage's *Hermsprong; or, Man as He Is Not* (1796), which Mary Godwin read in 1815. The creature is one of the best of these characters, and his education (described below) prepares him for a world far better than the one he meets. If we take the fiction seriously, though, we must look at the creature not just as a victim targeted for his appearance but as a moral agent who consistently responds to violence with worse violence.

❦ See illustration on pages 146–47.

Chap I

"It is with difficulty that I remember
the æra of my ~~own~~ being. all the events of
that period appear confused & indistinct.
~~I know only that I felt a strange~~ a strange
sensation ~~seo~~ seized me ~~and a it appeared~~
I saw, felt heard and smelt at the same
time and it was indeed a long time be-
fore I learned to distinguish between the
~~various~~ opperations of my various senses. By degrees
I remember a stronger light pressed upon
my nerves ~~and~~ so that I was obliged to close
my eyes. darkness then came over me
~~and troubled me.~~ But hardly had I felt
this when / by opening my eyes as I now suppose
the light poured in upon me again — I walked
and I believe descended; but presently I found
 alteration
a great ~~difference~~ in my sensations; before
dark opaque bodies had surrounded me
impervious to my touch or sight. and I
now found that I could wander on at liberty
with no obstacles which I could not either
 more
surmount or avoid the light ~~to~~ became ∧
more oppressive to me and the heat wearying
me as I walked I sought a place where I could
 recieved
perceive shade. This was the forest near Ingolstadt
and here by the side of a brook I lay ~~being~~
 resting from my fatigue
for some hours ∧ untill I felt tormented by
hunger and thirst. This roused me from my near

(or)

dormant state and I ate some berries
which I found hanging on the trees or lying on
the ground — I slaked my thirst by the
brook and then again lying down I was
overcome by sleep. It was dark when I
awoke; I felt cold also, and half frightened
as it were instinctively
on seeing finding myself so desolate.
Before I had quitted your appartment
on a sensation of cold I had covered my
self with some clothes, but these were
not sufficient to secure me from the
dews of night. I was a poor helpless
miserable wretch — I knew no I could
distinguish no nothing, but feeling pain
invade me on all sides and I sat down
and wept.

Soon a gentle light stole over the
heavens and gave me a sensation of pleasure.
I started up, and beheld a radiant form
rise from among the trees. I gazed with
a kind of wonder — It moved slowly; but
it enlightened my path, and I again
went out in search of berries. I was still
cold when on the ground under one of the
trees I found a huge cloak with which I
covered myself and sat down on the ground.
No distinct ideas occupied my mind all was
confused and I felt the light, and hunger
and thirst and darkness; innumerable
sounds rung in my ears and on all sides
various scents saluted me; the only thing
that I could distinguish was the bright

1. THE CREATURE'S READING LIST

THE CREATURE's first social lesson is Victor's abandonment; his second is an attack by some villagers frightened by his ugliness. The creature takes the hint and moves under cover of darkness, hiding from everyone. He takes shelter in a tiny shed attached to a cottage with chinks in the walls. Through them the creature spies on and learns from a family of French émigrés, M. De Lacey and his grown children, Felix and Agatha. Yet another story within a story concerns Felix's Arabian fiancée, Safie, who through various misadventures arrives at the De Lacey cottage, joins the family, and begins to be schooled in the Roman alphabet and the French language. Indirectly the creature soaks up every lesson she receives. To make her feel more at home, Felix teaches her from Volney's *Ruins; or, A Survey of the Revolutions of Empires*, which draws on its author's experience in Egypt and Syria—the frontispiece shows him contemplating the ruins in Palmyra's Valley of Sepulchres (much damaged by the Islamic State in 2015). Volney made up his surname by combining "Voltaire," the Enlightenment philosopher, and "Ferney," Voltaire's home near Geneva—a pseudonym indicating sympathies with the French Revolution. Known as *Ruins of Empire*, this materialistic survey of religious history was popular among radicals in its time and was translated by Thomas Jefferson. It promotes liberty and equality of and for all people, and since, as Volney observes, people can't agree on religious questions, urges a strictly secular civil government.

❦ See illustration on pages 150–51.

Here an opulent City once flourished: this was the seat of a powerful Empire.—Yes, these places, now so desert, a living Multitude formerly animated &c.

Chap. II.

THE

RUINS:

OR

A SURVEY

OF THE

REVOLUTIONS

OF

EMPIRES.

═══════

BY M. VOLNEY,

ONE OF THE DEPUTIES TO THE NATIONAL ASSEMBLY OF 1789;
AND AUTHOR OF TRAVELS INTO SYRIA AND EGYPT.

─────────

TRANSLATED FROM THE FRENCH.

─────────────

THE SECOND EDITION.

─────────────

I will dwell in folitude amidft the ruins of cities: I will enquire of the
monuments of antiquity, what was the wifdom of former ages: I will
afk the afhes of legiflators, what caufes have erected and overthrown
empires; what are the principles of national profperity and misfortune:
what the maxims upon which the peace of fociety and the happinefs
of man ought to be founded? Ch. iv. p. 24.

──────────────

LONDON:

PRINTED FOR J. JOHNSON, ST. PAUL'S CHURCH-YARD.

─────────

M.DCC.XCV.

Plutarch's *Lives*

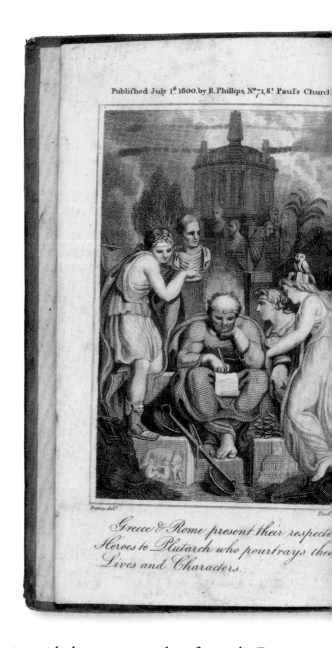

Published July 1st 1800, by R. Phillips, No 71, St. Paul's Churc[...]

Burney, delt. *Dad[...]*

Greece & Rome present their respect[...]
Heroes to Plutarch who pourtrays the[...]
Lives and Characters.

During his time with the cottagers, as he refers to the De Laceys and Safie, the creature finds a rucksack containing three books for which Safie's lessons have prepared him. They are a treasure to him, producing in his mind "an infinity of new images and feelings, that sometimes raised me to ecstasy, but more frequently sunk me into the lowest dejection." The first is a volume of Plutarch's *Lives,* often translated as *Parallel Lives,* an important work of biography since it first appeared about eighteen hundred years ago. Plutarch, born a Greek and natu-ralized a Roman, compared the lives of eminent Greeks and

A SELECTION

OF THE

VES OF PLUTARCH

ABRIDGED;

CONTAINING

IE MOST ILLUSTRIOUS CHARACTERS

OF ANTIQUITY;

FOR THE USE OF

SCHOOLS.

By WILLIAM MAVOR, LL.D.

OF HURLEY, BERKSHIRE, CHAPLAIN TO THE EARL
DUMFRIES, AUTHOR OF THE BRITISH NEPOS,
IE NATURAL HISTORY FOR SCHOOLS, THE
SYSTEM OF STENOGRAPHY, &c.

LONDON:

or R. PHILLIPS, No. 71, St. Paul's Church-yard;
T. HURST, J. WALLIS, AND WEST AND HUGHES, PATER-
R-ROW; BY LACKINGTON, ALLEN, AND CO. FINSBURY
QUARE; CHAMPANTE AND WHITROW, OLD JEWRY;
BY CARPENTER AND CO. OLD BOND-STREET;
AND BY ALL OTHER BOOKSELLERS.

Price 4s. 6d. bound, with full Allowance to Schools.]

Romans, beginning with Theseus, founder of Athens, and Romulus, founder of Rome. The lives were used to encourage ambition and the emulation of great men—"emulation" was a key concept in eighteenth-century British education—as well as offering examples of vices to avoid. Mary Shelley would have known them since girlhood, perhaps from a children's edition like this one. She and P. B. Shelley were reading them in the summer of 1816. The creature's preference for the peaceful lawgivers Numa, Solon, and Lycurgus reflects, he is aware, the cottagers' calm home that is his model.

This is the last time! Werther! You will never see me again.

SEEING THAT the creature's romantic model is *The Sorrows of Young Werther* (1774), Mary Shelley's original readers might have guessed that *Frankenstein* would end in tears. Goethe's tale is simple: Werther, a German artist, falls in love with Charlotte, who is engaged to Albert. Despite this, Werther cultivates a friendship with both of them, and eventually leaves their little town because the situation is too painful. He goes to nearby Weimar (where Goethe spent much of his life) and suffers social humiliation as well as continued longing for Charlotte. He returns to the little town where Charlotte and Albert are now married and determines that suicide is the only solution. Werther writes to Charlotte, asking for a pair of pistols for a journey he intends to undertake, and with one of these he carries out his plan. In its day *Werther* was monumentally successful and inspired a number of copycat suicides. We should not understand the creature's support of Werther's decision as a sign of suicidal tendencies but rather as evidence that he is a thoroughgoing Romantic.

Milton's Paradise Lost

*P*aradise Lost (1667) is the creature's favorite book. In over 10,000 lines of blank verse, Milton recounts the creation of the world, the fall of Adam and Eve, and their expulsion from Eden, transforming the Bible's bare bones into a modern epic. Sometimes the creature feels as lonely as Adam before Eve, "united by no link to any other being in existence." More often, he considers Satan "the fitter emblem of my condition." In Genesis, Satan appears only as the serpent, but Milton tells how the most beautiful angel, Lucifer, foments rebellion against God and plummets to Hell, freshly created for him and the other rebel angels. Mary Shelley follows her account of the creature's reading of *Paradise Lost* with the last work he comes across: Victor Frankenstein's journal minutely describing the creature's making, carelessly left in the pocket of the clothes the creature finds in the workshop and dons on leaving. The creature already knows he is hideous, but now he learns why, and how. His learning is no comfort: "Increase of knowledge only discovered to me more clearly what a wretched outcast I was." Mary Shelley read or, more likely, reread *Paradise Lost* close to the composition of *Frankenstein,* probably in this copy, given her by P. B. Shelley on 6 June 1815, when she was still Mary Godwin.

PARADISE LOST.

BOOK I.

OF Man's firſt diſobedience and the fruit
Of that forbidden tree, whoſe mortal taſte
Brought death into the world and all our woe,
With loſs of Eden, till one greater Man
Reſtore us and regain the bliſsful ſeat, 5
Sing heav'nly Muſe, that on the ſecret top
Of Oreb, or of Sinai, didſt inſpire
That ſhepherd, who firſt taught the choſen ſeed,
In the beginning how the heav'ns and earth
Roſe out of Chaos; or if Sion hill 10
Delight thee more, and Siloa's brook that flow'd
Faſt by the oracle of God; I thence
Invoke thy aid to my advent'rous ſong,
That with no middle flight intends to ſoar

<div align="center">A 2</div>

Above

FRANKENSTEIN;

OR,

THE MODERN PROMETHEUS.

IN THREE VOLUMES.

Did I request thee, Maker, from my clay
To mould me man ? Did I solicit thee
From darkness to promote me ?——
 PARADISE LOST.

VOL. I.

London :
PRINTED FOR
LACKINGTON, HUGHES, HARDING, MAVOR, & JONES,
FINSBURY SQUARE.

1818.

2. THE PUBLICATION OF FRANKENSTEIN

M ARY SHELLEY composed *Frankenstein* between mid-June 1816 and early April 1817, a span of just under ten months.[4] By 10 April 1817, she had embarked on first revisions and probably at this point decided to make what she had planned as a two-volume work into three volumes. The novel was largely finished in May, and P. B. Shelley began to offer it anonymously to publishers. Byron's publisher, John Murray, turned it down, as did P. B. Shelley's, but in August, *Franken-stein* was accepted by the firm that became Lackington, Hughes, Harding, Mavor and Jones. There were many more anonymous first-time authors in 1817 than there are now, but such publications were still a risk, and the best terms P. B. Shelley could negotiate on behalf of his wife were one third of the profits. (Royalties as we know them not did not then exist. Writers hoped to sell their copyright in full, bargaining for additional payments if a certain number of copies were sold, but rank beginners sometimes had to pony up part of the costs or wait for payment until books had been sold.) The deal was concluded in September, and, although Mary Shelley gave birth to a daughter, Clara Everina, on September 2nd, she was reading proofs in October. The novel appeared 1 January 1818 in an edition of 500 copies in boards, priced at 16 shillings, 6 pence—not cheap, but not an unusual price. Whoever owned this copy with its charming pink covers might have paid a bit more. The author's profit came to £41 13s. 10d.

◀ The first edition, 1818

Praise for *Frankenstein,* 1818

Eleven days after *Frankenstein* was published, Claire Clairmont wrote to Byron on the occasion of the first birthday of their daughter, Allegra. Toward the end, she turns to family news and tells him that Mary has just published her first novel. "It is a most wonderful performance full of genius & the fiction is of so continued and extraordinary a kind as no one would imagine could have been written by so young a person. . . . How I delight in a lovely woman of strong & cultivated intellect." Byron did not reply; he had come to loathe her. He particularly disliked women of strong and cultivated intellects. Three months later, Clairmont, the Shelleys, and their children went to live in Italy. Byron was in Venice and had taken possession of Allegra—he had the means to raise her in comfort and dignity, while Claire Clairmont had nothing. P. B. Shelley sent him a copy of *Frankenstein,* commenting: "It has had considerable success in England; but she [Mary Shelley] bids me say, 'That she would regard your approbation as a more flattering testimony of its merit.'" In fact, the novel made only a small initial splash, but its reviews were largely favorable. The best resulted from a copy P. B. Shelley sent to Walter Scott, the most popular writer of the day. Scott reviewed it with great enthusiasm, though he assumed that the donor was also the author. Mary Shelley later wrote him to clear her husband of responsibility for "a juvenile attempt of mine."

What news shall I tell you? Mary has just published her first work a novel called Frankenstein or, the Modern Pro=metheus. It is a most wonderful performance full of genius & the fiction is of so continued and extraordinary a kind as no one would imagine ~~to belong to~~ could have been written by so young a person. I am delighted & whatever private feelings of envy I may have at not being able to do so well myself yet all yield when I consider that she is a woman & will prove in time an ornament to us & an argument in our favour. How I delight in a lovely woman of strong & cultivated intellect. How I delight to hear all the intricacies of mind & argument hanging on her lips! If she were my mortal enemy, if she had even injur=ed my darling I would serve her with fidelity and fervently advocate her as doing good to the whole. When I read of Epicharis the slave in Tacitus & of Hypatia of Alexandria in Gibbon, I shriek with joy & cry Vittoria! Vittoria! I can not bear that women should be outdone in virtue & knowledge by

A joint letter to Claire Clairmont, 1821

THE Shelleys led a peripatetic life in the Italian states, especially between the spring of 1818 and the beginning of 1820. Despite their appreciation of Italy's pleasures—"the paradise of exiles," as P. B. Shelley called it—and despite making new friends and finding old ones, there were tensions in their household. The relationship between Mary Shelley and Claire Clairmont, going back to earliest childhood, was deep but intractably painful. The Shelleys, too, had their difficulties, such as P. B. Shelley's inclination to fall for young women (though it's unlikely that he had been unfaithful), a coolness on Mary Shelley's part, and, worst of all, the deaths of first, the baby Clara of dysentery soon after they arrived, and then of William

on 7 June 1819. They found some relief in their work, for they were not on vacation and spent much of their time reading, writing, studying languages, and translating—alone, together, and with their friends. One of their acquaintances remembered P. B. Shelley "always reading, and at night has a little table with pen and ink, she [Mary Shelley] the same."[5] They also followed current events with great interest. Their account in this joint letter to Claire Clairmont, written just days after the Greek revolution against Turkish rule began, derived from a special source of information: their friend, the exiled Prince Alexander Mavrocordato, briefly Mary Shelley's tutor in modern Greek. Soon after he went home to Greece to help lead the war.

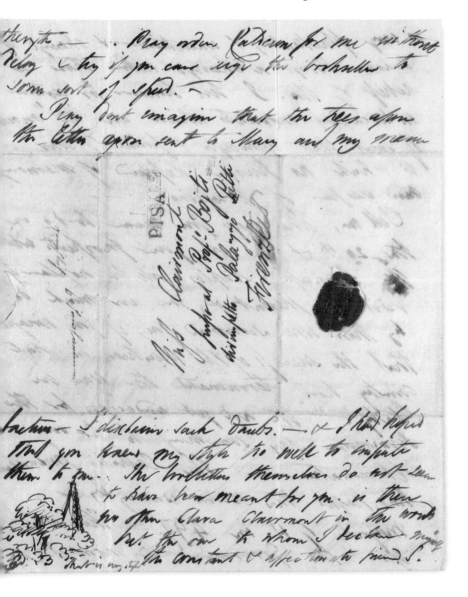

IN JANUARY 1820 the Shelleys moved to Pisa to be near Margaret King Moore, Lady Mount Cashell, a former student of Mary Wollstonecraft's and a writer for the Godwins' Juvenile Library. With her new partner, George William Tighe, a fellow Irishman, Mrs. Mason, as she now called herself, had settled in Pisa. Tuscan cities were choice destinations for both English and Italian liberals as the duchy's government was less authoritarian than those of other Italian states. Mrs. Mason proved a good friend, though she particularly took Claire Clairmont under her wing, beginning with the tough-love solution of getting her out of the Shelleys' household. Mason and P. B. Shelley reread William Godwin's *Political Justice* together. Mary Shelley felt that Mason was not so fond of her as of the others, but she enjoyed the company of Laurette and Nerina, Mrs. Mason's daughters with Tighe. Other friends— Edward and Jane Williams, Shelley's cousin Thomas Medwin, and Byron, along with his new love, Teresa Guiccioli, and her brother and father—joined them. Alternating winters in Pisa with summers near water, the Shelleys continued their sad, sociable, and industrious life.

Mrs. Mason, formerly Lady Mount Cashell, ca. 1831

Percy Florence Shelley learns his letters

Pᴇʀᴄʏ ꜰʟᴏʀᴇɴᴄᴇ, born 12 November 1819, was the last of the Shelleys' children and the only one to survive into adulthood. Named for his father and the city of his birth, he spoke Italian as his first language. One isn't sure whether or not to believe the anecdote of Mary Shelley's response to the actress Fanny Kemble, who is said to have recommended sending Percy Florence to a school that would teach him to think for himself: "Ah! No, no, bring him up to think like other people."[6] He grew up to be mildly eccentric, fond of yachting and tricycle riding, addicted to amateur theatricals, and very good to his mother. Mary Shelley was ambitious for him as a toddler, asking her friend Maria Gisborne in December 1821 to send ivory letters with which to teach him the alphabet—he had just turned two. (Maria Gisborne, formerly Maria Reveley, had taken care of the infant Mary Godwin after Mary Wollstonecraft died in 1797.) Mrs. Gisborne did not come through, it seems, since Shelley asks for them again in a postscript of November 1822.

Mary Shelley's manuscript revisions, ca. 1823

MARY SHELLEY kept this copy of *Frankenstein* with her during her married years in Italy, and she used it as P. B. Shelley had used copies of his printed works—to draft revisions for a new edition. Here, for instance, she expands the character of Frankenstein's poetic friend Henry Clerval; near the conclusion, she extends the scene in which Victor and Elizabeth approach their honeymoon house where Elizabeth will die, heightening the suspense. Mary Shelley gave this copy to a woman known only as Mrs. Thomas, who befriended her at the end of her time in Italy. The catalogue of deaths in her immediate circle between 1818 and 1822 is staggering: after the deaths of Clara in 1818 and William in 1819, Allegra Byron died in April 1822, having caught typhus at the convent where Byron had sent her to be educated. On 8 July of that year, P. B. Shelley, their friend Edward Williams, and an English cabin boy, Charles Vivian, drowned in the Ligurian Sea as they returned from Leghorn. Mary Shelley moved with Percy Florence to Genoa before returning to England. In such circumstances one can see why a second edition of a novel wouldn't matter much. On the flyleaf, Mrs. Thomas describes her friend in 1823 as "helpless, Pennyless, and broken hearted."

tribute to the happiness of others, entirely forgetful of herself.

The day of my departure at length arrived. I had taken leave of all my friends, excepting Clerval, who spent the last evening with us. He bitterly lamented that he was unable to accompany me: but his father could not be persuaded to part with him, intending that he should become a partner with him in business, in compliance with his favourite theory, that learning was superfluous in the commerce of ordinary life. Henry had a refined mind; he had no desire to be idle, and was well pleased to become his father's partner, but he believed that a man might be a very good trader, and yet possess a cultivated understanding.

We sat late, listening to his complaints, and making many little arrangements for the future. The next

loved poetry and his mind was filled with the imagery and sublime sentiments of the masters of that art. a poet himself, he turned with disgust from the details of ordinary life. His own mind was all the inspiration that he prized; beautiful & majestic thoughts the only wealth he coveted — daring as the eagle and as free,

morning early I departed. Tears gushed from the eyes of Elizabeth; they proceeded partly from sorrow at my departure, and partly because she reflected that the same journey was to have taken place three months before, when a mother's blessing would have accompanied me.

I threw myself into the chaise that was to convey me away, and indulged in the most melancholy reflections. I, who had ever been surrounded by amiable companions, continually engaged in endeavouring to bestow mutual pleasure, I was now alone. In the university, whither I was going, I must form my own friends, and be my own protector. My life had hitherto been remarkably secluded and domestic; and this had given me invincible repugnance to new countenances. I loved my brothers, Elizabeth, and Clerval;

common laws could not be applied to him; and while you gazed on him you felt his soul's spark was more divine — more truly stolen from Apollo's sacred fire, than the glimmering ember that animates other men.

NOTES

1. Clairmont 1995, Vol. 1, p. 49, letter of 29 May 1816.

2. Douthwaite 2009, p. 382.

3. For the most complete record of the composition and publishing history of *Frankenstein*, see Robinson 1996. This is also accessible online as part of the Shelley-Godwin Archive.

4. All information on the timing here is taken from Robinson 1996.

5. Sophia Stacey, quoted in Cameron 1974, p. 74.

6. Retold in Seymour 2000, p. 421, and the note on p. 604. The anecdote comes from Matthew Arnold, *Essays in Criticism*. Seymour cites another telling in Anne Thackeray, Lady Ritchie's *Chapters from Some Memoirs*, London, 1894, pp. 205-6, and this is the version I have quoted.

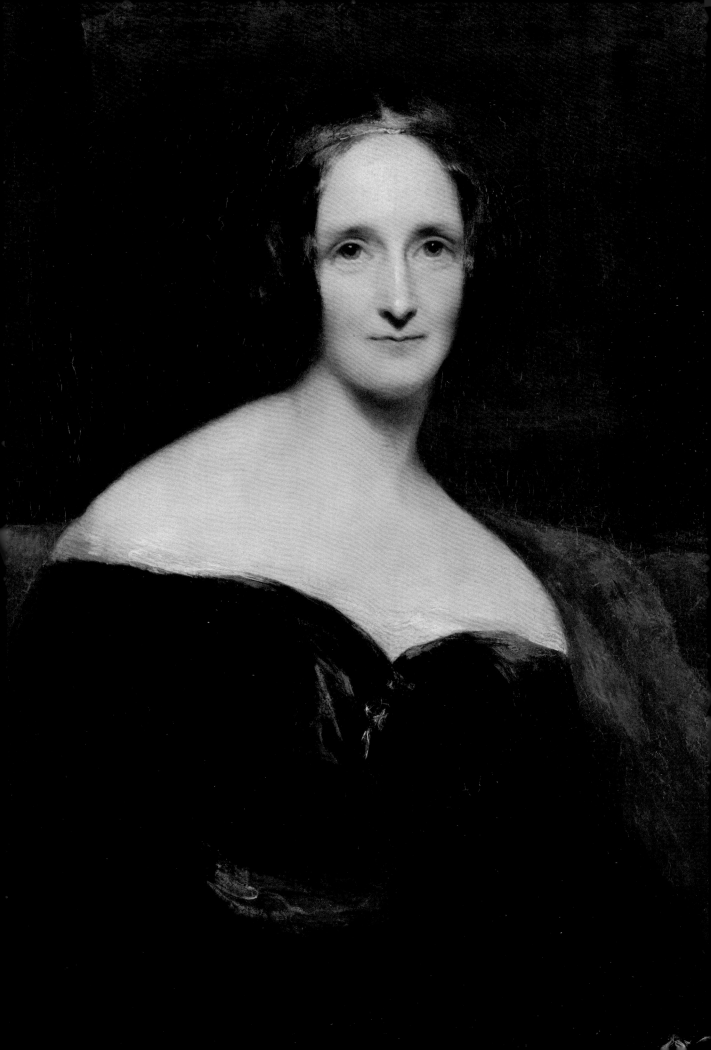

CHAPTER 6
LIVING ON

THE SUMMER OF 1822 would have been hard for Mary Shelley even if her husband hadn't drowned. The family had settled with their friends Edward and Jane Williams and their two children near Lerici, on the Ligurian coast. They shared Casa Magni, "the big house," but it was too small for two families. Mourning for Allegra, who had died in April, Claire Clairmont came and went. Mary Shelley was depressed and having a difficult pregnancy. On 16 June she miscarried and began to hemorrhage; Shelley plunged her into a sitz bath full of ice, saving her life. It was easier for him: he liked Lerici and very much liked sailing on the *Don Juan*, the building of which his new friend E. J. Trelawny had overseen. He also liked Jane Williams, to whom he gave poems and a guitar. Edward Williams somehow didn't mind. Mary Shelley found that sailing with Shelley was all that made her feel better: "My only moments of peace were on that unhappy boat, when lying down with my head on his knee I shut my eyes and felt the wind and our swift motion alone."[1]

The summer's big event was to have been the arrival of their friend Leigh Hunt with his wife Marianne and the six Hunt children. With his brother John, Leigh Hunt had long edited *The Examiner*, a literary newspaper that championed Keats, Shelley, and liberal politics and had landed both brothers in prison. Now Hunt had come to Italy to launch a new journal, soon to be named *The Liberal*, with Shelley and Byron. Shelley and Williams sailed to meet them at Leghorn, heading back to Lerici on the 8th of July.

They never returned. "We hoped—" Mary Shelley wrote to Maria Gisborne, "and yet to tell you the agony during those 12 days would be to make you conceive a universe of pain—each moment intolerable and giving place to one still worse."[2] The "we" meant just Mary and Jane, who were like sisters during these days and for some time after. Claire Clairmont also suffered but did not share their bond.

The bodies—Shelley's first—washed up on the 18th and 19th. Trelawny, a great help during this period, came to tell them that the worst had happened. His kindest act, Mary Shelley wrote, was to refrain from consoling her the night he broke the news. Rather, he "launched forth into an overflowing and eloquent praise of my divine Shelley."[3] Trelawny would go on to organize the beach cremations for Shelley and Williams and Shelley's burial in the Protestant Cemetery in Rome.

After the obsequies, the surviving inhabitants of the Casa Magni went to Pisa. Mary Shelley then moved near Genoa with the Hunts. Byron, one of Shelley's executors, was generous, except to Claire Clairmont, to whom he gave nothing.[4] By the summer of 1823, the group had

spun apart. Claire Clairmont went first, embarking on a long, largely unhappy life in Russia and Europe as a governess. Jane Williams returned to England with an introduction from Mary Shelley to Thomas Jefferson Hogg, with whom she later lived as his wife. (She had a husband from whom she was estranged.) Byron and Trelawny went to Greece to fight for its independence; Byron would die there in 1824. Trelawny returned, and though he capitalized endlessly on his connections with the poets, he remained a friend to Mary Shelley and Claire Clairmont for many years.

Mary Shelley returned to England in August 1823. She arrived to find herself famous, as she wrote to Leigh Hunt: *Frankenstein* was a theatrical hit.[5] The play's popularity had already enabled William Godwin to bring out a second edition, which now bore her name. And while copyright laws meant that she made no money from any production, fame sold books.

Selling her works would remain a necessity for decades. Her father-in-law, Sir Timothy Shelley, proved vindictive and as tightfisted as his son had been generous. He offered a small allowance so long as his daughter-in-law (whom he never met) refrained from publicizing the Shelley name and suppressed her memorial project, an 1824 edition of P. B. Shelley's *Posthumous Poems*. Mary Shelley had already published a second novel, *Valperga*, while in Italy. Now, as "the author of *Frankenstein*," she began to write for periodicals and the annuals, ladies' gift books that came out at the new year. Her second-best novel, *The Last Man* (1826), incorporated sketches of Shelley and the now-dead Byron and portrayed a world decimated by disease. Others followed—*Perkin Warbeck*, *Lodore*, and *Falkner*—none of them much read today. *Mathilda*, unpublished in her lifetime because of its theme of father-daughter incest, now receives more attention. She wrote travel works and potboiler biography as well, and with her earnings and Sir Timothy's allowance sent Percy to Harrow and Cambridge.

Mary Shelley was never allowed to live down the elopement of 1814; in any case she was proud of her partnership with P. B. Shelley. She was a renowned author herself, and plenty of people, especially in literary circles, cared nothing about her mildly irregular past. Nor did she lack suitors: Prosper Mérimée courted her, as did John Howard Payne, composer of the song "Home, Sweet Home."[6] Trelawny may have proposed, as he had earlier to Claire Clairmont. She refused them all, though she did not rule out the idea of remarrying.[7] Early on after returning from Italy, she told Trelawny in 1835, she had longed for intimacy, but "being afraid of men—I was apt to get tousy-mousy for women," but now "experience and sufferings have altered all that—I am more wrapt up in myself . . . & prospects for Percy."[8] Her friendships with women, including some outcasts like Caroline Norton, who fought the sexist child custody laws, were an emotional mainstay of her widowed life.

When Charles, P. B. Shelley's son with Harriet Westbrook, died at eleven, Percy Florence had become the heir to the Shelley estates, and Sir Timothy became slightly more generous. When he finally died in 1844, their financial anxiety was at last relieved, although the estate came with large debts contracted by P. B. Shelley that had to be repaid.

Mary Shelley was already suffering from headaches caused by a brain tumor. She worried about her son finding a wife; but when in 1848 Percy at last married, his choice, a widow named Jane Gibson St. John, was all his mother might have wished: Jane had first been friends with Mary Shelley and adored her mother-in-law. All three planned to live at Shelley's boyhood home, Field Place. After so many years of being unwelcome, the new family found it cold and damp and vulnerable to visits from P. B. Shelley's relatives, whom they did not care for. They were preparing to move to Bournemouth when, on 3 February 1851, Mary Shelley died in her London home. At their new home, Percy Florence and Jane built a shrine to her and P. B. Shelley. They moved the graves of William Godwin and Mary Wollstonecraft to Dorset and buried them all together. Mary Shelley might have preferred to be in Rome, near her husband, but Trelawny had bought the plot years before.

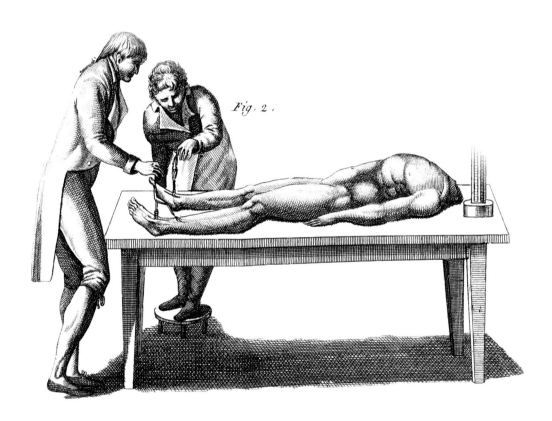

Fig. 2.

Percy Bysshe Shelley, 1822

As HE approached thirty, Shelley was going gray and had become a bit stout, as this portrait by his friend Edward Williams attests. Certainly he felt the weight of his experience, saying to Marianne Hunt the night before he left on his fatal journey, "If I die tomorrow I have lived to be older than my father, I am ninety years of age."[9] Shelley and Williams sailed to Leghorn to meet the Hunts on July 1st, and during the next week, Shelley helped them settle on the bottom floor of Byron's Pisan palazzo. He visited Mrs. Mason, who remembered him in high spirits the day she last saw him, "his face burnt by the sun and his heart light that he had succeeded in rendering the Hunts tolerably comfortable."[10] Shelley returned to Leghorn, and on the 8th, after waiting out a storm, he, Williams, and their cabin boy, a young Englishman named Charles Vivian, sailed toward Lerici. About ten miles out, they were caught in a sudden squall. Trelawny's friend, Captain Daniel Roberts, sought them with his telescope and later claimed to have caught sight of them taking in the sails. If true, it was the last any of their acquaintance saw them alive.[11]

A salvaged manuscript, ca. 1821–22

QUITE A NUMBER of premonitions and dreams about Shelley's death from his circle of intimates are recorded in the summer of 1822. It would be a mistake to take these too seriously. Human psychology dictates that no matter how bad news is, we want to know it, and one self-reassuring response to the most shocking news is to find ways to show we weren't surprised at all. But although the *Don Juan* had more rigging than it needed, and no flooring to keep out water, no one expected Shelley and Williams to drown. It had been packed with entertainments and provisions: books, clothing, Shelley's spyglass, Williams's journal—and this manuscript, Shelley's "Indian Serenade." Also known as "The Indian Girl's Song," this dramatic love lyric is not an expression of Shelley's emotion but rather a "highly successful conventional exercise" on "a favorite Shelleyan theme."[12] Captain Daniel Roberts oversaw the investigation of the boat's wreckage when it came to light in September 1822. He and Trelawny had the contents auctioned for the benefit of the two widows. Roberts kept this manuscript for himself, though, attesting to his acquisition of it on another leaf. It's a mercy that Shelley brought such a slight poem; he drowned at the height of his powers, and it would have been an even worse loss if his great unfinished work, *The Triumph of Life*, had gone down with him.

Shelley's grave, 1873

AFTER P. B. Shelley's death, Mary Shelley settled near Genoa with the Hunts for about a year. She was worried about money; Shelley's annuity died with him, and she had no idea if Sir Timothy could be prevailed on to support her and her son. Byron found a way to provide her with both money and occupation, and she found herself making fair copies of *Don Juan* for him, as she had in 1816 with *Childe Harold*. Her original plan was to live in Rome, to be near Shelley's grave in the Protestant Cemetery, where their son William and John Keats were also buried. In the preface to *Adonais,* his elegy for Keats, Shelley described the place as "romantic and lonely," "an open space among the ruins covered in winter with violets and daisies. It might make one in love with death to be buried in so sweet a place."[13] In fact, although they knew each other's work and were acquainted through Leigh Hunt, the two poets were not close, Keats feeling keenly Shelley's social superiority. But they are inextricably linked by their burial place and premature deaths, a linkage that began as soon as Shelley died: days afterward, Mary Shelley wrote that "Adonais is not Keats's it is his own elegy."[14]

TO WILLIAM SHELLEY.

(With what truth I may say—
Roma! Roma! Roma!
Non è più come era prima!)

My lost William, thou in whom
 Some bright spirit lived, and did
That decaying robe consume
 Which its lustre faintly hid,
Here its ashes find a tomb,
 But beneath this pyramid
Thou art not—if a thing divine
Like thee can die, thy funeral shrine
Is thy mother's grief and mine.

Where art thou, my gentle child?
 Let me think thy spirit feeds,
Within its life intense and mild,
 The love of living leaves and weeds,
Among these tombs and ruins wild;—
 Let me think that through low seeds
Of the sweet flowers and sunny grass,
Into their hues and scents may pass
A portion——

June, 1819.

Shelley's Posthumous Poems, 1824

THE FRAGMENT to "My lost William," set in the Protestant Cemetery, mentions its most striking tomb, the ancient pyramid of Caius Cestius. Shelley's flat-stoned grave is not far away. William's grave, although marked, is unknown, as an adult skeleton was found when workers went to exhume him for burial near his father. Mary Shelley undertook the editing of *Posthumous Poems* soon after Shelley's death, and the book was published in June 1824. She was impelled not just by grief and the wish to preserve the best part of her late husband but also by remorse at how far estranged they had grown when he died. Matters with Sir Timothy were not entirely clarified in the summer of 1824, however, and in August he demanded the suppression of this book as a condition of any help, along with a promise from her not to bring "dear S's name" before the public during his lifetime—"Sir T. writhes under the fame of his incomparable son as if it were a most grievous injury done to him," she wrote to Leigh Hunt.[15] Not until 1838, after a number of badly edited unauthorized editions of Shelley's poetry had appeared, did he relent, and even then Mary Shelley had to smuggle in biographical information by appending long notes.

Fragments of Shelley's skull, 1822

THE BODIES of the three men were dreadfully damaged by their days in the sea, and the Italian health authorities directed that they be buried in quicklime on the beach to reduce the danger of infection. Shelley was identified by his clothing and was found with a copy of Keats's poetry in his pocket. E. J. Trelawny, who would have had an outstanding career in public relations, concocted the pagan ceremonies at which Shelley and Williams were cremated, Williams on the 15th of August, Shelley on the 16th. Trelawny had an iron grill constructed to hold the bodies over the flames and stood watching throughout the process, which was "exceedingly slow." There was frankincense to cover the smell. "Lord B. wished much to have the skull if possible—which I endeavoured to preserve—but before any part of the flesh was consumed on it, on attempting to move it—it broke to pieces—it was unusually thin and strikingly small."[16] Byron may have already left by then; he was nauseated by the scene. Mary Shelley and Jane Williams were not present. Most famously, Trelawny reached into the fire and snatched up what he believed was Shelley's heart. It has been debated in later years whether or not this was the organ in question. At the time, Leigh Hunt and Mary Shelley had a quarrel over who should have possession of it. She (correctly, one feels) won the point. The remains of the organ, long reduced to dust, were found in a copy of *Adonais* in her writing desk after her death and buried with her in Bournemouth.

Mary Shelley in black velvet, 1831

MARY SHELLEY's sense of complete isolation gradually disappeared. In her journal of 22 January 1830, she wrote, "I have begun a new kind of life somewhat—going a little into society . . . People like me & flatter & follow me, & then I am left alone again. Poverty being a barrier I cannot pass—still I am often amused & sometimes interested."[19] It was at this time that she met the Irish painter Richard Rothwell, a portraitist of the society people she was beginning to know, and she invited him to her parties. (As one of her biographers has observed, she did not invite anyone, including family, who might "gossip about her past."[20]) Her acquaintance with such people helped her to keep Percy Florence comfortable at Byron's school, Harrow, one of the most exclusive in England.[21] Rothwell painted her in the spring of 1831, when she was

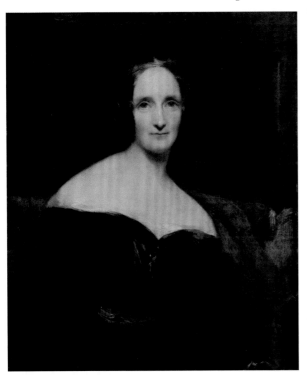

thirty-three. She is depicted as a beauty of the deep-eyed, thin-lipped English school; her hair looks something like the spaniel-ear style that Elizabeth Barrett Browning (and many other Englishwomen) sported in the 1830s, but this is produced by the fillet over her hair. The black velvet is elegant and appropriate for a famous widow, though at this point she had not entirely ruled out remarrying. She would not have been able to afford the portrait herself, and Rothwell exhibited it in 1840. Sometime later her daughter-in-law, Jane, Lady Shelley, acquired it and left it to the National Portrait Gallery.

The Last Man, 1826

THE SUMMER of 1824 was not quite as catastrophic as 1822 had been, but it was bad enough. The news of Byron's death reached England in May. When his body was returned from Greece in July, Mary Shelley was permitted to visit his coffin at the house in London where it was lodged before burial in his family vault in Nottinghamshire. She was already at work on *The Last Man,* but the loss of Byron, she wrote to Trelawny, made her cling "with greater zeal" to her remaining friends.[17] In September, a week after resigning the right to use her own name, she felt as lonely as she ever had; writing pleased her sometimes, but "double sorrow comes when I feel that Shelley no longer reads & approves of what I write."[18] All of this went into *The Last Man,* a novel set in a 2078 that looks surprisingly like the early nineteenth century—Mary Shelley offers a description of the "aerial barks" (balloons, probably; there were no dirigibles in her time) in which characters fly over Europe, but she has little interest in seeing the future. Rather, she imagines a world in which an unstoppable plague slowly consumes everyone. Adrian, Earl of Windsor, resembles Shelley, and Lord Raymond is Byronic. Lionel Verney, the shepherd from the Lake District, is as isolated as Frankenstein's creature at the end, floating the seas on a boat with Homer and Shakespeare and a few other books, well aware that all the libraries in the world are open to him, and stoically resigned to his position as the last man.

THE
LAST MAN.
BY
THE AUTHOR
OF
FRANKENSTEIN.
—
VOL. I.

THE
LAST MAN.
BY
THE AUTHOR
OF
FRANKENSTEIN.
—
VOL. II.

THE
LAST MAN.
BY
THE AUTHOR
OF
FRANKENSTEIN.
—
VOL. III.

Frankenstein in popular prints

THESE PRINTS are among the earliest surviving evidence of *Frankenstein*'s entry into the popular psyche. George Cruikshank's 1821 dentist has aspirations to the high life: we see on his bookshelf not just a *Treatise on Tooth Powder & Brushes* and *Lock on the Gums* but also the 1806 novel *Winter in London*, subtitled *Sketches of Fashion*, as well as *Tales of Terror* (p. 51) and, not least, *Frankenstein*, rendered *Frankensteiv* (one suspects a slip of the etcher's needle). The style is modeled on Gillray's for maximum satirical power. The 1828 *Grocer* is a strikingly unsuccessful attempt at the style of Giuseppe Arcimboldo, famous for his portraits composed of fruits, vegetables, books, and so on. While the print is unremarkable as a piece of graphic work, it shows us Victor Frankenstein entering the popular consciousness separate from the novel—he wanted to make a man "and so, sir / He tried this first attempt upon a Grocer!" Such references continued throughout Mary Shelley's lifetime. By midcentury there were cartoons by John Tenniel (using the name Frankenstein as a political bogey man) in which the creature, too, had taken up an independent place in world culture.

THE GROCER.

Frankenstein wanted to make man & so. Sir.
He tried this first attempt upon a Grocer! *T. R*

London, Published July 1. 1828. by W.B. Cooke. 9. Soho Square.

Tugging at a ~~High~~ Eye Tooth —————

RAILWAY LIBRARY || TWO SHILLINGS

PERKIN WARBECK

BY THE

AUTHOR OF FRANKENSTEIN

LONDON : GEO: ROUTLEDGE AND CO

Perkin Warbeck, 1857

THE SUBJECT of Mary Shelley's 1830 novel *Perkin Warbeck* is a conspiracy for the English throne that took place late in the Wars of the Roses. While the conspirators' claims are now entirely discredited and were in Mary Shelley's time as well, she decided to treat them as true, making its hero a misjudged martyr rather than a thoroughgoing liar. In 1491 a French textile trader named Pierrechon de Werbeque (ca. 1474–1499), anglicized to Perkin Warbeck, was put forward as Richard, Duke of York, the younger of the two Plantagenet princes who died in the Tower of London in 1483—whereupon their uncle (traditionally blamed for their deaths) had become Richard III. After being raised high into European court life by enemies of the English, Warbeck was imprisoned in the tower. In 1499 he confessed and was hanged at Tyburn. The novel is not Mary Shelley's best, but it was nonetheless reissued in 1857. The spread of railways throughout the United Kingdom, coupled with rising literacy and fast-growing urban populations, meant that many more people needed something to read on the train in the later nineteenth century than they had when *Perkin Warbeck* first appeared. Publishers profited from this market by reissuing both popular and serious literature as yellowbacks, so called for their bright yellow illustrated cloth bindings. Mary Shelley's continuing popularity is indicated by the fact that in this edition for George Routledge's Railway Library, "suitable for railway or home reading," she is still not named except as the "author of *Frankenstein*."

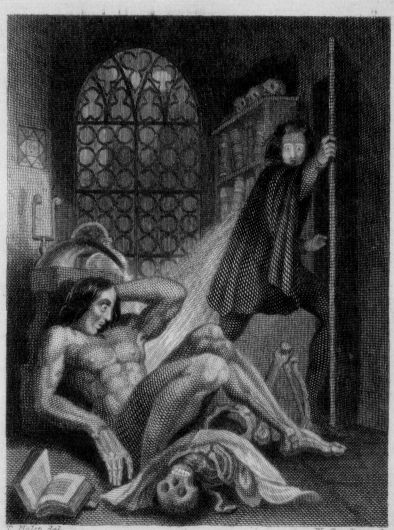

T. Holst, del. W. Chevalier, sculp.

FRANKENSTEIN.

"By the glimmer of the half-extinguished
light, I saw the dull, yellow eye of the
Creature open; it breathed hard, and a
convulsive motion agitated its limbs,
*** I rushed out of the room."

Page 43.

London, Published by H. Colburn and R. Bentley, 1831.

FRANKENSTEIN,

BY

MARY W. SHELLEY.

*The day of my departure at
length arrived.*

Page 31.

LONDON:
COLBURN AND BENTLEY,
NEW BURLINGTON STREET.
1831.

The first illustrated edition, 1831

THE 1831 EDITION of *Frankenstein* was the first to add illustrations. The title-page vignette is puzzling: we see Victor Frankenstein leaving home, one hand in Elizabeth Lavenza's, the other covering his teary face. Victor, however, does not weep in the novel, and his whole family sees him off in a coach. The internal dating of the novel is tricky, but it can't take place before the 1794 revolution in Geneva, and the style of clothing the two figures wear is much older. This may be explained by the fact that Theodor von Holst's lifelong favorite source for images was Goethe's *Faust*, a work for which doublets and dirndls are much more appropriate. (Holst was a favored student of Henry Fuseli.) At left is the image everyone remembers. Victor is at the door, still wearing a cloak from the wrong century. The creature is huge, muscular, and surprised, although his sleek black hair is undisturbed and his face not at all frightening. By 1831, *Frankenstein* had been an extremely popular dramatic subject for eight years, and it's likely that the creature's muscularity and ordinary face are inspired by T. P. Cooke, whose beauty and physique were the keynotes of his embodiment of the role. This edition, then, did not set the idea of the creature's appearance but reflects one already rooted in the popular imagination.

◀ See illustration on pages 188–89.

A rationale for revisions, 1831

THE THIRD EDITION of *Frankenstein* is a slightly more conventional work than the first edition or the second (which differed very little from the first). Victor's friend Henry Clerval, the creature's penultimate victim, may have acquired some of P. B. Shelley's attributes, becoming dreamier and more poetic. Mary Shelley reworked the earliest chapters to fix what she noted in the Mrs. Thomas copy as "tame and ill arranged" plotting and added material to emphasize Victor's sense of being doomed by fate. The most important difference between the 1818 and the 1831 editions, though, is Shelley's introduction describing the ghost story contest. By now she was a seasoned professional, used to negotiating on her own behalf. Writing

Dessiné par H. Platel.

Genty, éditeur, rue S.t Jacques. N.º 33.

M.r Cooke, dans le rôle du monstre.
(*Théâtre de la porte S.t Martin. 3.me Acte.*)

Lith. de A. Chagire.

CHAPTER 7

FRANKENSTEIN ON STAGE AND SCREEN

UNTIL THE TWENTY-FIRST CENTURY, nearly all versions of *Frankenstein* performed by actors depended on changes introduced by Richard Brinsley Peake's 1823 melodrama *Presumption! or, the Fate of Frankenstein*. In this first adaptation for the stage, the creature does not speak. Thomas Potter Cooke's performance of the creature, beloved for its grace and athleticism, originated in pantomime rather than drama. Mary Shelley saw Cooke's portrayal in 1823. While she had written a novel in which creature and creator are eloquent beings formed by books, Cooke's creature is a silent, magical character. He breaks down doors and snaps swords in two even as he floats through the air like Papageno, but his twinship with Victor is lost.

The novel's intertwined narratives disappear as well, along with many secondary characters. Fritz, a bungling comic servant traceable to Roman comedy, is added, along with some dancing gypsies. (Only the patent theaters, Drury Lane and Covent Garden, were licensed to perform straight dramas; all others had to include song and dance—hence the gypsies, as well as the term *melodrama*—meaning a mixed-form performance.) The ethical scope of the novel is further diminished by the simplistic imperative not to presume on God's work. This imperative only became stronger in the cinematic versions. As I mentioned in the introduction, this condemnation was essentially new in 1823, and the creature's muteness made it easier for the audience to disapprove of Frankenstein for making him. The deep-reaching ambiguity and slippery identifications of the novel disappeared with the first word of the title *Presumption! or, the Fate of Frankenstein*.

Ambiguity has never been the strong suit of melodrama, and in 1823 audiences did not miss it; they went to the theater for pleasure, not to think about moral subtleties. And *Presumption!* delivered: despite warnings in the press about Shelley and her circle of radical atheists, despite leaflets denouncing the "decidedly immoral tendency" of the novel, its subject "pregnant with mischief," Peake's play was a hit.[1] Cooke's performance was the key factor: over six feet tall, clad in a gray-blue leotard, his exposed skin painted the same color, with a toga over the leotard, he moved with lyrical athleticism. On playbills his character was denoted by a series of hyphens. This "nameless mode of naming the unnameable is rather good," Mary Shelley wrote to Leigh Hunt, adding "The story is not well managed—but Cooke played ———'s part extremely well."[2] Others tried to manage the story better: the lack of copyright

protection for adaptations meant anyone could put *Frankenstein* on the boards, and between 1823 and 1826 "at least fifteen dramas employed characters and themes from Shelley's novel."[3] These played in both England and France, since Cooke's wordless role was easily transferred across the Channel. Serious productions were parodied by burlesques, forerunners of *Young Frankenstein*. In one, the scientist becomes Frankenstitch, a tailor. Richard Brinsley Peake wrote two of his own, *Another Piece of Presumption* (1823) and *Frank-in-Steam; or, The Modern Promise to Pay* (1826), in which Frankenstein is "a natural and experimental philosopher—in love and in debt."[4]

Presumption! and its closest rival, Henry Milner's 1826 *Frankenstein; or, The Man and the Monster*, along with their French counterparts, played well into the second half of the nineteenth century. *Frankenstein* had long before become iconic and mythical, instantly recognizable to anyone in Britain, France, the United States, and much of the rest of the world. The narrative was a natural choice for the movies. Perhaps the only surprise in its being produced by Edison Studios in 1910 was that it hadn't been done before—they had been in business since 1894. An amalgamation of tarantula and dust bunny emerges from Frankenstein's sulphurous vat in the 1910 film. The director, J. Searle Dawley, was so determined not to offend that the 14-minute production is almost unintelligible, and its cultural impact was minimal.

The opposite is true for James Whale's 1931 version, a film so powerful that the impact of its vision on the popular psyche has been deeper than that of the novel. The 1931 *Frankenstein* and its 1935 sequel, *The Bride of Frankenstein*, together went far toward restoring the numinous quality of the novel, achieving this by a radically reimagined, though still simplified, version of the narrative. The most significant new elements are the creation scene and Boris Karloff's makeup and performance. The creature's animation had been dramatized as early as 1826, but James Whale introduced the equipment and raised the slab to the heavens. Jack Pierce's makeup preserved the creature's unnatural color, discernibly strange even in black and white, and added electrodes to his neck. The 1935 sequel, with Elsa Lanchester playing both Mary Shelley and the creature's bride, and Ernest Thesiger as Dr. Pretorius, maker of homunculi and a bad influence on Frankenstein, has aged even better than the original. Both films create sympathy for the creature through his encounters with stupid and sadistic people, and while there is no suggestion that he *is* a person, or that his bride might be, both Karloff and Lanchester in her all-too-brief appearance have dignity and enormous charisma.

The two James Whale *Frankenstein* films sparked a mass of new energy for the narrative. Other directors drew from it for years after with imitations and derivative films, some quite funny, none as haunting; posters from a number of them are shown below. At present there is no falling off in numbers of *Frankenstein* films and television shows. Some are faithful to Mary Shelley's novel: in his 1994 film version Kenneth Branagh prided himself on that count, but Kevin Connor's 2004 two-part miniseries is said to be closer still. Others—Danny Boyle's 2011 theatrical version, for instance, in which Benedict Cumberbatch and Jonny Lee Miller

alternated the parts of creature and doctor—are true to the spirit but not the letter of the book. Still others, the John Clare story line in the television series *Penny Dreadful* (2014-16), for example, have little in common with Mary Shelley's work, but nonetheless reveal new facets of its premise. *Penny Dreadful*'s version of the creature, though still a murderer, endears himself to audiences (especially Romanticists) by naming himself after and reciting the work of John Clare (1793-1864), a working-class poet much loved in Britain, and makes the character even more literary than Mary Shelley's.

We have included a selection of scenes that have traveled from page to stage to screen: the creature's making, the contact (whether murderous or salvific) between him and a small child, and the moment of Elizabeth's deathly prostration on her wedding bed. These scenes appeal to the denominator we all have in common—a living body—and visual media render them in ways the novel could not. By offering contrasting images, we hope to multiply their meanings for both readers and watchers.

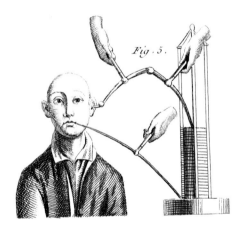

Theatre Royal, English Opera House, Strand.

The whole of the Audience Part of the House has been embellished with

NEW AND SPLENDID DECORATIONS.
TWELVE ELEGANT NEW CUT GLASS CHANDELIERS
have been added, and are to be lighted with WAX; in addition to a
NEW LARGE CENTRE GAS LUSTRE.
The Seats and Cushions of the Boxes and Pit, and the whole of the Upholstery Work of the Theatre, are entirely NEW.

This Evening, MONDAY, July 28th, 1823,

Will be produced (for the FIRST TIME) an entirely new ROMANCE of a peculiar interest, entitled

PRESUMPTION!
OR, THE
FATE OF FRANKENSTEIN.
WITH NEW SCENES, DRESSES, AND DECORATIONS.
The MUSICK composed by Mr, WATSON.

" THE event on which this fiction is founded has been supposed, by Dr. DARWIN, and some of the physiological writers of Germany, as not of impossible occurrence.—I shall not be supposed as according the remotest degree of serious faith to such an imagination; yet, in assuming it as the basis of a work of fancy, I have not considered myself as merely weaving a series of supernatural terrors. The event on which the interest of the story depends is exempt from the disadvantages of a mere tale of spectres or enchantment; it was recommended by the novelty of the situations which it developes; and, however impossible as a physical fact, affords a point of view to the imagination, for the delineating of the human passions, more comprehensive and commanding than any which the ordinary relations of existing events can yield. " *From the Preface to the Novel of* FRANKENSTEIN.

The striking moral exhibited in this story, is the fatal consequence of that presumption which attempts to penetrate, beyond prescribed depths, into the mysteries of nature.

Frankenstein, Mr. W A L L A C K,
De Lacey, *(a banished Gentleman)* Mr. R O W B O T H A M,
Felix De Lacey, *(his Son)* Mr. P E A R M A N,
Fritz, Mr. K E E L E Y,
Clerval, Mr. J. BLAND, William, Master BODEN,
Hammerpan, Mr. SALTER, Tanskin, Mr. SHIELD, Guide, Mr. R. PHILLIPS, Gypsey, Mr H. PHILLIPS,
(------) Mr. T. P. C O O K E.

Elizabeth, *(Sister of Frankenstein)* Mrs. AUSTIN,
Agatha De Lacey, Miss L. D A N C E,
Safie, *(an Arabian Girl)* Miss POVEY, Madame Ninon, *(Wife of Fritz)* Mrs. J. WEIPPERT.
Chorus of Gypsies, Peasants, &c. &c.
Messrs. Bowman, Buxton, Lodge, Mears, Povey, Saunders, Shaw, Sheriff, Smith, Taylor, Tett, Walsh, Willis.
Mesdames & Misses Bennett, Bessell, Dennis, Goodwin, Lodge, Jerrold, Southwell, 2 Stiltons, Vials, Vidall.

After which *(Third Time this Season)* O'KEEFE's Musical Entertainment, called

THE RIVAL SOLDIERS.
Captain Cruizer, Mr. ROWBOTHAM, Serjeant Major Tactic, Mr. W. BENNETT,
Lenox, Mr. BROADHURST, Sinclair, Mr. PEARMAN, {Corporal, Mr. MEARS,
Nipperkin, *(third time)* Mr. W. CHAPMAN,
In which Character he will introduce the Comick Song of *" THE NIGHTINGALE CLUB."*
Mary, Miss HOLDAWAY.

To conclude with *(Second Time this Season)* the Operatick Farce, called

SHARP AND FLAT.
Sir Peter Probable, Mr. W. BENNETT,
Captain Belrose, Mr. BROADHURST, in which Character he will sing *"My native land, good night!"*
Solomon Sharpwit, *(second time)* Mr. W. CHAPMAN,
Nikey, *(second time)* Mr. KEELEY, Brisk, Mr. SALTER,
Rosabel, Miss HOLDAWAY, Jenny, *(second time)* Mrs. J. WEIPPERT.

Boxes 5s. Second Price 3s. Pit 3s. Second Price 1s. 6d. Lower Gallery 2s. Second Price 1s. Upper Gallery 1s. Second Price 6d.
Boxes, Places, Private and Family Boxes, may be had of Mr. STEVENSON, at the Box-Office, Strand Entrance, from 10 till 4.
Doors open at half-past Six, begins at Seven —VIVAT REX!—No Money returned —{Lowndes, Printer. Marquis Court, Drury Lane.
☞ **THE ILLUMINATED TRELLIS ARCADES**
will be opened for the reception of the Visitors of the Theatre at SECOND PRICE, which will commence at NINE o'clock.

☞ *In consequence of the encreased attraction of the revived Opera, and the numerous demands at the Box-Office, The KNIGHT OF SNOWDOUN will be repeated on Wednesday and Friday.*

Mr. WALLACK
(who can perform only for a limited period previous to his return to America) being nightly received with enthusiastick plaudits, will appear in a new Character *This Evening*; and repeat the Character of *Roderick Dhu*, on *Wednesday* and *Friday*.
Miss LOUISA DANCE will appear in a new Character *This Evening*; and on *Wednesday* and *Friday*, as *Ellen*, in the revived Opera.
Mr. W. CHAPMAN, being nightly received with the greatest applause and laughter, will perform, *This Evening*, *Nipperkin*, and *Solomon Sharpwit*; and on *Wednesday* and *Friday*, the Part of *Macloon*.
Mr. RAYNER having received the most enthusiastick applause throughout his whole performance of the arduous Character of *Giles*, in The MILLER'S MAID, and the whole Entertainment having been honoured with the acclamations of crowded Audiences, it will be repeated *To-morrow* and *Thursday*.

Miss KELLY
will perform, *To-morrow* and *Thursday*, *Phœbe*, in The MILLER'S MAID.

To-morrow, The MILLER'S MAID, with (first time at this Theatre) the Farcetta of WHERE SHALL I DINE? and other Entertainments.
On *Wednesday*, The KNIGHT OF SNOWDOUN, with other Entertainments.

PART 1:
FRANKENSTEIN ON STAGE

The first performance, 1823

P LAYBILLS FROM THIS PERIOD were printed on flimsy, almost tissue-thin paper; their survival is a testimony to their effective writing and the pleasure that audiences received from the shows they describe. Playbills sell hard: their primary purpose was to fill theaters, so they used every available induce-ment to do that; in the playbill for the first night of *Presump-tion! or, the Fate of Frankenstein*, the first thing mentioned is the newly redecorated theater with new seats and cushions in the boxes and the pit. And since *Presumption!* was new, the writer quotes from P. B. Shelley's preface and adds, in case anyone should miss it: "the fatal consequence of that presumption which attempts to penetrate, beyond prescribed depths, into the mysteries of nature." The satisfaction offered by this little dose of smugness is not the main selling point, though: it's the promise of the story, the novelty of the title, the mystery of T. P. Cooke's role (———), and not least, the variety of other shows to be performed that night. *Presumption!* is labeled a ro-mance, and there will also be O'Keefe's musical entertainment of *The Rival Soldiers* and the operatic farce *Sharp and Flat*. The second two presentations would have been shorter than the main billing, but whether you paid five shillings for a box or sixpence for a second price (i.e., later entry), you would have plenty of entertainment.

The highly popular romance, 1824

ALMOST A YEAR after its premiere, the success of *Presumption!* is evident from this playbill, as is the play's absorption into the theatrical repertory of the day. The 13th of July 1824 was Mr. Taylor's benefit night at the Theatre Royal, Covent Garden, one of the patent theaters—meaning that Mr. Taylor, one of the regular players, would receive the proceeds that night after costs had been covered. (It was also the last night of the season.) The managers were not, therefore, going to stage anything risky: a crowd was especially desirable, and particularly to be expected on a benefit night, and there was *Presumption!* to reel them in. It was not first on the bill that night, that honor going to *John Bull,* starring the deserving Mr. Taylor. The striking moral was still an inducement, but there were more thrilling ones as well—the "mysterious and terrific appearance of the Demon from the laboratory of Frankenstein," and the conclusion with the "FALL of an AVALANCHE." Special effects and impressive scenery were just as popular in nineteenth-century theater as they are in twenty-first-century cinema, and what designers lacked in computer-generated imagery they made up for with canvas, paint, thunder machines, sulphurous explosions, colored lights, enormous sets that moved and collapsed, and more.

Mr. TAYLOR's NIGHT.

THEATRE ROYAL, COVENT GARDEN.

This present TUESDAY, July 13, 1824, will be acted the Comedy of

JOHN BULL.

Peregrine, Mr. COOPER,
Hon. Mr. Shuffleton, Mr. JONES,
Sir Simon Rochdale, Mr. BLANCHARD, Frank Rochdale, Mr. BAKER,
Job Thornberry, Mr. FAWCETT,
Dennis Brulgruddery, Mr. CONNOR,
Dan, Mr. TAYLOR,
Earl Fitzbalaam, Mr. CLAREMONT, Mr. Pennyman, Mr. LOUIS
John Burr, Mr. ATKINS, Simon, Mr. EVANS, Williams, Mr. MEARS
Lady Caroline Braymore, Mrs. CHATTERLEY,
Mary Thornberry, Miss CHESTER,
Mrs. Brulgruddery Mrs. DAVENPORT.

With the ORIGINAL EPILOGUE *of the Birth, Christening, Parentage,
and other Family Misfortunes of Dennis Brulgruddery.*

IN THE COURSE OF THE EVENING,

Master SMITH will sing '*Sweet Home,*' and '*We're a' Noddin.*'

Mr. PHILLIPS
(By permission of S. J. Arnold, Esq. Proprietor of the Theatre Royal, English Opera-House)
will accompany Himself on the Piano-Forte in a *New Bacchanalian Song.*

The popular Glee of '*Mynheer Van Dunk,*'
By Messrs. PYNE, TAYLOR, and PHILLIPS.

Master BIRCH,

(A Boy only Twelve years old) will perform on the FLUTE,
DROUET's celebrated Variations to '*GOD SAVE the KING.*'

To conclude with, *for the 3d time at this Theatre,* (by permission of S. J. Arnold, Esq.)
the highly popular Romance, of peculiar and terrific interest, called

PRESUMPTION:
Or, The FATE OF FRANKENSTEIN.

The Musick composed by Mr. WATSON.

" The event on which this fiction is founded has been supposed, by Dr. DARWIN, and some of the physiological
writers of Germany, as not of impossible occurrence.—I shall not be supposed as according the remotest degree of
serious faith to such an imagination ; yet, in assuming it as the basis of a work of fancy, I have not considered
myself as merely weaving a series of supernatural terrors. The event on which the interest of the story depends is
exempt from the disadvantages of a mere tale of spectres or enchantment ; it was recommended by the novelty of
the situation which it developes ; and, however impossible as a physical fact, affords a point of view to the imagi-
nation, for the delineating of the human passions, more comprehensive and commanding than any which the ordi-
nary relations of existing events can yield." *From the Preface to the Novel of* FRANKENSTEIN.

*The striking moral exhibited in this story, is the fatal consequence of that presumption which attempts
to penetrate, beyond prescribed depths, into the mysteries of nature.*

Frankenstein, Mr. BENNETT,
De Lacey, (*a banished Gentleman*) Mr. CHAPMAN, Felix De Lacey (*his Son*) Mr. DURUSET
Fritz, Mr. KEELEY, Clerval, Mr. HORREBOW, William, Master BODEN,
Hammerpan, Mr. EVANS, Tanskin, Mr. LEY, Gipsey, Mr. TINNEY,
(------) Mr. T. P. COOKE,
Elizabeth, (*Sister of Frankenstein*) Miss HENRY, Agatha de Lacey, Miss LOVE,
Safie (*an Arabian Girl*) Miss BODEN, Madame Ninon (*Wife of Fritz*) Miss JONES.

Chorus of Gipsies, Peasants, &c.

Mess. George, Henry, Norris, I. & S.Tett, Watts - Mesds. Appleton, Barnett, Dunn, Gifford, Grimaldi, Henry, &c.

Among the many striking effects of this Piece, the following will be displayed :

Mysterious and terrific appearance of the Demon from the Laboratory
of Frankenstein. DESTRUCTION of a COTTAGE by FIRE.

And the FALL of an AVALANCHE.

In consequence of the repeated enquiries after the last new Comedy of

CHARLES the SECOND, or the Merry Monarch,

it is respectfully announced that that very favourite Piece will be acted on *Saturday next,*

Tomorrow, for the Benefit of Miss BEAUMONT, Shakspeare's COMEDY of ERRORS.
With (in one act) The IRISH WIDOW. The Widow Brady by a LADY, (her second
appearance on any stage.)—And the melo-Drama of ELLA ROSENBERG.

On Thursday, for the Benefit of Mr. J. ISAACS and Mr. CLAREMONT, the Comedy of The
SCHOOL for SCANDAL. With the musical Farce of The PADLOCK.

On Friday, the Comedy of THE SCHOOL OF REFORM.
Lord Avondale, Mr. EGERTON, General Tarragon, Mr. BLANCHARD,
Mr. Ferment, Mr. JONES, Frederick, Mr. BAKER, Robert Tyke, Mr. RAYNER,
Mrs St. Clair, Mrs. FAUCIT, Mrs Ferment, Mrs GIBBS, Mrs Nicely, Mrs. DAVENPORT.
After which, The HUNTER of the ALPS.

On Saturday, Shakspeare's Comedy of MUCH ADO ABOUT NOTHING.
To which will be added the new Comedy in three acts, called
CHARLES the SECOND ; or, The MERRY MONARCH.

Being the LAST NIGHT of performing this Season.

Printed by W. Reynolds, 9, Denmark-court, Strand.

Last Night but Two of Mr. MATHEWS' Engagement,
LAST WEEK OF THE SEASON.

☞ Owing to the great demand for the new Musical Farce "BEFORE BREAKFAST," in conjunction with "JONATHAN IN ENGLAND," those Pieces will be repeated together *This Evening, To-morrow,* and *Monday next,* being positively the Last Nights of Mr. MATHEWS' Appearance this Season.
THE NEW GRAND OPERA (for the last time this season) on *Saturday.*
Miss CLARA FISHER on *Tuesday* and *Wednesday next,* as *Little Pickle,* in The SPOIL'D CHILD.
Mr. T. P. COOKE every Evening, as **THE MONSTER,** in **PRESUMPTION; or, the FATE OF FRANKENSTEIN.**

Theatre Royal, English Opera House, Strand.
This Evening, THURSDAY, SEPTEMBER 28th, 1826,
Will be presented *(Seventeenth Time)* an entirely NEW MUSICAL FARCE, called

BEFORE BREAKFAST.
The MUSICK (published by CRAMER, Regent Street) composed by Mr. BARNETT. The NEW SCENE by Mr. PITT.
Nicholas Trefoil, *(a Gentleman's Gentleman, out of place)* Mr. MATHEWS,
in which Character he will sing a NEW SONG, called
"COUNTRY SPORTS."
Sir William Buffer, *(retired with Civic Honors)* Mr. BARTLEY,
Major Havannah, *(from the Tropic)* Mr. W. BENNETT,
Lieutenant Havannah, *(from the Depot at Chatham)* Mr. J. BLAND,
John, *(Servant to Sir William)* Mr. W. CHAPMAN,
Fanny, *(Niece of Sir William)* Miss BODEN.
After which *(Eleventh Time this Season)*

JONATHAN IN ENGLAND!
Jonathan W. Doubikins, *(a real Yankee, landed at Liverpool)* Mr. MATHEWS,
Sir Leatherlip Grossfeeder, Mr. BARTLEY,
Mr. Ledger, *(a Liverpool Merchant)* Mr. W. BENNETT,
Mr. Delapierre, *(an American Gentleman)* Mr. J. BLAND,
Natty Larkspur, Mr. W. CHAPMAN, Jemmy Larkspur, Mr. TAYLEURE,
Tidy, *(Waiter at Waterloo Hotel)* Mr. SALTER, Butler to Sir Leatherlip Grossfeeder, Mr. MINTON,
Agamemnon, *(Jonathan's Nigger)* Mr. SLOMAN,
Police Officers, Messrs. BOWMAN and SHAW, *Waiters, Porters, Servants, &c.*
Lady Grossfeeder, Mrs. JERROLD, Mary, *(her Neice)* Miss BODEN,
Patty, Mrs. J. WEIPPERT, Mrs. Lemon, *(Landlady of the Greyhound)* Mrs. TAYLEURE,
Blanch, *(a Black Housemaid)* Mrs. BRYAN.
The Scene of Act the First is at Liverpool—of the Second in London.
To conclude with *(Seventh Time this Season)* a Romance of a peculiar interest, entitled

PRESUMPTION!
Or, THE FATE OF FRANKENSTEIN!
Frankenstein, Mr. BAKER,
De Lacey, *(a banished Gentleman)* Mr. W. BENNETT, Felix De Lacey, *(his Son)* Mr. THORNE,
Fritz, Mr. W. CHAPMAN, Clerval, Mr. J. BLAND, William, Master BODEN,
Hammerpan, Mr. SALTER, Tanskin, Mr. MINTON, Guide, Mr. J. COOPER, Gypsey, Mr. J. O. ATKINS,
(- - - - -) Mr. T. P. COOKE.
Elizabeth, *(Sister of Frankenstein)* Miss BODEN, Agatha De Lacey, Miss HAMILTON,
Safie, *(an Arabian Girl)* Miss GOWARD, Madame Ninon, *(Wife of Fritz)* Mrs. J. WEIPPERT.

WITH AN ENTIRELY NEW LAST SCENE,
Conformably to the termination in the original Story, representing

A SCHOONER IN A VIOLENT STORM!
In which FRANKENSTEIN and THE MONSTER are destroyed.

Stage Manager, Mr. BARTLEY.—— *Musical Director, Mr. HAWES.*—— *Leader of the Band, Mr. WAGSTAFF.*
BOXES 5s. Second Price 3s. PIT 3s. Second Price 1s.6d. LOWER GALLERY 2s. Second Price 1s. UPPER GALLERY 1s. Second Price 6d.
Boxes, Places, Private and Family Boxes, to be taken at the Box-Office, Strand Entrance, from 10 till 4.
Doors open at half-past 6, begin at 7. No Money returned. Vivat Rex! Lowndes, Printer, Marquis Court, Drury Lane.

To-morrow, BEFORE BREAKFAST, with JONATHAN IN ENGLAND, and PRESUMPTION; or, the *Fate of Frankenstein.*
On Saturday, (25th and last time this season) The ORACLE, with PRESUMPTION; or, the *Fate of Frankenstein.*
On Monday, BEFORE BREAKFAST, with JONATHAN IN ENGLAND, and PRESUMPTION; or, the *Fate of Frankenstein.*
Being POSITIVELY the LAST NIGHT of Mr. MATHEWS' APPEARANCE THIS SEASON.
On Tuesday, The LIBERTINE, with The SPOIL'D CHILD, and PRESUMPTION; or, the *Fate of Frankenstein.*
On Wednesday, The MARRIAGE of FIGARO, with The SPOIL'D CHILD, and PRESUMPTION; or, the *Fate of Frankenstein.*
Thursday, The VAMPIRE, with (by particular desire) GRETNA GREEN, and PRESUMPTION; or, the *Fate of Frankenstein.*
Being the LAST NIGHT of THE COMPANY'S PERFORMING THIS SEASON.

Persistence of *Presumption!*

A NOTHER INDUCEMENT to an audience that the management almost certainly assumed to be all white was the casual racism evident in the description of the cast of *Jonathan in England!*, playing for the eleventh time that season on 28 September 1826. (Jonathan was a stereotypical name for a white Yankee, as Agamemnon was for an enslaved African American.) *Presumption!* has slipped to third on the bill and regained its exclamation point. This is the third separate theater at which the play has appeared, and T. P. Cooke is the creature here, too, as he was in France. Notice that there is an entirely new last scene with a schooner in a violent storm. In fact the sinking ship is not "conformable with the termination of the original story"—which ends with the creature hastening to immolate himself—but it would have been a pleasure to watch it go down.

Presumption! in the provinces, 1833

I N THE PROVINCES, *Presumption!* could still top the bill when T. P. Cooke appeared as (***). He was 47 and had been playing the role for ten years; he was to play it for many more. The management's triumph in securing him is palpable—this "Rara Avis," after his London triumph, had gone to the French capital and played the "singular character Eighty Nights, to the amazement and delight of Parisian audiences"—and now he had come to Plymouth. This playbill advertises, as well, the role that for Cooke was even more popular than the creature, that of the sailor William in *Black-Eyed Susan,* in which he danced his celebrated hornpipe. Cooke's career was coterminous with the period of the great popularity of the many plays based on Mary Shelley's novel, and undoubtedly his superlative performance was a major reason for its endurance.

THEATRE ROYAL, PLYMOUTH.

Mr. SANDFORD most respectfully begs leave to acquaint the Nobility, Gentry, his Patrons, and the Public generally that he has been fortunate enough to engage that **most distinguished** and **justly Celebrated Actor,**
MR.

T. P. COOKE

who, during the **RACE WEEK,** will appear in those characters by the performance of which he has so repeatedly crowded to excess the Theatres Royal, Drury-Lane, Covent Garden, Dublin, Edinburgh, and every great Theatre throughout the United Kingdom ! Our Dramatic Critics have all agreed that the various representations of **MR. T. P. Cooke** are at once so Vigorous, so Chaste, and so True to Nature, that they despair of ever witnessing the same characters embodied, in a like degree of perfection, by any other Actor.

On MONDAY NEXT, August 19, 1833,

Will be presented (FIRST TIME HERE) the Romantic Drama called

PRESUMPTION!

Or, The Fate of Frankenstein.
With New Scenery, and Decorations,
The Part of the (※ ※ ※) Mr. T. P. COOKE.
(His first appearance on this Stage.)

After the wonderful assumption of this Rara Avis, every night throughout a whole Season in London, Mr. T. P. COOKE was called to the **Capital** of **France,** where he performed this singular character Eighty Nights, to the amazement and delight of Parisian Audiences.

Frankenstein, Mr. WILTON—Clerval, Mr. BUTLER—William, Master DEARLOVE
De Lacy, Mr. VIVASH—Felix, Mr. WAYE—Fanskin, Mr. SMITH—Hammerpan, Mr. FULLER
Guide, Mr. MURRAY

And Fritz, by Mr. MEADOWS.
(From the Theatre Royal, Covent Garden, who is also engaged to perform with MR. COOKE.)
Gypsies, Villagers, &c. &c.
Agatha, Mrs. J. H. HUGHES—Elizabeth, Mrs. HENRY—Safie, Mrs. WAYE
and Madame Ninon, Mrs. JEFFERSON.

Some of the leading incidents that will be portrayed in the course of the Piece are as follow :
THE
Study and Laboratory of Frankenstein,
With the appalling and terrific appearance of the (———!)
GYPSIES' ENCAMPMENT.
Effects of Air, Fire, and Music's Fascination on the untutored Mind of the (———.)
Exterior of De Lacy's Cottage,——Recognition of the lost Safie.
(——'s) Discovery of De Lacy's Blindness--
His Sympathy—and subsequent Attachment to him.
Rescue of AGATHA.
(———) Wounded, and Destruction of the Cottage by Fire !
Various other incidents, terminating with the
Annihilation of the (——) & Frankenstein
By the fall of a tremendous Avalanche.

After which

Sylvester Daggerwood,
Sylvester Daggerwood, Mr. MEADOWS.

To conclude with the Popular Drama called

Black-Eyed Susan.

Admiral, Mr. WILTON---Capt. Crosstree, Mr. BUTLER--Lieut. Pike, Mr. WAYE,
Hatchett, Mr. SAUNDERS---Raker, Seaweed, Mr. MURRAY---Doggrass, Mr. VIVASH
Gnatbrain Mr. MEADOWS.
Jacob Twig, Mr. FULLER--Blue Peter, Mrs. WAYE
Master at Arms, Mr. JOHNSON—Midshipman, Mr. KENNEDY
Susan, Mrs. J. H. HUGHES--Dolly Mayflower, Mrs. HENRY
AND
William - - - - - - Mr. T. P. COOKE.
As originally acted by him upwards of Two Hundred successive Nights, in which character he will introduce the Song
'Bound 'Prentice to a Coasting Ship'
And dance his celebrated Hornpipe.

On TUESDAY, 20th Instant, SECOND NIGHT of
Mr. T. P. COOKE, and Mr. MEADOWS.

Doors to be open at half-past Six, and Performance to commence at half-past Seven—Second Account at Nine.
Tickets to be had at Mr. NETTLETON's, where places for the Boxes may be taken.
N.B.—No Free Admissions during Mr. T. P. Cooke's performances, the Press alone excepted.

Nettleton, Printer to His Majesty, Whimple Street, Plymouth.

T. P. Cooke as the creature, 1832–34

THE MONSTER of *Presumption!* is neither disgusting nor articulate. T. P. Cooke's popularity derived from his grace and physical beauty, visible in both of the images shown here. Despite Richard Brinsley Peake's brazen lifting of Mary Shelley's description of the creature, the part as enacted by Cooke and others is by no means "too horrible for human eyes." He thus does not need to speak; no narrative purpose would have been served by his being able to explain away his ugliness, as Shelley's creature does. Instead he has brute power and rage, qualities that would be transferred to the cinema. But where Boris Karloff's creature is defined by the compassion he arouses, Cooke's role elicited a sense of poignancy more than pity. In *Presumption!* the monster makes "gestures of conciliation" to Frankenstein, discovers the hard way that fire is painful, expresses delight in music when Felix plays his flute, and catches at the melody in the air, as much an angry Ariel as a Caliban.

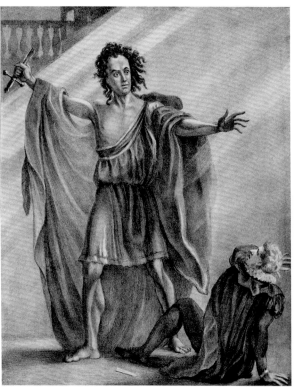

Zametti and the monster, 1826

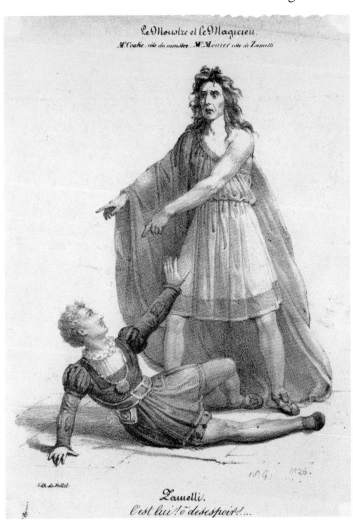

Le Monstre et le Magicien.
Mr Cooke, rôle du monstre. Mr Menier rôle de Zametti

Zametti.
C'est lui! ô désespoir!...

THE FRENCH VERSION of *Frankenstein, Le Monstre et le magicien*, moves the story to the sixteenth century, near Venice, and makes Frankenstein—now called Zametti—a magician, not a scientist. In this and *Presumption!* there is no scene of creation. Rather, audiences saw the window of Frankenstein / Zametti's workshop with red and blue lights indicating the process of the creation (a matter of seconds, not minutes) and heard a running commentary by the comically frightened servant, Fritz. The creator would then stagger out of the door and slam it, only for it to be broken down by the monster. (The preceding image provides further proof of the creature's strength as he snaps a sword in two.) This scene comes close to the dramatic end of the play, when the monster has killed little Antonio offstage. Soon Cecilia, Zametti's fiancée, dies when she takes the bullet Zametti had aimed at the monster. Shortly thereafter, Zametti meets the monster one last time on board a ship on the storm-tossed Adriatic; while fantastic creatures fly across the clouds, the monster brings down and kills Zametti, only to be himself struck by lightning.

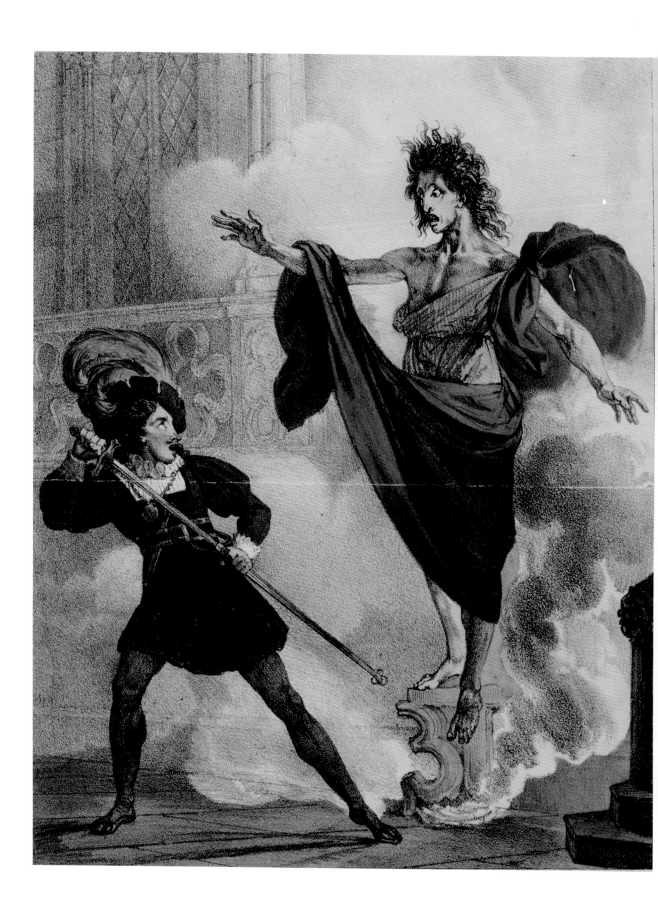

Alchemical ingredients

*L*E *Monstre et le magicien* made audiences wait until the end of the first act to see the monster, who appears wrapped in a large cloak amidst a red flame. The first act begins with a thunderstorm, and the tension builds when the magician conjures up a genie who gives him a mysterious flask, apparently containing an elixir of life. There is a precedent for this plot device: *Der Freischütz*, Karl Maria von Weber and Friedrich Kind's massively successful opera opened in 1824. Its plot revolved around bullets produced by alchemy, making them certain to hit their mark (in England it starred the ubiquitous T. P. Cooke). After this, alchemy "became a permanent part of *Frankenstein* adaptations."[5] Zametti's magical powers are demonstrated by his calling up the genie, who scolds him for his *présomption* and warns him that his alchemical experiments will cost him his happiness. The folkloric element of the story, diluted in the novel by the creature's intellect, is thus brought to the fore.

Another adaptation, 1826

HENRY MILNER's *Frankenstein; or, The Man and the Monster!* is in all essentials a translation of *Le Monstre et le magicien*, though the magician's name has reverted to Frankenstein. It is the first, however, to include the creation scene: in a laboratory littered with chemical (and alchemical?) apparatus, Frankenstein "rolls back the black covering" on a body spread on a table, which slowly begins to rise and glares at him when it is sitting up. Music, rather than lighting or stage business, served the purpose of dramatizing the creature's vivification. As with *Presumption!* the description of the creation owes a good deal to Mary Shelley: he is, the stage directions tell us, "a colossal human figure, of a cadaverous livid complexion."[6] The frontispiece of Duncombe's edition indicates the production retained the toga and the long black hair by now familiar to audiences. Here the part of the creature is played by Richard John Smith (O. Smith), who was almost as popular as Cooke and would later take on the role of Scrooge in *A Christmas Carol.*

THÉATRE DE l

Les bureaux ouvriront à SEPT heures moins 1/4 — AUJOURD'HUI

REPRÉSENTATIONS DE

M. FRANÇOIS RAVEL

Mime Américain, rôle du *Monstre*.

REP

LEMO

LE MA

Drame-Fantastique à grand Spe

1er Tableau. — LE RETOUR DES EXILÉS.

2me Tableau. — LES RUINES DE SAINT-ULRIC.

3me Tableau. — LA CRÉATION DU MONSTRE.

4me Tableau. — LA FÊTE DES BOHÉMIENS.

5me Tableau. — LA TOILETTE DE LA MARIÉE.

6me Tableau. — L'INCENDIE DE FERNA.

7me Tableau. — LE TIGRE ET SA PROIE.

8me Tableau. — LE RAVIN DES TORRENTS.

9me Tableau. — LES NAUFRAGÉS.

10me Tableau. — LA TEMPÊTE.

11me Tableau. — L'APOTHÉOSE DE PAULA.

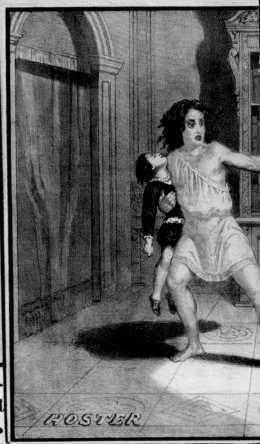

Mr FAILLE *Janskin*, SCHEY *Pietro*,
MACHANETTE *Matheus*, LAUTE *Holben*,
DORNAY *Le Capitaine*, MARIUS *Faustus*,
RICHER *Petrusko*. Mme THÈSE *Cécilia*,
BLANCHARD *Paula*, M.-BLUM *Zinetta*.
La petite EUGÉNIE débutera par le rôle d'*Antonio*.

Chaque Dame munie d'un Billet pris au Premier bureau recevra un Eventail représentant une des scènes capitales du **MONSTRE**.

HOSTER

MBIGU-COMIQUE

Typ. MORRIS et Comp., rue Amelot, 64.

H 22 JUIN 1861.

On commencera à SEPT heures 1|4.

ATION

e

RENTRÉE DE
M. CASTELLANO

Rôle de *Zametti le Magicien.*

NSTRE

GICIEN

e, CINQ actes et ONZE tableaux.

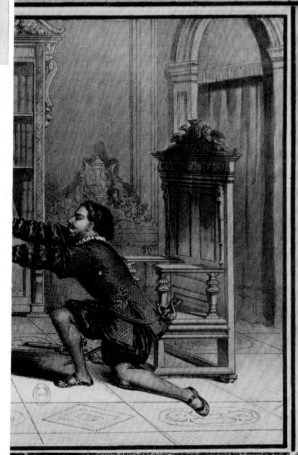

À 10 heures, **BALLET.**

LA ZINGARA

Grand Divertissement Bohémien.

RENTRÉE DE
M. RUBY

Premier Danseur comique du Théâtre Royal de la Monnaie
à Bruxelles.

DÉBUTS DE
Mlle LÉLIA NAVARRE

Première Danseuse du même Théâtre.

CORPS DE BALLET:
Mmes ZOMBACH, BLANCHE, CLÉMENCE-SERRÉ, CHEVALIER
ALEXANDRINE, CATARINA, ROSE, CLÉMENCE,
GABRIELLE-MEYER, LÉONTINE, DOUVRY, BELLISSON
HÉLOÏSE, JULIE, CLÉMENTINE, SOPHIE, VIRGINIE.

Au 1er tableau,

LES GITANOS

Chanté par **M. RONDEAU,** Baryton du th. de Bordeaux

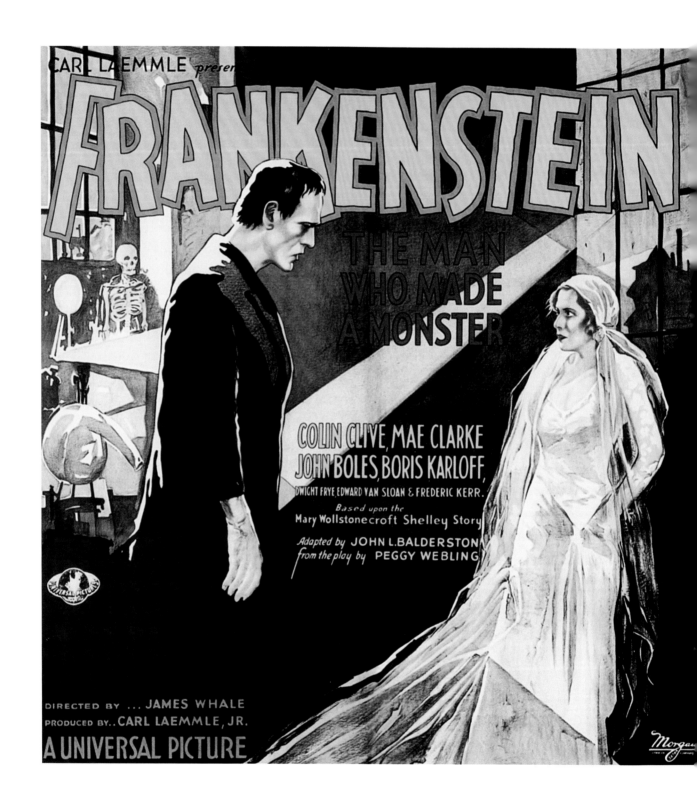

The definitive cinematic *Frankenstein*

James Whale's *Frankenstein* smashed the older models of the monster and replaced them with Boris Karloff. Karloff, more human without electrodes, is seen here in tense mutual regard with Mae Clarke. The moving force behind Whale's *Frankenstein* was the English actor-producer Hamilton Deane: in 1927 Deane commissioned a theatrical adaptation of the novel from the playwright Peggy Webling as a repertory companion to his recent success as Count Dracula. When both *Dracula* and *Frankenstein* were hits with English audiences, Deane hired John Balderston, an American writer who specialized in British subjects, to adapt them for the American stage and eventually for the screen. The year 1931 was a jubilee for horror movies, with Universal releasing both Whale's *Frankenstein* and Tod Browning's *Dracula*. (The latter starred Bela Lugosi, who had been considered for Karloff's part, with a makeup scheme derived from Carl Boese's 1920 *Golem*.) After having failed to borrow the notoriously rare one-sheet poster for this exhibition, by a stroke of luck, we found something even better—the sole surviving copy of a giant six-sheet lithograph billboard advertisement. Never used, in pristine condition, it is the ultimate cinematic artifact of *Frankenstein*.

A vital passage in the screenplay, 1931

```
Q                                                               32.

    D-16   MEDIUM SHOT

                                 FRANKENSTEIN    (laughing crazily)

                                     It's alive!    It's alive!
    Victor leaps forward.

                                 VICTOR

                                     Henry - in the name of God!

                                 FRANKENSTEIN

                                         (standing up, his
                                          feet apart)

                                     God?    Now I know how it
                                     feels to be God!

    FADE OUT
```

MARY SHELLEY described seeing *Presumption! or, The Fate of Frankenstein* to Leigh Hunt, telling him how the servant, Fritz, watches through a window and "runs off in terror when F exclaims 'It lives!'"[8] Fritz pauses to cry "Oh, dear! Oh, dear! Oh, dear!" before running, and on stage Frankenstein repeats himself just as Colin Clive does, saying "It lives! It lives!" In the novel, the reader at that moment is deep in Frankenstein's mind, and there's no need for such a speech. But on the stage and screen, the inclination to have something like this exuberant line would be almost irresistible; in *Frank-in-Steam*, his second burlesque of his own play, Richard Brinsley Peake went for bathos: "It lives—it snores—it cries!"[9] But "It lives!" "It's alive!" and even "It snores" all convey the story's central premise: a moment ago it was a corpse, and now it breathes.

Boris Karloff in
The Bride of Frankenstein, 1935

WHALE and Karloff agreed that the creature was essen-
tially an innocent. But where Mary Shelley had created
a being of extraordinary intelligence, Karloff's is close to an
animal, perhaps a large dog. He is also, as we see here, un-
free and pitiable. Whale turned to this interpretation when
his partner, David Lewis, having read the novel at Whale's
request, responded by saying "I was sorry for the goddamn
monster."[10] This became the key to Karloff's performance and
Whale's direction. But the creature was still a killer, and, as
Whale said, "the transition from slow-thinking stupid monster
into a developed criminal had to be done quickly." His solu-
tion was to show the servant, Fritz, torturing the creature with
a flaming torch. Karloff said later: "Over the years thousands
of children wrote, expressing compassion for the great, weird
creature who was so abused by its sadistic keeper that it could
only respond to violence with violence. Those children saw
beyond the make-up and really understood."[11] We sympathize
with Karloff's creature, while we identify with Mary Shelley's.

◖ See illustration on pages 224–25.

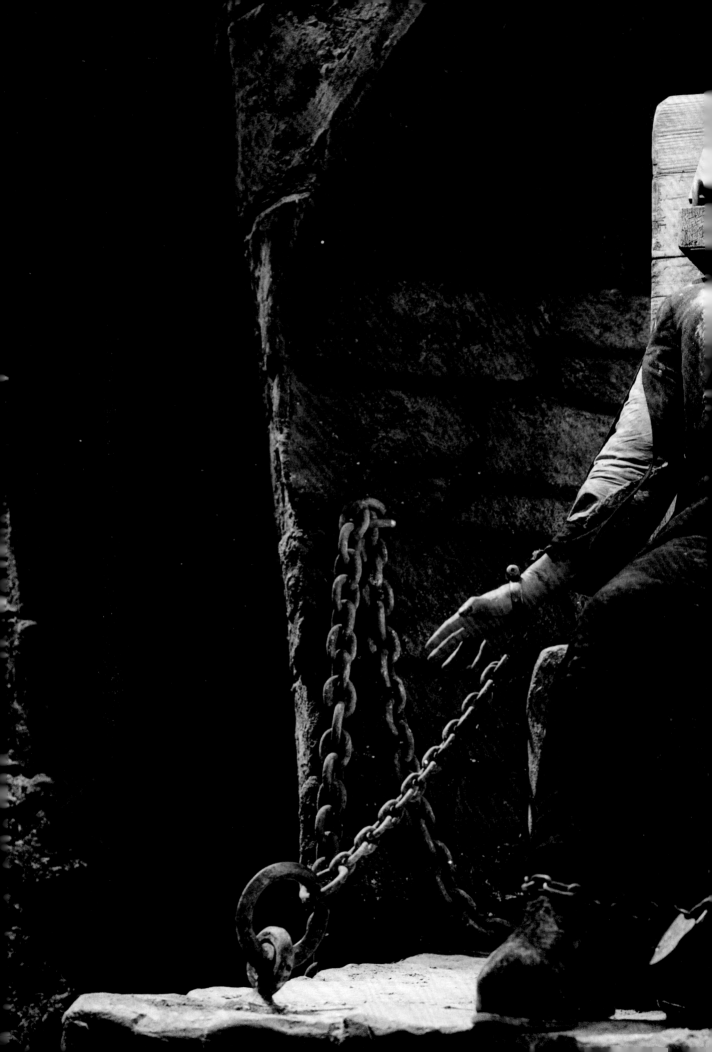

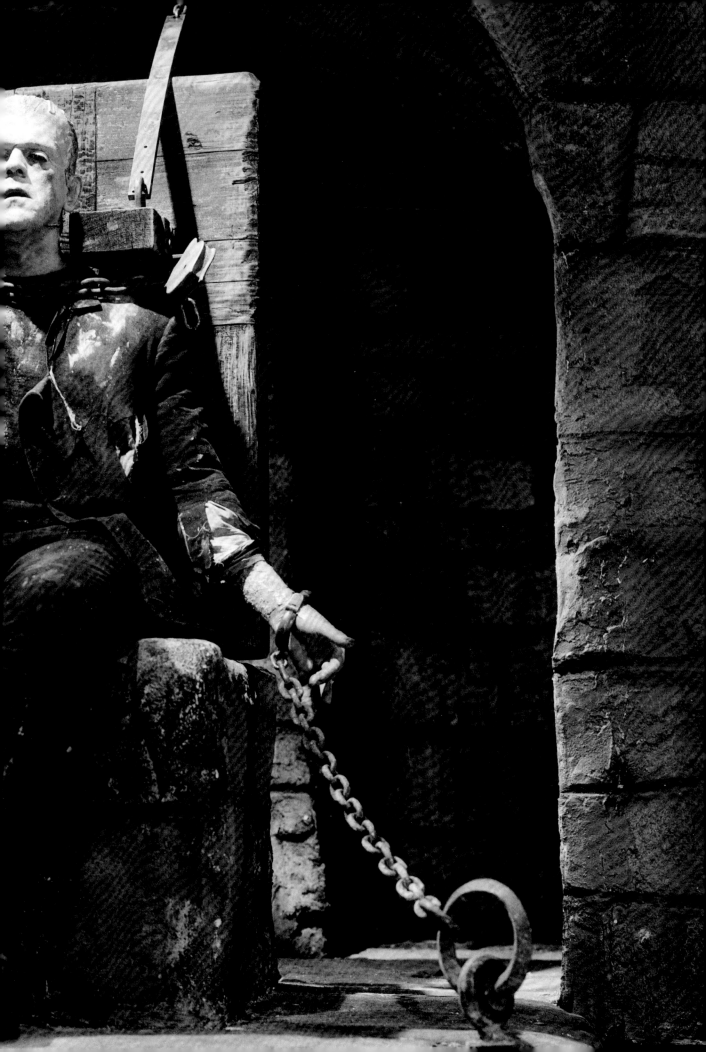

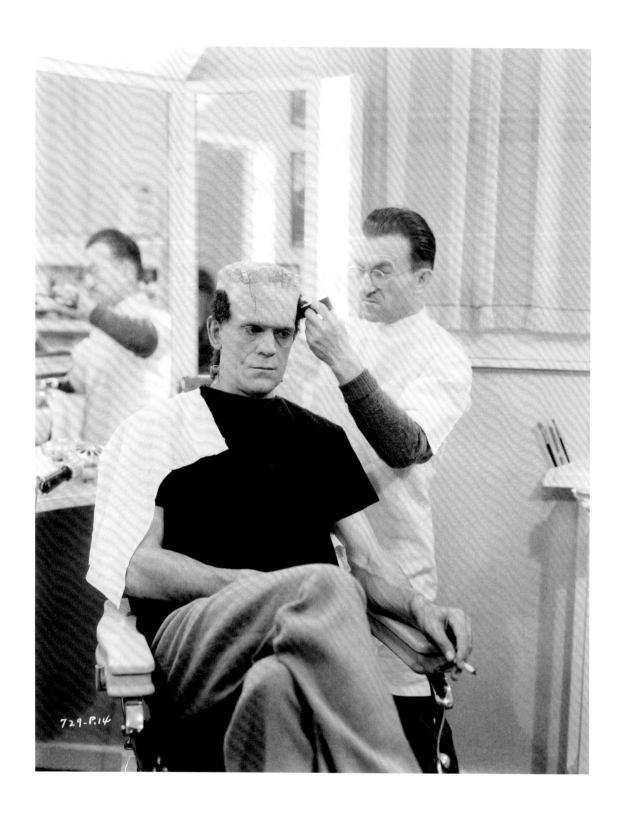

729-P.14

226 IT'S ALIVE!

Jack Pierce and Boris Karloff, 1935

BORIS KARLOFF (1887–1969, born William Henry Pratt, a Briton, like most of the cast) did have a prominent brow, but he was a handsome man, and only Jack Pierce's makeup made the creature ugly. For James Whale's landmark 1931 film of *Frankenstein,* Pierce made hundreds of sketches before submitting just one that combined the cadaverous with the electric. The creature's forehead is clamped shut where his transplanted brain has been popped in. Pierce imagined the electrodes on his neck—inevitably mistaken for bolts—as "inlets for electricity," the creature's spark of life.[12] Karloff's head was built up with layers of collodion and cheesecloth, which appeared as pores. This surface was then covered with blue-green greasepaint—not in homage to T. P. Cooke's creature, but because in black and white it photographed a deathly gray. Karloff removed a bridge from the side of his mouth and sucked his cheek in for that sunken look. Finally, because his eyes were too natural and, as Karloff commented, "too understanding where dumb bewilderment was so essential," Pierce added wax to his eyelids, making them "heavy, half-seeing."[13] In addition to having a five-pound steel rod run along his back, Karloff wore eleven-pound boots of the type used by road workers to keep their footing in hot tar. A double-quilted undersuit added bulk to his costume. Filming in August, after an hour Karloff would often change from his sopping wet undersuit to a spare one, still damp from its last wearing. "So I felt, most of the time, as if I were wearing a clammy shroud of myself," he recalled later. "No doubt it added to the realism."[14]

A Hollywood fixer placates the censors

"Now I know how it feels to be God!" proved an extremely problematic line and was often cut by local censor boards in a country where it was perceived as blasphemous. In 1931 Jason S. Joy was the head of the Studio Relations Committee, acting as the liaison between the motion picture studios and the organization putting into practice what would soon be known as the Hays Code. The head of that organization, Will Hays, was already busy—backed by the Federal Trade Commission and a Supreme Court ruling that motion pictures did not enjoy freedom of speech—working to ensure that movies were safe for the innocent, God-fearing public. Joy had a small staff and little love for his job, however—in 1935 he would become the head of public relations at Twentieth Century-Fox—and he was willing to speak up for the studios. When the Kansas State Board of Censors asked for thirty-one deletions in the film, Joy telephoned and talked them down to ten. In the post-code *Bride of Frankenstein* blasphemy is roundly condemned, as when Elizabeth scolds her fiancé, renamed Henry (while Clerval becomes Victor), for his presumption at his slightest sign of enthusiasm for his previous labors.

August 18th 1931.

Mr. Carl Laemmle Jr.,
Universal Studio,
Universal City, California.

Dear Mr. Laemmle:

 We have read the August 12th script of "FRANKENSTEIN" and
are of the opinion that the only incidents in it about which to really
be concerned are those gruesome ones that will certainly bring an
audience reaction of horror. We think that you ought to keep thorough-
ly in mind during the production of this picture that the telling
of a story with a theme as gruesome as this will not permit the use
of superlative incidents of the same character. Therefore, considera-
tion should be given to scene A-12 showing the body of the hanged
man, and scene H-4 showing the dwarf hanging by a chain; and the several
other gruesome incidents which make up a part of the script.

 In scene D-16 we suggest that instead of having Frankenstein
say: "Now I know how it feels to be God", he say: "Now I know how it
feels to be a god".

 Best wishes always,

 Sincerely yours,

 Jason S. Joy.

JVW:H

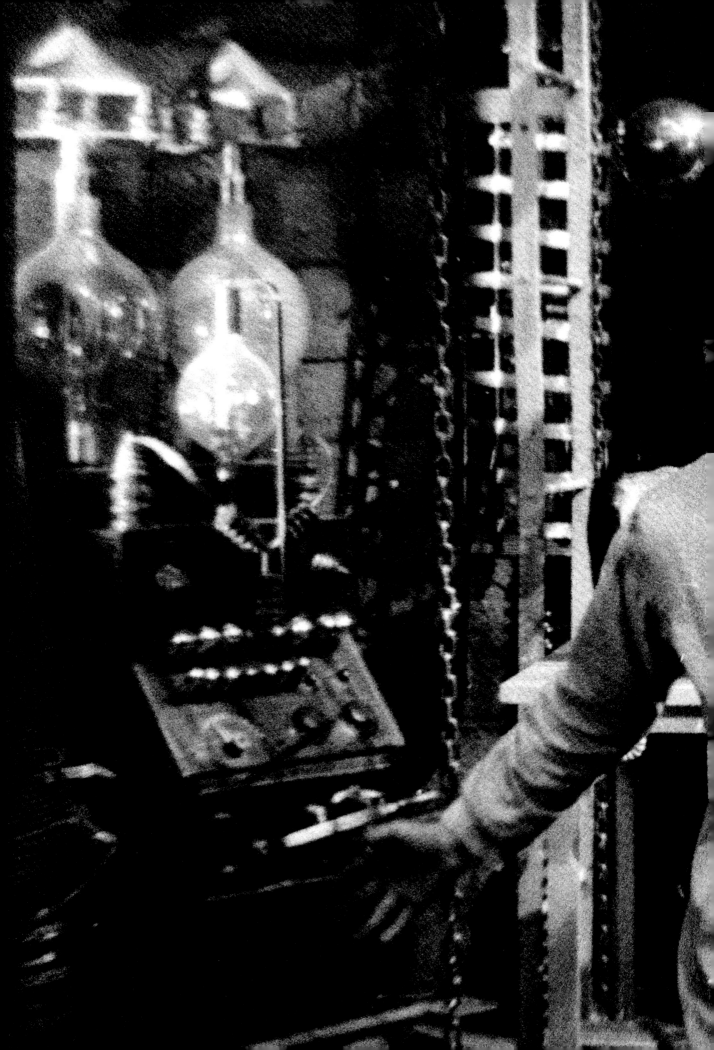

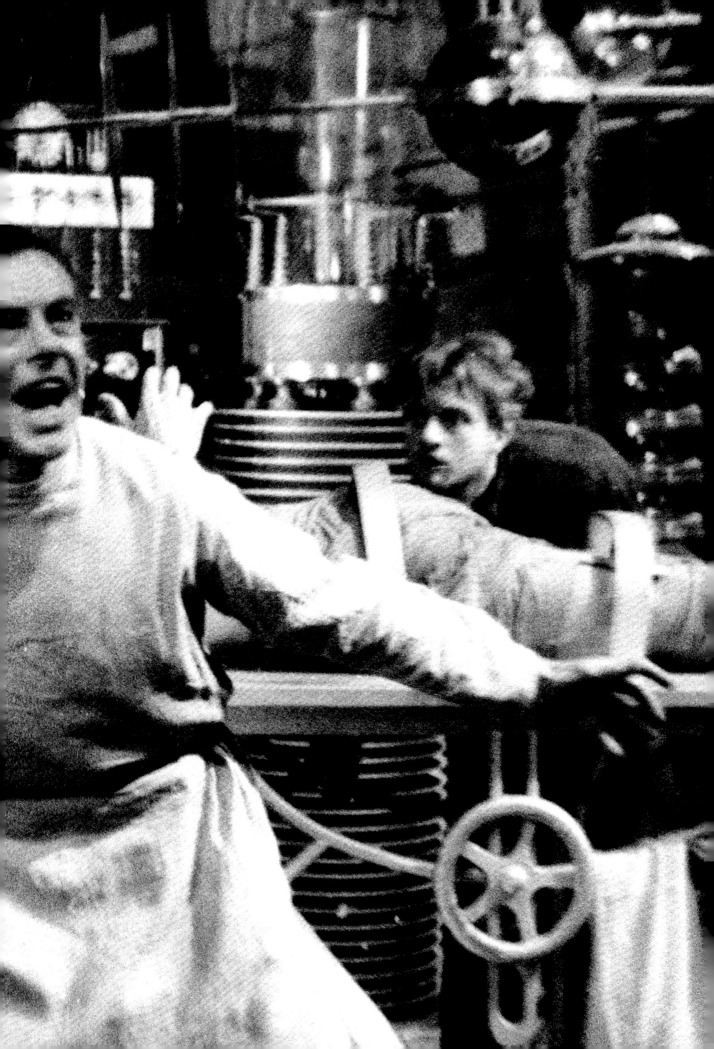

Mad scientist

COLIN CLIVE's liveliest moment is seen here. A victim of alcoholism and tuberculosis, he died at age thirty-seven, two years after finishing *The Bride of Frankenstein.* During the making of *The Bride,* a friend of James Whale's remembered, Clive would lurk in his dressing room: "they'd call him and he'd come out and do the 'it's alive' thing and then go back."[15] In 1931, however, he conveyed Frankenstein's triumph with almost-airborne exhilaration. In the background, Kenneth Strickfaden's apparatus looms—composed from "what kind of junk I had at hand," he said—though since he had made a profession of supplying "scientific" equipment to Hollywood, it was pretty impressive junk, and conveyed real electricity. The writers had called for a laboratory that resembled the one in Fritz Lang's *Metropolis* (1927), that nonpareil of modernist design, and while *Frankenstein* is set in a strangely unmoored earlier period, there is a resemblance.[16] Boris Karloff, strapped to the table, was nervous: "I could see directly above me the special effects men brandishing the white-hot scissorlike carbons that made the lightning. I hoped that no one up there had butterfingers."[17]

◄ See illustration on pages 230–31.

Why shouldn't I write of monsters?

The Bride of Frankenstein opens in what is presumably the Villa Diodati: Byron and Shelley banter with Mary Shelley, who is sewing. Little did the audience know that Elsa Lanchester was also the bride—the credit for that role indicated by "?" She described the reasoning for the double role in her 1983 memoir: "In this delicate little thing was an unexploded atom bomb. My playing both parts cemented that idea."[18] Byron emphasizes Mary Shelley's delicacy, asking "Can you believe that bland and lovely brow could have conceived of *Frankenstein?*" She replies that such figures as Byron and Shelley need "stronger stuff than a pretty little love story. So why shouldn't I write of monsters?" There was a better answer filmed, but the full retort was cut for the censors: "You say look at me," Mary Shelley says, pointing to her partner, "I say look at Shelley—who would suspect that pink and white innocence, gentle as a dove, was thrown out of Oxford University as a menace to morality, had run away from his lawful spouse with innocent me but 17. . . . I am already ostracized as a free thinker, so why shouldn't I write of monsters?"[19] One can only wish that stomachs had been stronger in 1935. The studio, Universal, emphasized Mary Shelley's femininity by sending Elsa Lanchester's dress, "the most fairy-like creation I have ever seen . . . in a film," touring to be displayed in the foyers of select theatres. Its train is so long that Gavin Gordon, playing Shelley, steps on it when he blots the blood from the finger she has pricked while sewing. Mary Shelley's needlework thus eclipses the labor of writing a novel.

❡ See illustration on pages 234–35.

WARNING!
THE MONSTER
DEMANDS
A MATE!

CARL LAEMMLE
presents

KARLOFF in

The BRIDE of
FRANKENSTEIN

COLIN CLIVE · VALERIE HOBSON · ELSA LANCHESTER ·
UNA O'CONNOR · ERNEST THESIGER and C.C.CLIVE ·
directed by JAMES WHALE produced by CARL LAEMMLE, JR.
SCREENPLAY BY WILLIAM HURLBUT and JOHN BALDERSTON
A UNIVERSAL PICTURE

The monster demands a mate

THE PRESS BOOK for *The Bride of Frankenstein*, a collection of photographs and promotional materials sent to journalists, depicts an imperious Mary Shelley, whose glance reflects power and knowledge, not innocence. It also reflects her novel, in which the monster *does* demand a mate. In James Whale's film, however, the idea of a bride for the creature originates with a new character, Dr. Septimus Pretorius, Henry Frankenstein's former university teacher and a paragon of evil. He has come to induce Frankenstein to collaborate with him, in the scene ending with Pretorius's toast on gin, "my only weakness," to "a new world of gods and monsters!" The professor has been cultivating homunculi, tiny people, and keeps them in jars. To create this effect, actors worked in enormous jars; one was a tiny Henry VIII, a joke for Elsa Lanchester since her husband, Charles Laughton, had recently won an Academy Award for his portrayal of the king. In life Ernest Thesiger was, Elsa Lanchester remembered, charmingly acid-tongued; he was also, like James Whale, a more or less uncloseted gay man. During breaks, Thesiger would work on the needlepoint at which he was expert, having learned the craft as rehabilitation for an injury he suffered in the First World War.[20]

A sympathetic creature

W HILE the creature is ugliness incarnate, Elsa Lanches-
ter's bride is beautiful—strange, certainly, but a credible
cousin to the female robot in Fritz Lang's *Metropolis*. She ex-
presses only aversion to the creature, and the audience's sym-
pathy is directed to him as he strokes her hand and inquires,
"Friend?" In addition to issuing cord-destroying screams,
Lanchester expressed the bride's clear *no* by imitating the hiss-
ing swans in Regent's Park.[21] The soundmen made her noises
even stranger by running a few of them backward. In the novel,
the bride is never vivified, and Victor scatters her pieces in the
North Sea. The ending of *The Bride of Frankenstein* is thus some-
thing new from the writers of the film, John Balderston and
William Hurlbut. In this version, the creature motions Henry
Frankenstein and Elizabeth away from the laboratory tower.
"Go! You live! Go!" he commands them. "We belong dead," he
continues, gesturing toward himself, the bride, and Dr. Pre-
torius, his hand on the lever that will bring the tower crash-
ing down on their heads. Mary Shelley's creature also plans to
commit suicide, telling Walton, "I shall ascend my funeral pile
triumphantly, and exult in the agony of the torturing flames."
But for most of the novel, the creature loves life and clings to it.
Only at the end, from remorse at his crimes, is he suicidal. The
conclusion of *The Bride* offers a clear and plausible alternative:
a creature who should not have existed at all, having learned of
his unnatural origins during a scene in a crypt with Dr. Preto-
rius, chooses a dignified and purposeful death.

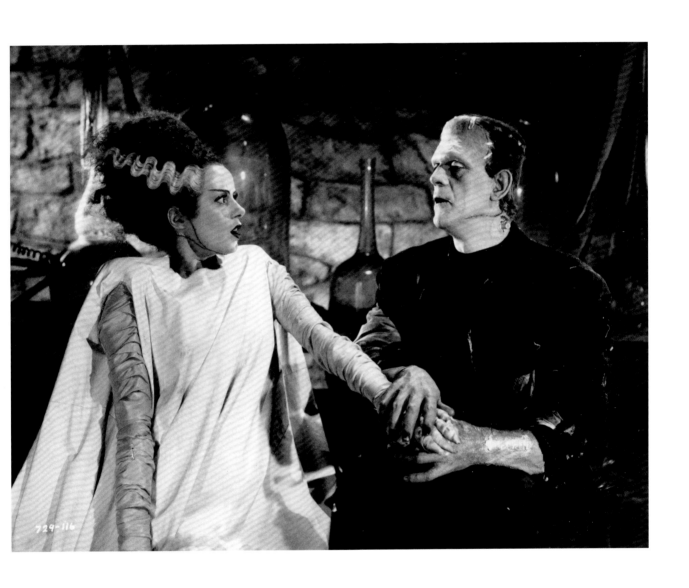

Elsa Lanchester's fright wig

ELSA LANCHESTER wrote in her memoir, "I've often been asked how my hair was made to stand on end. Well, from the top of my head they made four tiny, tight braids. On these was anchored a wired horsehair cage about five inches high. Then my own hair was brushed over this structure, and two white hair pieces—one from the right temple and the other from the left cheekbone—were brushed onto the top."[22] Elsa Lanchester's hair was a magnificent auburn. Herbert Farjeon, a critic and versifier, described her in an early London stage success, *Riverside Nights:* "Her hair is in the chestnut trees of London and her feet are in the mud of the Thames."[23] When it came time to design the bride's hair, however, Josephine Turner and Leland Crawford devised a shape based on the bust of Nefertiti, discovered in 1912, and added white lightning bolts

at the sides, the feminine counterpart to Karloff's electrodes. Turner and Crawford replicated that design in the wig shown here, made for the Museum of the Moving Image.

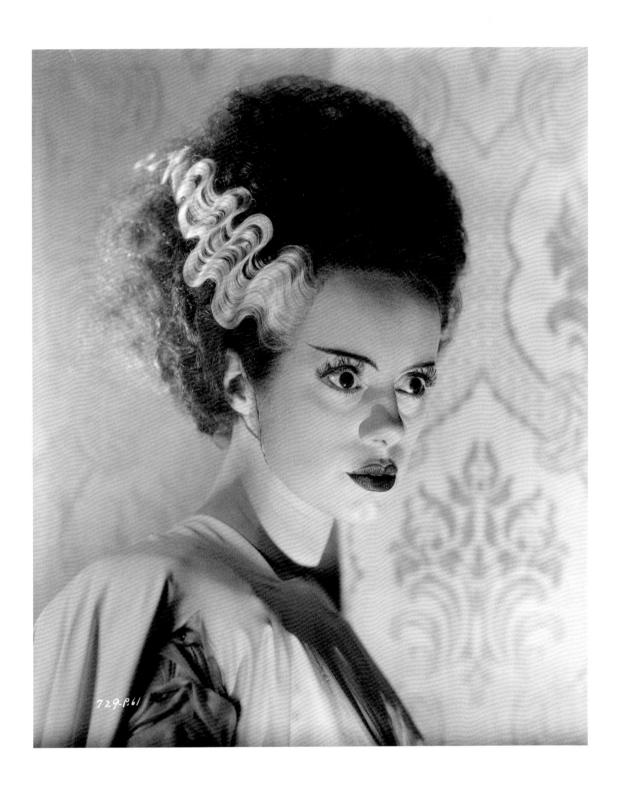

729-P-61

ANGLE ON A HOSPITAL DOOR 66

The upper half of the door is made of glass. On the glass is printed:

B R A I N D E P O S I T A R Y

AFTER 5:00 P.M. SLIP BRAINS

THROUGH SLOT IN DOOR

The SHADOW of a Man can be SEEN silhouetted from inside the Depositary. The Shadow has a large hump on his back.

 CUT TO:

INT. DEPOSITARY - NIGHT 67

LOW THUNDER

A row of brains in jars, under domes, rests on a long, narrow table.

Igor tiptoes slowly, examining the labels on each glass dom

ALBERTUS MAGNUS CORNELIUS AGRIPPA LAWRENCE TALBOT
 (Physicist) (Natural Philosopher) (Hematologist)

Then he comes to:

 HANS DELBRUCK
 (Scientist & Saint)

Igor approaches the glass dome, lifts it off, and takes the jar containing the brain of Hans Delbruck.

As he turns to go, he SEES HIMSELF in a full length mirror. He drops the jar in fright.

He looks down and sees the gooky mess of brain and glass.

He looks at the Movie Audience.

 IGOR
 Funny thing is...I tried!

He looks quickly at the "Brain Table," grabs a jar from under the glass dome nearest to him and leaves.

On the glass dome -- whose contents Igor has just taken -- printed:

 DO NOT USE THIS BRAIN!

 "ABNORMAL"

 CUT TO:

Screenplay for *Young Frankenstein*, 1974

IN A SCENE from James Whale's 1931 *Frankenstein*, before Henry and Elizabeth are to be married, Baron Frankenstein toasts their future: "A son to the house of Frankenstein! To young Frankenstein!" he calls out, and all echo him. *Young Frankenstein*, the 1974 comedy by Mel Brooks and Gene Wilder, is that son, or rather great grandson, and the most delightful of Frankenstein's progeny. Its faithfulness to the original is truly filial—though *mutatis mutandi*, the necessary changes being made, for the fact that it is a comedy directed by one of the bawdiest, and two of the funniest men ever to work in the movie industry. They went to great lengths to reproduce the look of the 1931 original, shooting in black and white, rebuilding the set, and incorporating the faux scientific equipment that Kenneth Strickfaden had fabricated for Whale forty-three years earlier. At the same time, there is more of Mary Shelley in *Young Frankenstein* than in Whale's films: Gene Wilder, as the neurosurgeon Frederick Frankenstein, hears the anecdote of Dr. Darwin and the vermicelli from a smarty-pants student (see p. 74). Later, as he embraces his legacy, he reads aloud from the novel itself, though the book he holds is titled *How I Did It*, by Victor Frankenstein. The biggest change, however, stems from the fact that comedies end with weddings. *Young Frankenstein* has two—Gene Wilder marries his lovely assistant, Inge, played by Teri Garr, while Peter Boyle, as the creature, gets Madeline Kahn, formerly affianced to Dr. Frankenstein.

The face of Abby Normal

WILLIAM TUTTLE, the makeup artist on *Young Fran-kenstein,* had a less daunting task than Jack Pierce did in 1931: Peter Boyle never looks as different from himself as Boris Karloff does. While Brooks heightened the joke about the creature's abnormal criminal brain with Marty Feldman's lines about its source, "Abby someone . . . Abby Normal," from the beginning Boyle's character is gentler and more intelligent than Karloff's—there's no wax on his eyelids, and indeed his eyes are full of understanding and curiosity. He is gifted, moreover, with an enormous *schwanstücker,* a faux-German word coined by Mel Brooks to signify exactly what you are thinking. In the course of the film he kidnaps Madeline Kahn, who plays Elizabeth, Frankenstein's fiancée. To Gene Wilder she is a prude—"No tongue!" she chides before their goodnight kiss. When the creature carries her off with the strong implication that he intends to rape her, she screams. But soon, indeed momentarily, she signifies how impressed she is and then sings out that favorite from *Naughty Marietta,* "Ah, sweet mystery of life! At last I've found you." Cut to the creature and Elizabeth sharing cigarettes. There is a danger that the whole film will turn into a penis joke, and it is astonishing that Brooks and Wilder have managed to make rape funny—except that in this world, it's not rape. The gain for the female characters is that at least they do not have to faint or die. For the creature, there is a far better reward at the end of the film.

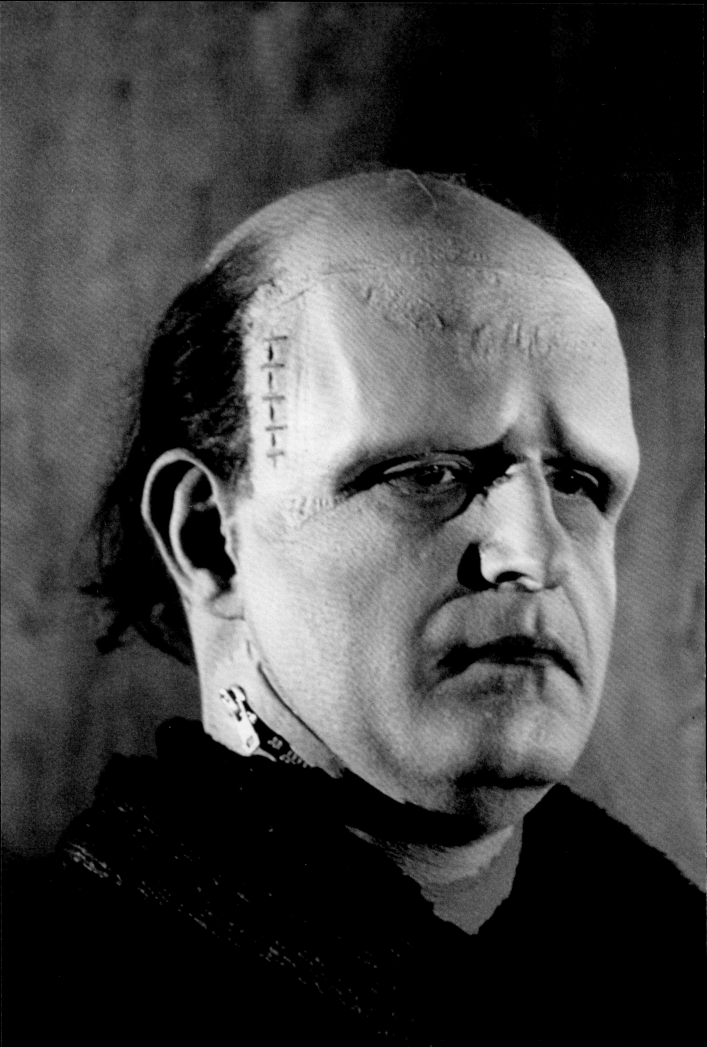

Peter Boyle in *Young Frankenstein*

WHEN Gene Wilder embraces his destiny as a Frankenstein, he is sure that love will save the creature. He hugs him close, telling him in the voice of the 1970s, "You are not evil! You . . . are . . . *good!*" The creature's first step in rehabilitation is to become, far more than Boris Karloff was, a dog. Wilder shows him off at the Bucharest Academy of Science, beginning with tricks rewarded with a doggie treat and ending with *Puttin' on the Ritz* in full evening dress, the creature barking like a singing canine. But Wilder goes further than earlier Frankensteins, deciding to cure the creature's "imbalance in the cerebral spinal fluid" with his own. They lie down on twin tables, metal caps wired up to Strickfaden's equipment, and trade fluids. When the villagers rush in to kill the creature, they first seize Gene Wilder. Peter Boyle, still strapped to his table, commands them to put him down. Rising, and suddenly articulate, he redeems the genre for all the little kids who pitied Boris Karloff, saying: "For as long as I can remember, people have hated me. They looked at my face and my body, and they ran away in horror." Frankenstein alone "held an image of me as something beautiful." Mel Brooks doesn't let redemption become sappy; the creature is last seen as a bored husband in half glasses and leopard print pajamas, reading the *Wall Street Journal*, while Madeline Kahn, her hair in full Elsa Lanchester glory, vamps it up.

Robert De Niro in
Mary Shelley's Frankenstein, 1994

Other productions of *Frankenstein* take the novel more seriously. The photograph of De Niro in his makeup reminds us that living things have beauty simply by virtue of being alive. This is one of the points of Mary Shelley's novel brought out by Kenneth Branagh's 1994 film, which aims at a more faithful translation to the screen. Branagh plays Frankenstein and De Niro the creature, with Elizabeth played by Helena Bonham Carter. Branagh's laboratory is hardly Mary Shelley's; he used everything Kenneth Strickfaden ever threw at the screen and much, much more. It is hard not to love a film with so many good actors, but the overwrought emotions on everyone's shouting lips and the stupidity of the primary characters—the creature excepted—are nearly unbearable. Despite his pretensions to fidelity, Branagh had the creature rip out Elizabeth's heart; Frankenstein then brings her back to life. The film's real contributions to cinema are the ugliness of De Niro's makeup (see the next illustration) and that of Helena Bonham Carter as the revitalized Elizabeth. Like a scabby, one-eyed doll, patches of raw skin dotting her almost bald scalp, she reaches out to De Niro's stitches and touches her own as she realizes what's become of her. It's almost a tender scene, but its effect vanishes when she immolates herself and sets the mansion on fire.

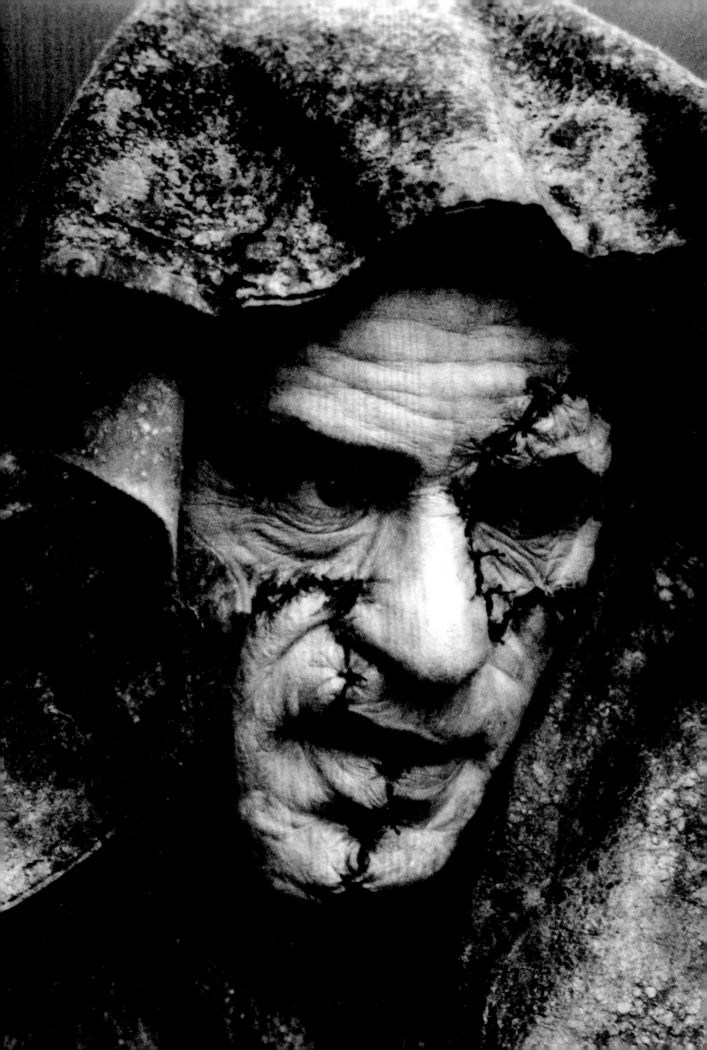

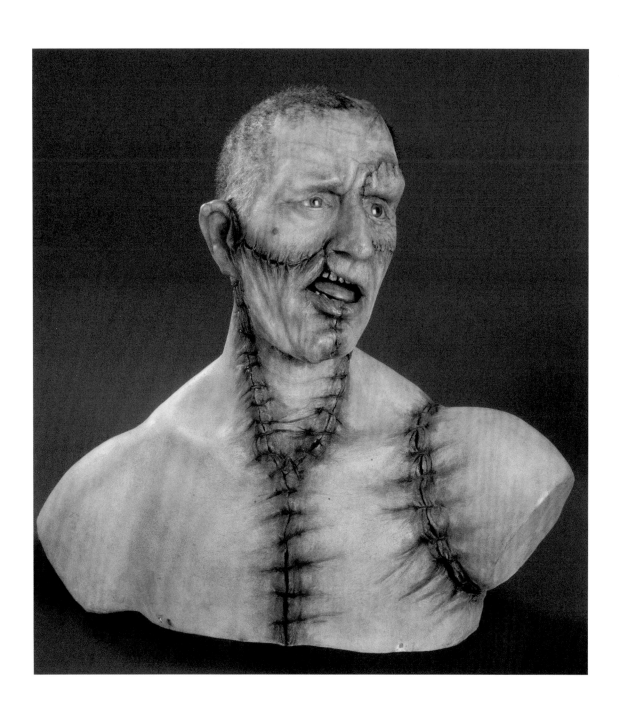

Torso model of the creature, 1994

THE CREATURE, like the Buddha, teaches us that to be is to suffer. But also: "As, in water, face answers face, so is the heart of man to man" (Proverbs 27:19). In the novel Victor Frankenstein says, twice, that the creature is too horrible for human eyes. But the creature shows us that nothing is too horrible for human eyes, both in the sense that human eyes have seen the worst and human beings have committed the worst. Human eyes can bear anything, but only up to a certain point. The face on the model for Robert De Niro's makeup is twisted in pain that might make one turn away. The closest thing to a real creature in this book, it was fabricated by Daniel Parker and the staff of his special effects firm, Animated Extras. He earned an Academy Award nomination for this makeup concept, complicated by the suggestion that the creature's grafted body parts should heal in the course of the film—an agonizing process beginning with horrifying open wounds. Then the blood clots, the wounds close, and the stitches fall out, leaving the creature a patchwork of cicatrices where he had been pieced together.

PART III:
ICONIC SCENES

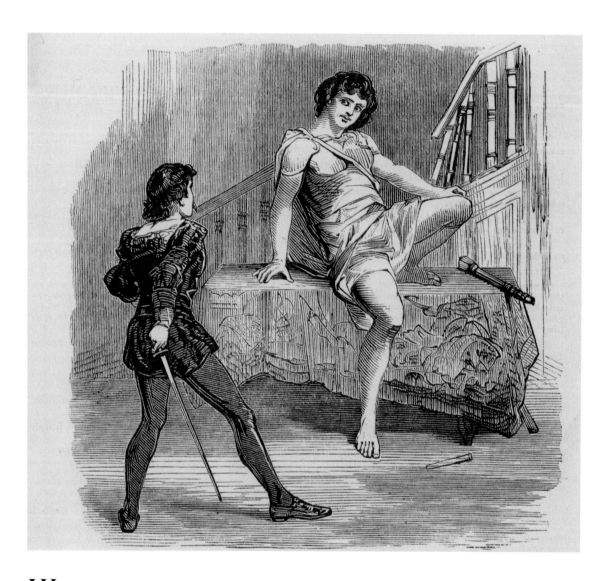

Illustration in

Frankenstein: A Romantic Drama

1. THE CREATION

THE ASSEMBLAGE AND VITALIZATION of the creature in *Frankenstein* depend on magical thinking. The events portrayed are impossible, now as in Mary Shelley's time. While, as mentioned in the general introduction, this creates narrative difficulty, artists rewriting or re-creating the moment have great freedom. Shelley turned to the sources for body parts she knew from her experience—the gibbet, the abattoir, the charnel house, the grave. James Whale used the first and last of these and added the lecture hall at the Ingolstadt Medical College, from which his clumsy servant, Fritz, steals the criminal brain. Early theatrical versions evaded the difficulty by showing Fritz as he watched the creation, indicated by colored flashes of light through a window and described in words taken straight from Shelley's novel. The agent of vitalization is, of course, pure magic, which is why it was so easy for dramatists to turn to alchemy and Doctor Faustus. In this frontispiece from a later edition of Richard Brinsley Peake's 1823 play, issued sometime between 1863 and 1878, evasiveness is taken as far as it can go: the sprightly monster rises from the covered table upon which he's been napping. He has a hint of a moustache and a torn toga, but there is not the slightest hint of monstrosity. Perhaps years of seeing the creature as a figure for burlesque informed the illustrator's vision; *Frankenstein* can be very funny.

Illustration in *John Dough and the Cherub*, 1906

*J*ohn Dough and the Cherub is a novel for children by L. Frank Baum, already famous for *The Wonderful Wizard of Oz* when this was published in 1906. John Dough, the adult-sized gingerbread man, is accidentally vivified when the baker mixes into his dough the elixir of life his wife has carelessly left on the counter. "Of course the face was made of the white dough, with just a trifle of the pink coloring mixed into it to make it resemble real flesh." Baking is a quick, easy, and, here, implicitly racist way to make an unfrightening creature. But the shock on the baker's face is convincing. The creature's strangeness, though tamed, is hard to take; the folk story on which *John Dough* is based, with its refrain "Run, run, as fast as you can, / You can't catch me, I'm the gingerbread man!" is itself rather creepy. The novel, which takes John Dough on a rocket to the Isle of Phreex, where he has adventures with the eponymous cherub, better known as Chick the Incubator Baby, has all the peculiarity of *The Wizard of Oz* without being as resonant either with children or adults.

Special effects in the Edison Studios, 1910

J. SEARLE DAWLEY's very free adaptation of the novel gives us another creature produced by cookery, this one emerging from a vat. While Mary Shelley made much of Frankenstein's work on the creature, the film (around fifteen minutes long) reduces this to showing Frankenstein prancing about his college room in excitement. And while the creation may seem tame now—the creature's arms are obviously being manipulated with wires—Dawley's cauldron nonetheless has a frontward orientation few other films have used and gives the audience a chance to watch the creature come to life face to face. The smoke and steam, the genuinely strange (if not scary) creature, and the intercuts between the vat and Frankenstein's tidy college room just beyond work together to vest the scene with a lasting weirdness of its own.

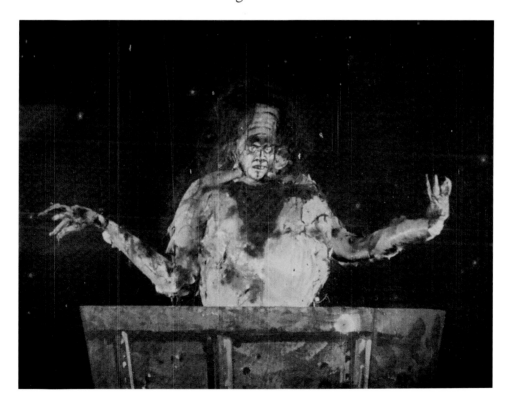

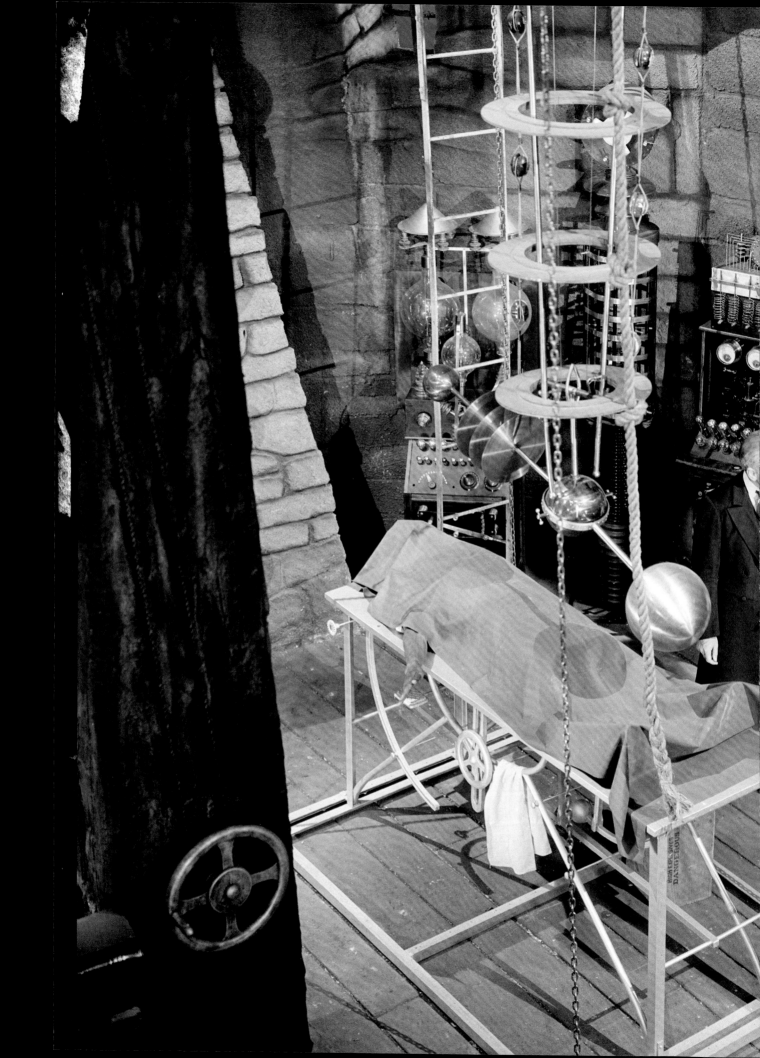

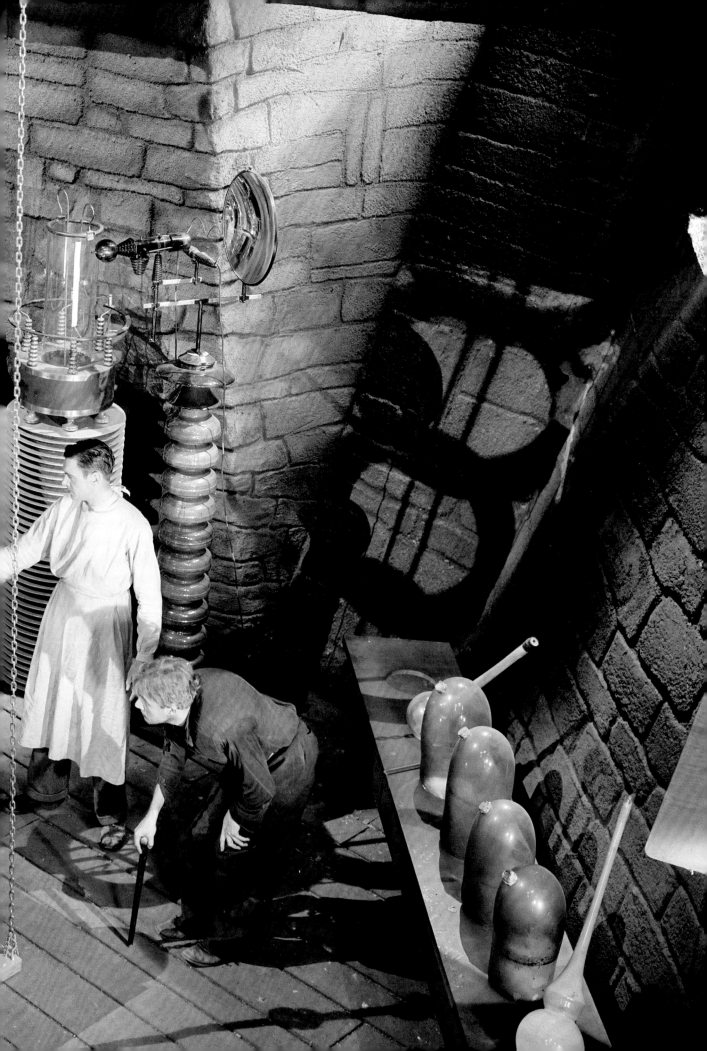

James Whale's treatment, 1931

THE CREATURE under wraps is as mysterious as any fetus in the days before ultrasound. For both Mary Shelley's and James Whale's avatars of the creature, his repellence is a disability as obstructive as a missing limb or a disfiguring disease. In the novel, his skin is yellow. Shelley's biographer Miranda Seymour sees as this as a possible recollection of the Lascars, i.e., indentured Asian or Arab sailors whom the young Mary Godwin might have seen working on the docks of Dundee. In the plays he is blue, and in Whale's films, blue-green shot for gray, although on lobby posters his face is green. All this is to say that Frankenstein's creature is not white. John Dough and the monster in the ca. 1863–78 edition of Peake, who *are* white, make the point even more clearly: their whiteness is part of why they're not scary. As we've seen from the playbill that included *Jonathan in England* (p. 202), racist stereotypes were fully formed by the 1820s. While the racism latent in the image of the yellow, blue, or green creature mostly remains latent, a black Frankenstein's creature ran through American print culture in cartoons and essays of the later nineteenth century.[24] For many viewers, it is difficult to see the last scene of Whale's film—in which the creature, chased by a mob with torches and baying bloodhounds, is cornered and burned alive—without feeling that one is watching a lynch mob.

◀ See illustration on pages 256–57.

2. CREATURE AND CHILD
Strike me, but spare my son!

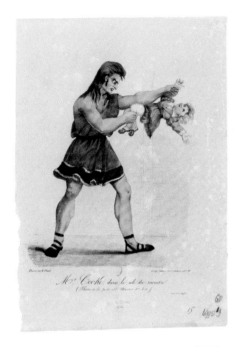

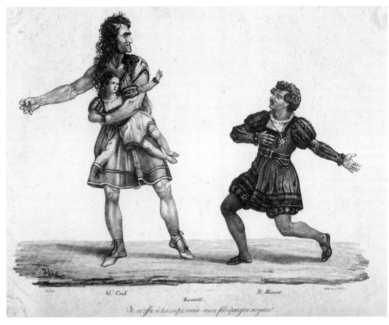

T HE EARLY THEATRICAL adaptations present the crea-
ture's murderous nature unambiguously. In Peake's *Presump-
tion! or, The Fate of Frankenstein*, little William is killed offstage af-
ter the creature kidnaps him late in the play. Hard on the heels
of that murder comes the death of Frankenstein's fiancée. After
that, all that remains is to dispatch Frankenstein and the monster.
(Mary Shelley was right when she said the story was badly man-
aged.) *Le Monstre et le magicien* makes a little more of the scene with
the child actor, with Zametti the magician pleading for his six-
year-old Antonio's life and offering himself up to the creature's
rage, only for the creature to escape over a wall with Antonio
(played in the first production by Mlle Charlotte Bordes). The
two lithographed scenes shown here are probably from the same
successful 1826 Parisian production. The one on the left, in color,
makes the most of the creature's violence. He seems about to tear
Antonio limb from limb, while the other emphasizes the crea-
ture's physical strength. Both show T. P. Cooke in action.

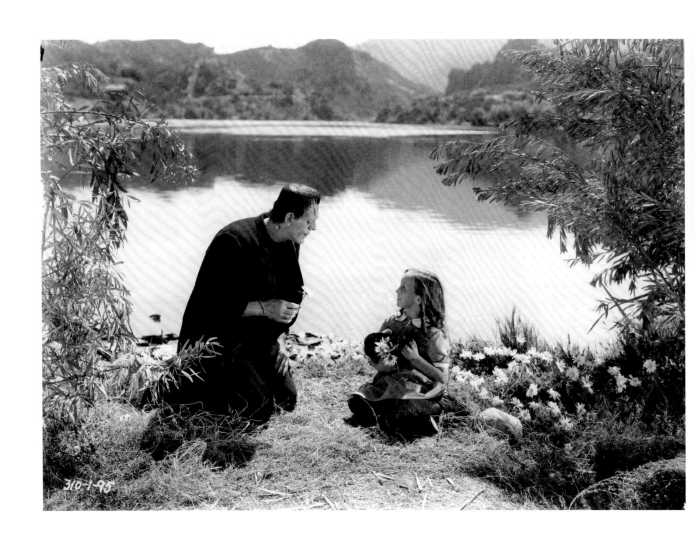

Boris Karloff and Marilyn Harris, 1931

MARILYN HARRIS, whom the creature unwittingly drowns in the 1931 *Frankenstein,* was a true child of Hollywood, born in Los Angeles and placed in an orphanage there. The woman who adopted her longed for a career in the movies but lacked beauty or talent. As Harris told the story years later, her adoptive mother "went to the orphanage, and said, 'I want the prettiest, blondest, blue-eyed baby you've got.' In those days you could do that."[25] Unlike her co-star Mae Clarke, Harris had no fear of Boris Karloff in his makeup and shared the car ride with him to Sherwood Lake in the Santa Monica Hills where the scene was shot. She failed to sink properly on her first try, and Karloff had to hurl her into the water again, with Marilyn making sure she stayed under long enough. Whale was satisfied with the second take, but Mrs. Harris, watching from the sides, encouraged him to take another, shouting "Throw her in again! Farther!" The scene was one of those most often cut by censors, who were either more tender-hearted than early-nineteenth-century audiences or less accustomed to the fact that children, too, are mortal.

Peter Boyle and Anne Beesley, 1974

IN THE COMEDIC WORLD of *Young Frankenstein* there is no room for the death of a child—so while the audience sees Peter Boyle stare meaningfully down the mouth of a well when Anne Beesley, in the role of his child playmate, little Heidi, asks "What shall we do next?" the following scene shows him plunking her on a seesaw that catapults her through her bedroom window and safely into bed just as her anxious parents check on her.

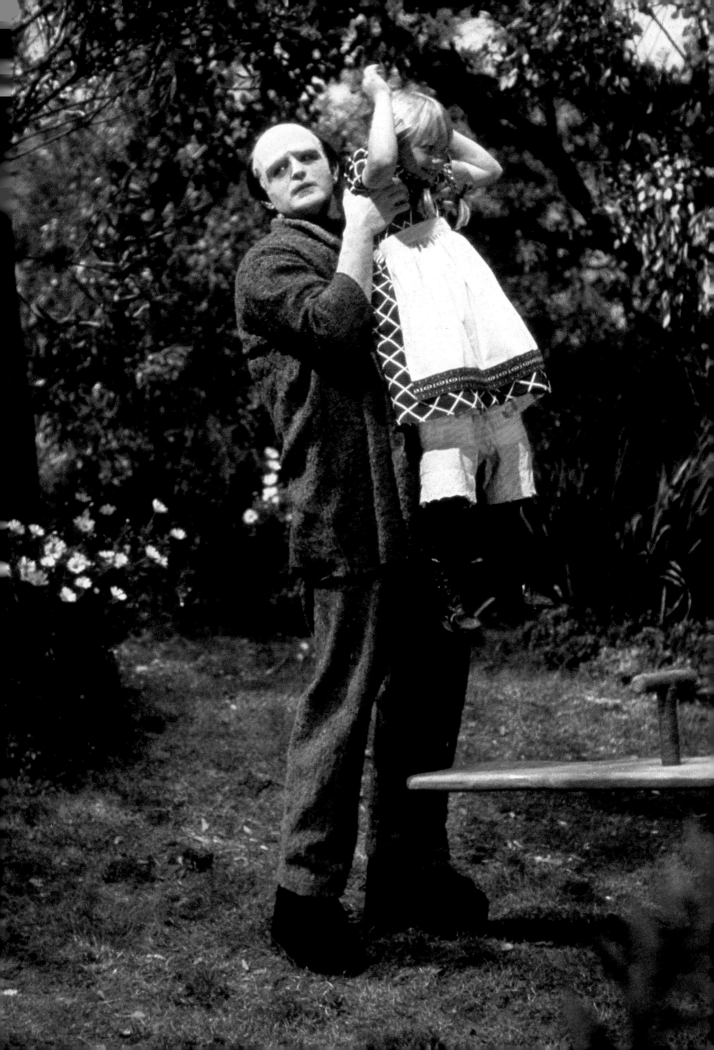

3. THE WOMAN ON THE BED

Death and the maiden

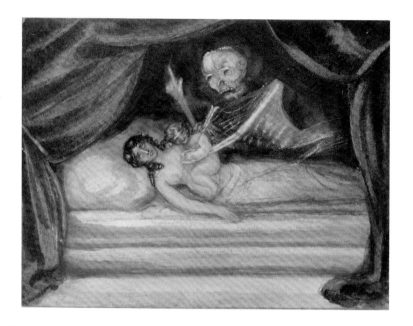

"LITTLE BY LITTLE dead women, suffering women, women who are torn, have appeared before me; it was like an immense plot coming out of the depths of time, created to make one see these women preyed on by their womanhood." So writes Catherine Clément in *Opera; or, The Undoing of Women.*[26] It is a point that Mary Wollstonecraft might have made. In her time, the model for the dying woman was Clarissa Harlowe, the eponymous heroine of Samuel Richardson's 1748 novel, who fades into death after she has been raped. Wollstonecraft's daughter Mary Shelley lived in a culture that made it easy to believe the death of a beautiful woman to be "unquestionably the most poetical topic in the world," as Edgar Allan Poe put it.[27] A creepy, sexy deathliness touches female characters across the decades, from Fuseli's *Nightmare,* illustrated in Chapter 1, to Poe's poetics, Puccini's *La Bohème,* or this watercolor by Lady Caroline Lamb, to name just a few of many possible examples. The beauty of a dead woman, or at least an unconscious woman, has been used by almost every director who has filmed *Frankenstein,* and many of the staged versions as well. The trope of death and the maiden is alive and well.

Beauty and the brute

JAMES WHALE's production makes Elizabeth Lavenza lovely, although the train of her dress is so long that it's already a joke. Boris Karloff's creature lurks outside, the signs of his violence all about the room. In the novel, Mary Shelley's most striking use of the imagery of death comes directly after Frankenstein has vivified the creature. After describing the creature's appearance, his attempt at making beauty having resulted in something hideous, Victor describes his disappointment: "the beauty of the dream vanished, and breathless horror and disgust filled my heart." He abandons the creature and goes to his room, where, after some pacing, he falls asleep, and has an all too explicit dream. In it he kisses Elizabeth Lavenza, only to have her lips go livid; in his arms she becomes the worm-eaten corpse of his mother. Victor wakes, nearly dead himself: "a cold dew covered my forehead," his teeth are chattering, his limbs are convulsed, when "by the dim and yellow light of the moon" he beholds the wretch looking at him. Victor's shaken body in the yellow moonlight mirrors the creature's, whose life began with a convulsive movement of his limbs, a gasping breath, and the opening of his "dull yellow eye." Victor's dream knots together himself, the creature, his mother, and his beloved. The implication of Elizabeth's transformation to a corpse when Victor has just transformed a corpse to something living is clear: no matter what he's achieved, death is the way of all flesh. And whatever one's gender, no matter how one's hair is draped, there is nothing attractive about this final lassitude.

❡ See illustration on pages 266–67.

Dust jacket of the photoplay edition, ca. 1931

UNIVERSAL STUDIOS made the image of the unconscious Elizabeth an important part of its advertising strategy. It appears in posters, the production still shown on the preceding pages, and movie tie-ins such as this photoplay edition, a reprint of the novel illustrated with scenes from the film. The dust jacket artwork brings Elizabeth together with the creature—she lovely and limp; he watchful and repellent. The conjunction makes the creature a voyeur and emphasizes the threat of rape. Elizabeth's dress touches the ground as her feet never will again in the novel. In the film she survives to marry Frankenstein and to escape again in the 1935 *Bride of Frankenstein*. This dust jacket, in three distinct fields, perhaps inspired by contemporary Soviet movie posters, allows for both possibilities. Taken in altogether, the image only slowly comes to make sense: of its three separate fields, Karloff's huge head is the most striking. After looking at him the viewer's eye is drawn down to Elizabeth's body, the negative space of the coverlet pointing like a green chin back up at the creature. Only then does one's eye come to rest on the title banner, and perhaps only then is it fully clear that this is a book cover, not a poster.

More deathbed scenes

LYND WARD's wood engraving of 1934 shows a sharper-edged Elizabeth than the cover of this pulp fiction paper-back edition, but both images are about equally interested in Elizabeth's syncope and her breasts. Ken Russell's film *Gothic* (1986), which imagines the whole summer on Lake Geneva, takes the idea to its logical extreme and shows not just an un-conscious woman on her bed (in that case it's Mary Shelley) but a tableau of Fuseli's *Nightmare*.[28] The paperback shows that the combination of death and sex, free of any narrative consideration, will always sell a book. The creature's staring at his hands, his street clothes, and the odd barracks-like inte-rior would have appealed to readers in 1953, when that book appeared. Mary Shelley's relationship to the dead (or unconscious) woman on the bed is tragically direct. She was intimately connected with all too many women who had been laid out as corpses: her mother, her two baby daughters, her half sister, and P. B. Shelley's first wife. The latter two died while she was composing *Frankenstein*. While there is no space here to parse her feelings minutely (though her letters and journals make that possible), we know that Mary Shelley had a large pool of sorrow from which to draw for the novel.

THE GREATEST HORROR STORY OF THEM ALL

FRANKENSTEIN

MARY
SHELLEY

25c

146
A LION BOOK
COMPLETE AND UNABRIDGED

Ernest Thesiger, Elsa Lanchester, and Colin Clive in *The Bride of Frankenstein*

FINALLY, here is a figure who combines both the creature on the table and the lovely woman laid out in death—Elsa Lanchester, "bound in yards and yards of bandage most carefully wound by the studio nurse," as the bride of Frankenstein's monster.[29] Her disposition on the table, vertical for the best view, is pure cheesecake, an easy maneuver around the code. James Whale and the writers of *The Bride of Frankenstein* were by no means humorless, and it is hard not to think that this combination of mummy and pinup girl was meant for anything but fun.

NOTES

1. Quoted in Forry 1990, p. 5.

2. Shelley 1980, Vol. 1, p. 378, to Leigh Hunt, 9–11 September 1823.

3. Forry 1990, p. 34.

4. Both reprinted in Forry 1990.

5. Forry 1990, p. 17.

6. Quoted in Forry 1990, p. 17.

7. See Forry 1990, p. 25, and Biger 2014.

8. Shelley 1980, Vol. 1, p. 378.

9. Peake, *Frank-in-Steam; or, The Modern Promise to Pay,* in Forry 1990, p. 182.

10. Curtis 1998, p. 146.

11. Jacobs 2011, p. 106.

12. Interview with Pierce quoted in Jacobs 2011, p. 93.

13 Jacobs 2011, p. 93, and Curtis 1998, pp. 138–39.

14. Quoted in Curtis 1998, p. 144.

15. Jack Latham, quoted in Jacobs 2011, p. 170.

16. Curtis 1998, pp. 140 and 142.

17. Jacobs 2011, p. 96.

18. Lanchester 1983, p. 134.

19. Quoted in Jacobs 2011, p. 174.

20. Jacobs 2011, p. 171.

21. Lanchester 1983, p. 136.

22. Lanchester 1983, p. 135.

23. Lanchester 1983, p. 79.

24. Young 2008.

25. Jacobs 2011, p. 100.

26. Clément 1988, p. 9.

27. Poe 1846.

28. On Ken Russell's film, see Frayling and Myrone 2006, p. 212.

29. Lanchester 1983, p. 135.

CHAPTER 8

FRANKENSTEIN DELINEATED

ANY ILLUSTRATION, no matter where it falls on the continuum between "commercial" and "pure" art, is a new imagining of the target work. With *Frankenstein* those reimaginings force artists to oscillate between two pairs of poles: first, on the one hand, immense freedom from the novel's being out of copyright and the vagueness with which creature and the creation are described; on the other hand, the copyright Universal Studios holds until 2026 on Jack Pierce's design for that familiar flat head. Artists can tell the story with any variations they like but cannot make their creatures look too much like Karloff. Second, there are the poles between the primary reactions Frankenstein's creation provokes: does the artist want to evoke horror or pity? If horror *and* pity, in what proportion? Do we call it monster or creature? Do we give it a name? The choices made among these options lead quickly to decisions about how to portray the creature, but the most important element is the first, the freedom allowed by the narrative and the creature's independence from it.

Frankenstein's creature was detached from the novel during Mary Shelley's lifetime. In the 1830s he already appeared in cartoons; in 1860 Frederick Douglass spoke of slavery as "everywhere the pet monster of the American people."[1] John Tenniel, best known for his *Alice in Wonderland* illustrations, used the creature in political cartoons three times: in 1854 as the Russians, just as the Crimean War began; in 1866 as the Brummagem (i.e., Birmingham) Frankenstein, representing the monstrous prospect of universal manhood suffrage; and in 1882 as the Irish Frankenstein contra the Irish nationalist movement. In 1968 the comedian Dick Gregory turned to James Whale's film to describe the riots in American cities sparked by racism and police violence: "Only now in the city of chaos are we seeing the monster created by oppression turn upon its creator."[2] In our time, cloning, stem cell research, and genetically modified foods have all been tarred with the name of Frankenstein. It is never a compliment. I invoke these examples—and could invoke many more—partly to indicate the areas of our culture that will not be explored in this book. Taking in illustrations, cartoons, comic books, and movie posters, this chapter could easily be four. We are therefore forced to be selective and concise. They are arranged in ascending order of their expected staying power. We hope that even a brief look at depictions of the creature "too horrible for human eyes" will let us take some measure of him as he moves away in time from his creator.

Movie posters have been particularly vulnerable because from 1940 to 1984 they were, in the United States, furnished by the National Screen Service, which required theaters to return them after a film's run for use in other theaters. Before 1940, studios sent them along with

reels of film on buses from theater to theater. Many of those that survive come from countries outside the United States, where the return of posters was not required. They became collectors' items in the late twentieth century, and both of James Whale's *Frankenstein* films appear on an early-twenty-first-century list of the most valuable movie posters. Having looked at the best of the early *Frankenstein* films in the last chapter, we have here chosen posters for films ranging from the comic to the execrable. In B movies we see *Frankenstein* at its most protean: beyond the persistence of the unnaturally made creature, these films varied enormously. The late 1950s and 1960s were their heyday, and as Anglo-American social mores loosened, films became bloodier and the focus of interest shifted to Frankenstein. This is especially true of the British series made by Hammer Film Productions between 1957 and 1974, in which Peter Cushing's doctor was the audience draw. I am sorry not to include a poster to show off Cushing's hollow-cheeked elegance, but none was to be had from the sources available to us.

The cartoons are taken from *The New Yorker* (1925–present) and *Punch* (1841–1992, 1996–2002). *The New Yorker* has long been, and *Punch* long was, the most prestigious publication for cartoons in the United States and the United Kingdom, respectively (although a number of important cartoonists have eschewed both). Both magazines constituted a sort of home-in-print for a considerable swath of their readers, who found them as comfortable as but much more interesting than an old flannel bathrobe. For many Americans, to read *The New Yorker* is to read the magazine of one's childhood, and for many, finding something to read *besides* the cartoons was a step toward adulthood. *Punch* held a similar position for Britons. The monsters who show up there are almost without exception made safe and tell us something about what their target audience finds comfortable and homely.

The level of honor given to comic books is disproportionate to the amount of labor they entail: rarely have so many artists worked so long for so little respect. But the medium is sturdy, immersive, and much loved. The early twenty-first century in the United States has been a golden moment for mordant, dystopic, politically conscious comic books. They were all of these things at the time of their invention in the 1930s, too, but were subjected to heavy censorship in 1954. Niche marketing and direct distribution have made idiosyncrasy once again viable in comic book writing and have produced publications that are once again safe for grownups. We look at a selection from across the history of the medium.

Finally we have chosen three illustrators, not as representatives but because these three— Lynd Ward, Bernie Wrightson, and Barry Moser—are still the most prominent to take on the novel since 1831. Perhaps the obvious explanation for this is the truest: since the late nineteenth century, illustrated novels for adults have been extremely uncommon. The division between stories with pictures and those without is entirely generational at present. It's no accident that the reputations of two of the men shown here were gained for work separate from illustration: Lynd Ward is remembered first of all as a wood engraver and as the maker of novels without words, while Bernie Wrightson, a renowned comic book artist, illustrated *Frankenstein* between

paying gigs. Only Barry Moser is known primarily as an illustrator—"probably the most im-
portant book illustrator working in America today."[3] He made this place for himself through
talent, perseverance, and the oldest-fashioned of ways: he controls the means of production,
the Pennyroyal Press, which publishes beautiful and careful editions of Moser's work. He
founded it with the help of the master printer Harold McGrath, to whom, in 1974, Leonard
Baskin had given the equipment of his Gehenna Press. Moser has kept the press going with
a series of ingenious fund-raising plans and finding the right patrons at the right time. Even
when you are your own publisher, making beautiful books without an independent fortune
requires a great deal of strategic thought. *Frankenstein*, for instance, was envisioned from the
start to come out not just from Pennyroyal Press but in a trade edition as well, in this case
from the University of California Press. Moser had less control over this: of the four essays
he had commissioned from experts in their fields, only Joyce Carol Oates's was retained. For
the UC Press, Moser's illustrations were the point, and they are all there.

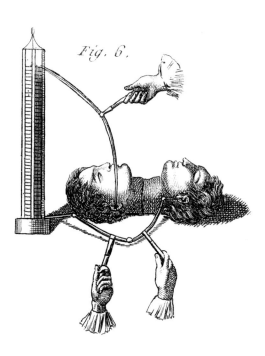

1. MOVIE POSTERS

Abbott and Costello Meet Frankenstein, 1948

T HE ONCE-RADIANT STAR of Bud Abbott and Lou Costello, a comedy team since the 1930s, was waning in 1948 when this film came out. Most famous for their quick-talking baseball routine, "Who's on first?" their comic personae had been long established: Costello, the heavyset one, was easily frightened and not too bright, while Abbott was the clever, sarcastic straight man. They had done scary comedies before, such as *Hold that Ghost* (1941); *Abbott and Costello Meet Frankenstein* capitalized on Universal's franchise of major monsters. Despite the title, Abbott and Costello meet not only Frankenstein's monster (portrayed by Glenn Strange) but also Dracula (Bela Lugosi) and the Wolfman (Lon Chaney, Jr.), all playing their parts straight. The laughter comes from tightly timed physical comedy and Lou Costello's rubber-faced registry of fear. The poster includes all three monsters and conveys a chase with a swift comma-shaped curve down the page. Abbott and Costello's reality (as opposed to the creature's imaginary nature) is signified by their photographs bursting into the safe yellow daylight, while the cartoon monsters run through a dark blue night. The film was a hit. In subsequent movies, Abbott and Costello met the Invisible Man, Dr. Jekyll and Mr. Hyde, Captain Kidd, the Mummy, the Killer, and the Keystone Kops—quite a cocktail party. Frankenstein's monster doesn't have much to do; he stumbles and crashes about, with nothing pitiful about him.

It's a grand New Idea for FUN!

UNIVERSAL-INTERNATIONAL presents

BUD **ABBOTT** and LOU **COSTELLO** meet **FRANKENSTEIN**

WITH

The Wolfman PLAYED BY LON CHANEY

Dracula PLAYED BY BELA LUGOSI

The Monster PLAYED BY GLENN STRANGE

LENORE AUBERT · JANE RANDOLPH

Original Screenplay by Robert Lees ... Frederic Rinaldo ... John Grant

DIRECTED BY CHAS T. BARTON · PRODUCED BY ROBERT ARTHUR

Universal International

Bride of the Monster, 1956

IN 1953, when this film began shooting, the currency of *Frankenstein* was so widespread that the famously dreadful Edward D. Wood, Jr., could make *Bride of the Monster* without Frankenstein's monster. In the poster we see Bela Lugosi as an atomic scientist carrying off the busty Loretta King, an intrepid reporter. Lugosi's energy was remarkable at age seventy-four; he was famous for the dedication he brought to all his roles. At Lugosi's house, King is nonplussed by the Tibetan servant, Lobo, played by the Swede Tor Johnson, a 6'3" former wrestler. We are led to fear this mute, towering, and barefoot figure as the monster. This is the cleverest part of the plot, since the actual monster, visible on the poster to the left of the capital *M*, is the annoyed octopus. This is the intended groom for King's character. She is saved by her craven policeman boyfriend. The creature, however, is still swimming in Lake Marsh. Wood's reputation as the worst director in Hollywood history was honestly earned, and for this film, he shot perhaps fifteen seconds of a small octopus in an aquarium—the best fifteen seconds of the film. He then sprang for the fabrication of a fake octopus, big enough to kill a man. The budget did not extend to mechanization, however, and victims had to supply their own flailing. In the mayhem of the police shooting at the octopus and the virtuous characters escaping, an atomic bomb goes off, harming only the guilty, and bringing the film to an end.

I Was a Teenage Frankenstein, 1958

I Was a Teenage Frankenstein gives us a victimized creature and a Dr. Frankenstein—the condescending Whit Bissell—whose wickedness is established when he feeds his fiancée to the alligator in the basement. The creature's ugliness comes only from his face, disfigured in a fatal car accident. Gary Coates's body retains its beach-Adonis beauty while his head is covered with a grotesque clay mask. This was too heavy to allow him to speak comprehensibly, so more often we see him in makeup that approximates the mask rather badly. Bissell's doctor delivers lines appealing to adolescent sarcasm such as "Speak, my boy! You have a civil tongue in your head. I know you have because I sewed it back myself," and, when the creature weeps upon seeing his face, "It seems we have a very sensitive teenager on our hands." This insistence on the creature's articulacy and the doctor's constant addressing him as "boy" effectively humanize him, and he wreaks minimal damage. Midway through, he is given a face transplant that restores his natural good looks. Entranced by the mirror, held prisoner by the doctor, the creature is, in effect, no longer dead—except that, as the creature, he must die. Like so many B-movie monsters, he goes out in a flurry of sparks, electrocuted on the lab equipment. But the source of the film's fascination, and the primary image of the poster, is the boy's ugliness. The director, Herbert Strock, splurged on shooting the final thirty seconds in color. Much of that time is given to a static shot of the creature's sad and hideous mask, while the audience's last look falls on the alligator gnawing Frankenstein's empty lab coat.

BODY OF A BOY!
MIND OF A MONSTER!
SOUL OF AN UNEARTHLY THING!

I WAS A
TEENAGE
FRANKENSTEIN

starring

WHIT BISSELL · PHYLLIS COATES · ROBERT BURTON · GARY CONWAY

Produced by HERMAN COHEN · Directed by HERBERT L. STROCK · Screenplay by KENNETH LANGTRY

A JAMES H. NICHOLSON-SAMUEL Z. ARKOFF PRODUCTION · AN AMERICAN INTERNATIONAL PICTURE

PRINTED IN U.S.A.
57-600

Frankenstein 1970

Frankenstein 1970 is a B movie of 1958, incoherent enough that the poster's image conveys nothing more specific than a monster scaring a seminaked woman. There is no effort to imagine 1970 in the film's design or writing. The big selling point— clear from the poster—is Boris Karloff. He plays the last of the Frankensteins, a penniless scientist who rents the family castle to a production company making a Frankenstein movie. Dr. Frankenstein's face has been mutilated by the Nazis, so he is notionally monstrous; but the changes wrought on him are so minor—his left eye has an unpleasant sag—that the effect is completely unfrightening. (One wonders if, after so many hours in Jack Pierce's chair, Karloff resisted anything more.) Nevertheless, the money from renting out the castle allows him to invest in an atomic reactor and carry on where his ancestor left off. The movie crew provides body parts—and extras. The creature is shown swathed in bandages until after the doctor has died. When his face is finally revealed, it is Karloff's, the sagging eye healed—an echo of the novel's conclusion, when creature and creator reunite. *Frankenstein 1970* gives us a doctor who is not ashamed to become his own creature.

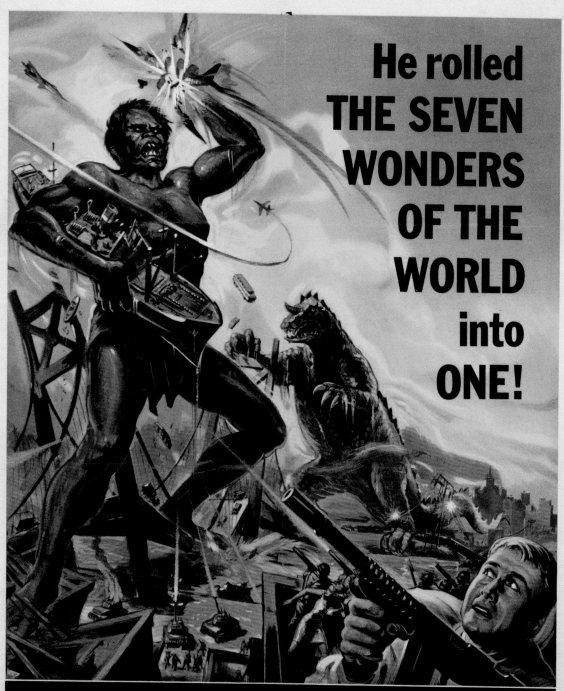

He rolled
THE SEVEN
WONDERS
OF THE
WORLD
into
ONE!

NICK ADAMS

STARRING IN

FRANKENSTEIN
CONQUERS THE WORLD

FROM AMERICAN INTERNATIONAL IN **COLOR**scope

A TOHO CO., LTD., HENRY G. SAPERSTEIN ENTERPRISE PRODUCTION

Frankenstein Conquers the World, 1966

LIKE *Frankenstein 1970* and *Bride of the Monster, Frankenstein Conquers the World* from Tokyo's Toho Studios uses the atom to power the creature's birth. While the atom is peripheral in the others, this production makes it central. The film begins during World War II with a trunk rescued from a German U-boat. A group of scientists open it to reveal the beating heart of Frankenstein's monster. "It can never die," one of them tells us. (Takashi Shimura is among them; though he acted in dozens of films, audiences outside Japan remember him best as the dying bureaucrat in Akira Kurosawa's *Ikiru*, 1952, one of cinema's great performances.) Just then the bomb is dropped on Hiroshima. Fifteen years later, reports of a strange feral boy come to the attention of Nick Adams, an American doctor at the Hiroshima International Institute of Radiotherapeutics. Eventually the boy comes under Adams's care. His nickname is Frankenstein, and he grows to be twenty feet tall, with a head of rough black hair. Once he escapes to roam the Japanese forests, Frankenstein makes himself a toga from animal skins, a bit like T. P. Cooke's costume from the 1820s but more like a cartoon caveman, reminding us that monstrosity is often an archaic version of ourselves. In Mary Shelley's novel, the creature develops and educates himself. As the poster shows, this creature's purpose in life is to expend as much destructive energy on as many objects as possible. After crushing planes, trains, and automobiles, he meets a worthy opponent in the horned monster Baragon, and they fight until the earth swallows them.

Andy Warhol's Frankenstein, 1974

A NADIR IN TASTE, this film, also known as *Flesh for Frankenstein* (the sequel to *Blood for Dracula*), celebrates sex, viscera, and sex with viscera. Naturally it was shot in 3-D. "To know life, Otto, you've got to fuck life in the gallbladder" is its most famous line, spoken by Udo Kier as Frankenstein to his assistant. When you've seen the poster, you've seen the best of *Flesh for Frankenstein,* though the opening scene of the Frankenstein children guillotining a doll has a solemn charm. We include it here as an example of rather good graphic design (in which the 3-D logo was no doubt an obligatory component), and proof of the limitless versatility of Mary Shelley's plot.

Andy Warhol's

FRANKENSTEIN

A Film by
Paul Morrissey

IN
3-D
STEREOVISION

ANDY WARHOL'S "FRANKENSTEIN" • A Film by PAUL MORRISSEY • Starring Joe Dallesandro
Monique Van Vooren • Udo Kier • Introducing Arno Juerging • Dalila Di Lazzaro • Srdjan Zelenovic
A CARLO PONTI – BRAUNSBERG – RASSAM PRODUCTION • COLOR

2. CARTOONS

Charles Addams, 1946

CHARLES ADDAMS's Addams Family cartoons appeared in *The New Yorker* from 1938 until his death in 1988, making him a pioneer in the domestic macabre. Morticia and Gomez and their children, Wednesday and Pugsley, along with Uncle Fester, Cousin Itt, Grandmama, and the servants Lurch and Thing, live in a dilapidated mansion. (It is said to be based on a building at the University of Pennsylvania, where Addams was a student.) The earlier cartoons make them—as here, where they are about to pour boiling oil on carolers—less cozy than the later ones. The Addams character closest to Frankenstein's creature is Lurch, the butler, whose squared-off head and bangs resemble those of Boris Karloff. The historian of the Addams Family points out, however, that Lurch also resembles Morgan, the terrifying mute butler in James Whale's 1932 film *The Old Dark House*—also played by Boris Karloff.[4] In any case, the great attraction of the Addams Family—the factor that led to their enormous spin-off success in television shows, movies, and Broadway musicals—is not just their combination of the familial and creepy, it's the fact that it would be a lot of fun to be an Addams, especially Gomez and Morticia, who have endless self-possession, self-confidence, and wealth, descendants more of Noël Coward than Mary Shelley.

Roz Chast, 2016

ROZ CHAST, like Charles Addams, is a beloved fixture at *The New Yorker*. Her *Bro of Frankenstein* is the direct descendant not of Mary Shelley's creature but of the Addams family. As a child, Chast was obsessed with books of Addams's cartoons. Chast's monsters live in a den suited to the frat boys they seem to be, with their college pennants and girly poster. Her cartoons generally don't inhabit the world of the macabre, but with her unmistakable broken-lined style, she has explored the darkest reaches of the domestic absurd.

Nicholas Hobart, 1983

THE ANGLO-CANADIAN cartoonist Nicholas Hobart contributed over a hundred cartoons to *Punch* in the 1980s and 1990s under the name Nick. Here he raises the not-so-grim possibility that Victor Frankenstein might have got his due, if only he had been able to return to the laboratory. While *Punch* never carried as many Frankenstein cartoons as *The New Yorker* has, the monster was a familiar figure there, too, as early as 1843, when they ran a cartoon with a furious horned monster, the "Irish Frankenstein," raising a shillelagh to a cowering Englishman. (Tenniel's similar cartoon of 1882 was the second.) The use of the creature for race-baiting or fearmongering persisted: a March 1930 cartoon titled "A Frankenstein of the East" shows a huge Indian genie, his turban emblazoned *CIVIL DISOBEDIENCE*, staring down a seated Mohandas Gandhi, saying "And what if I disobey *you?*" The occasion was the Salt March in the spring of 1930, the beginning of a mass campaign led by Gandhi in response to Britain's tax on salt and their repression of Indian salt reclamation. While the genie of civil disobedience seems a long way from the novel, the creature's demand for justice from Victor has in common with the Indian self-rule campaign a fundamental assertion of equity for all. Later *Punch* cartoons more often put *Frankenstein* in a domestic frame or show the creature as highly educated—Nicholas Hobart has made him part of the doctor's team.

"In accepting this Nobel prize on behalf of my colleague..."

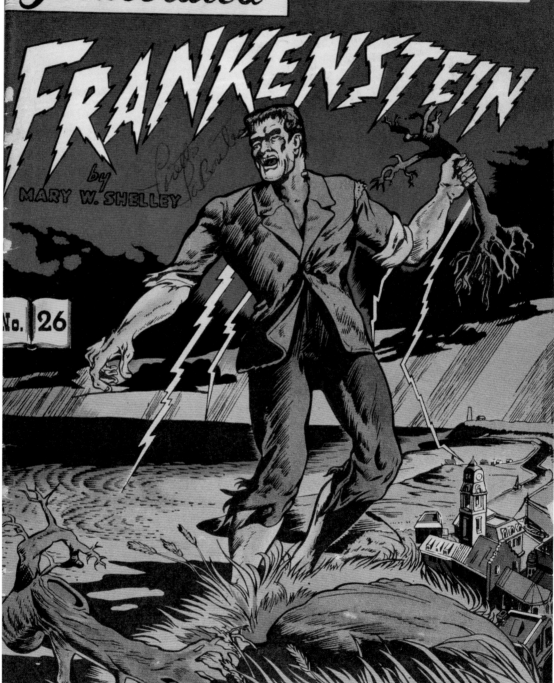

3. COMIC BOOKS

Classics Illustrated, 1945

THE COMIC BOOK as a separate slim magazine first appeared in 1933 as a promotional insert in newspapers. The color and action appealed enormously to young people, and the birth of *Superman* in 1938 made a permanent place for the medium in American, and eventually world, culture. Comic book production is group work: different artists produce the cover and the inside of a book. The penciller makes initial drawings; the inker goes over them; the letterer adds text, written by another colleague; and the colorist adds color. An artist like Dick Briefer, who did all the work on his *Frankenstein* (see below), seems all the more extraordinary by comparison. The Classics Illustrated series had a policy of following the original work. Since this is a faithful comic version of Mary Shelley's novel, Victor Frankenstein's story takes up most of the space. Some readers (including children) take pleasure in this fidelity, and the series may reasonably be seen as training wheels for the novels they represent. Others may agree with the critic who sees both novels and comic books ruined by the slavishness of the adaptations, which are "almost uniformly terrible."[5] In any case, *Frankenstein* was a popular success, and went through nineteen printings between 1945 and 1971. Its first cover avoided copyright infringement liability by giving the gargantuan creature a tan and two thirds of a three-piece suit. He retains the electrodes, and the title text implies his birth through lightning.

Classics Illustrated, 1958

IN 1951 Classics Illustrated raised its prices and replaced its cover art with paintings. The new creature remains enormous, but he is more human-like and better dressed—with shirt and boots as well as a jacket and trousers—and he glances over his shoulder with that quintessential 1950s expression of abject terror. In fact he looks more like a fugitive from a chain gang than a monster. It's not the Red Menace or Senator Joe McCarthy that are pursuing him, though—it's Victor Frankenstein, despite the fact that within the comic book it is the creature who chases Victor across the Arctic ice field. Although a prefatory note shows the creature's hand clutching a bloody piece of paper asking the reader to "dwell with tolerance" on the "incredible life of this nameless monster," the narrative within is sternly against the creature. Victor is clearly his victim, railroaded into agreeing to make a bride because the creature has "driven a devil's bargain." While the last scene of the novel gives the creature a moving soliloquy, this one shows him standing on the ice where the captain (not Walton—that part of the frame narrative has been jettisoned) refuses to save him, saying "'Tis better this way. He is a monster. Polluted by bitter crimes and torn by remorse. Death to him!" It is a cruel ending, and fitting for a cruel moment of American history.

CLASSICS Illustrated

FRANKENSTEIN

MARY W SHELLEY

Featuring Stories by the World's Greatest Authors

No. 26 15¢

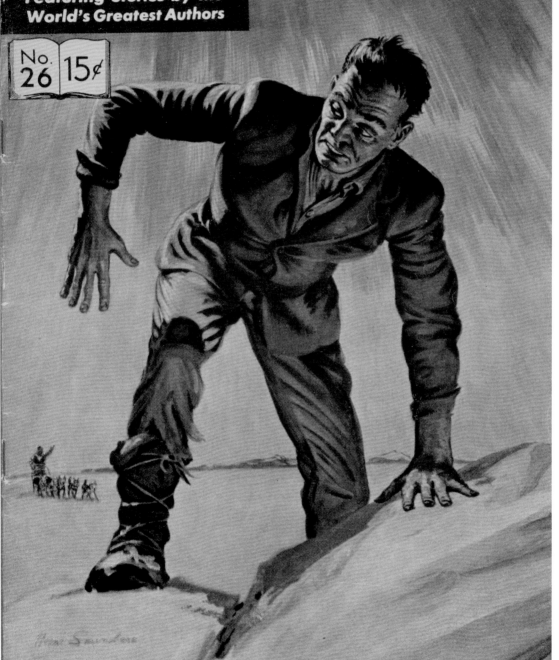

Dick Briefer,
1947 and 1952

DICK BRIEFER published the first comic book *Franken-stein* in December 1940. The long trajectory of his *Franken-stein* series is an object lesson in the creature's adaptability. His creature was never truly ugly: the wide-set eyes and pug nose give him a puppyish charm even when he is smashing through brick walls. But for the first five years of *Frankenstein*'s run, Briefer imagined him to be motivated by the wish to punish Victor Frankenstein with wicked deeds. This means he has to save Frankenstein's life again and again to rub his nose in that wickedness. In the summer of 1945, however, Briefer reframed his work and retitled it *The Monster of Frankenstein.* The creature was tamed and domesticated: "Meet Frankenstein, the merry monster," the promotional art announced.[6] The creature plays

games with children, and his greatest wish is for a peaceful, quiet house full of spiders, rats, and bats. Despite occasional dumb-blonde misogyny, the humorous character has considerable charm. "Frankenstein, the comic Addams style version, was my favorite," Briefer remembered later, referring to his contemporary Charles Addams (see p. 291).[7] In 1949 he put it to bed, but in 1952, at the behest of his publishers, he revived the scary *Frankenstein* with a newly malevolent creature, still with a soft spot for children. Briefer found no joy in this work, and it was killed off by the Comics Code of 1954 that sanitized comic books for decades. Briefer's work is remembered with affection and respect by comic artists, collectors, and historians.

Marvel's Monster of Frankenstein, no. 1

IN 1973 *Frankenstein* was rebooted as a comic with *The Monster of Frankenstein*, with a starring role for the monster and Victor shown only in flashback. The writer, Gary Friedrich, sets the story in 1898. Robert Walton IV, who takes Frankenstein's place as the storyteller, has followed his ancestor's path to the Arctic in search of the creature, whom he finds frozen in a block of ice. Walton's sailors get to work with chisels. With the creature still encased in ice, Walton recounts Frankenstein's history to a cabin boy. The retelling makes the creature heroic: where Mary Shelley's creature befriends the blind De Lacey, Friedrich also has him rescue the now nameless blind man from a ravening wolf. The story is interrupted by a raging storm. Walton's men, who have clearly been reading "The Rime of the Ancient Mariner" or the Book of Jonah, believe the creature is to blame for the bad weather and want to throw him overboard. Walton is knocked unconscious by a falling mast, and the issue ends just as the creature, thawed by a fire in the hold, returns to consciousness. Mike Ploog, the artist, saw the creature as "an outsider seeing everything through the eyes of a child." Ploog's portrayal of him may owe something to the 1968 *Planet of the Apes* film (itself a *Frankenstein* cousin), and his snub nose placed high on the face recalls Dick Briefer's *Frankenstein* in some panels.

Marvel's Monster of Frankenstein, no. 2

UNLIKE the Classics Illustrated version, *The Monster of Frankenstein* didn't try to fit the whole novel into forty-three pages but spread its narrative material over four issues. The second showed readers that the creature is capable of murder. Having saved the cabin boy from the fire, he clambers up the highest mast, carrying the boy as a human shield from the sailors who threaten from below. Here the creature continues the story that Walton began below, describing how he tore the heart from a stranger to help Victor make him a bride. Victor, too, is more violent: when the bride takes her first tottering steps, Victor is appalled at what he has done and stabs her again and again. She lives for only five panels. And yet it is in this issue that the creature is shown at his most sympathetic: the cabin boy, at the top of a mast, tells him, "You're no monster! And I don't think you want to hurt me!" The issue ends without our seeing the crisis resolved, but it is clear that the cabin boy will survive to hear another story. Like the monster's redemptive gratitude in *Young Frankenstein*, the cabin boy's faith is expressive of the 1970s, when kindness seemed to have more of a chance. But, like sharks, comic books must change or die, and after the first four issues, readers saw the creature cloned by the Nazis and joining leagues formed by other Marvel characters. After eighteen issues he suffered the last indignity—discontinuation because of poor sales.

Cover artwork, 1988 and 1994

EVEN THOUGH Classics Illustrated ceased publication in 1971, *Frankenstein* remains popular for faithful retelling. With such adaptations, the opportunity for the greatest originality, and the chance to collar potential readers, is in the cover art. Here we see covers from two such adaptations, both focusing on the creature's face. In 1988 a now-defunct publisher called Eternity put out "an all-new adaptation of the classic horror story" with a cover by J. W. Somerville. The creature's skin is blue; indeed with his spiky black hair and long bony features, this monster looks more like T. P. Cooke than any other twentieth-century representation known to this writer. But where Cooke was attractive, charismatic, even, this cartoon-

ish monster is fractious and angry. His teeth are bared. The stitches over his eyebrow might come from his creation, but they might also come from last night's bar fight. This is a creature who might belong to the Hell's Angels at their worst moment. The cover by Vincent Locke for Caliber Press's version of *Frankenstein,* on the other hand, depicts a beautiful corpse. The creature is slim, androgynous, its skin tones ranging from marble white to damson plum, the sutures on its throat like a girl's necklace. One portrayal emphasizes the creature's destructive energy, the other its vulnerability, and both are the best part of the comics they cover, which are deadly in all senses of the word. Even *Frankenstein* can get tired.

You have not read the book?

IF MARY SHELLEY's novel may be retold too often, its familiarity can also be a source of humor and emotion. *The Eyes of Frankenstein*, 2013, is such a work. An installment in the writer Steve Niles's long-running series *Criminal Macabre* featuring the private eye Cal McDonald, "a pill-popping alcoholic degenerate," *Eyes* is a four-part comic book with art by Christopher Mitten and a cover by Justin Erickson. (The cover shows the creature's face with portraits of Cal and Mo'Locke, his partner in crime fighting, superimposed over one of the creature's eyes.) Cal is part of a war among the supernatural beings

of Los Angeles. One night the police call him to a ruinous library where he finds Frankenstein's creature. "You really should just pick a name," Cal tells him after they have become reacquainted by an exchange of blows. The creature apologizes. "I lost control of myself . . . I am distraught," he tells us, turning to face both the reader and Cal in the next panel to say "I am going *blind.*" This disability will deprive him of his greatest solace: "Reading is all I have." When Cal asks again about his name, the creature tells him, "In the novel, I am called Adam," before asking, "You have not read the book?" Cal shrugs: "I skimmed it."

4. ILLUSTRATORS

Lynd Ward, 1934

LYND WARD combined radical political instincts with his own emotional style, its lines stretched like El Greco's but as precise as William Blake's. While studying printmaking in Germany, Ward—in a life-changing used-book purchase—saw the work of Frans Masereel (1889–1972), a Flemish artist who composed wordless novels, the narrative composed of woodcuts alone. Ward embarked on his own series of picture novels with wood engravings rather than woodcuts. Wood engravings are cut into the end-grain, the hardest part of a piece of wood; their lines are finer and more precise than is possible in woodcuts. As Art Spiegelman puts it: "To make a wood engraving is to insist on the gravitas of an image. Every line is fought for, patiently,

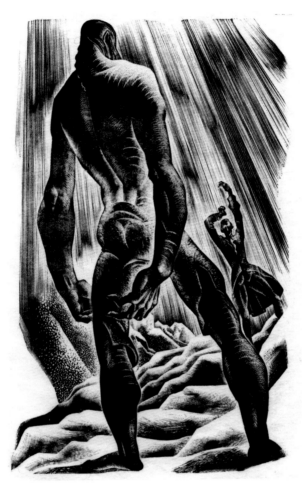

sometimes bloodily."[8] Ward's gravitas is perceptible in the expressionistic rays of light pouring down on the creature as he stands before Victor on the Mer de Glace. It's there, too, in the aspect of the novel that he conveys as few other illustrators do: the sense of the creature's bodily experience. The exaggerated lengths of his awkwardly dangling arms and legs and even the strangely oversized genitals remind the viewer of the fact that the creature is a newborn. Ward describes him as trying to get into Frankenstein's bed. This is not what Mary Shelley wrote: she had the creature only staring at Victor through the bed curtains. But Ward's artistic empathy reminds us that this enormous deathly infant might want to crawl into bed with its father to get warm.

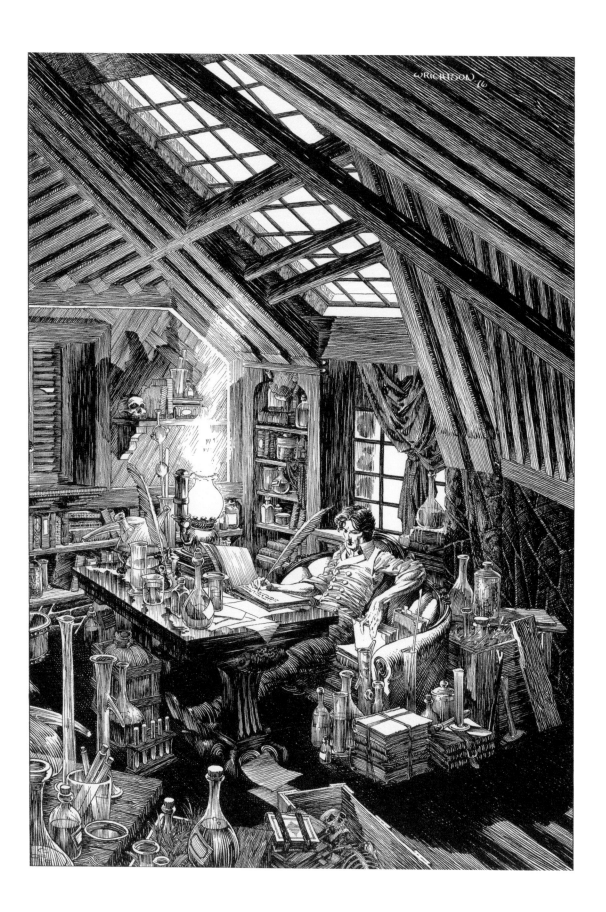

Bernie Wrightson, 1977 and 1978

WHILE Lynd Ward gave us the creature's bodily experience, Bernie Wrightson gave us the literary lives of both Victor Frankenstein and the creature. Wrightson straddles the worlds of illustration and comic books with his several reinterpretations of *Frankenstein*. In 1975 he drew and wrote a seven-page comic book called *Muck Monster*, his own version of the story, in which the creature refuses to come to life because he perceives that he wasn't meant to have it. He embarked on the illustrations for the novel in 1976 and worked on them for six years between paid jobs. Wrightson, celebrated for his detailed work, paid careful attention to every inch of the print showing Victor Frankenstein's study. The creature crouched in the little shed next to the De Laceys' cabin shows his despair at reading what we (presumably) see Frankenstein writing in his study—the journal detailing the filthy work of creation. In the last years of his life, Wrightson returned to *Frankenstein* and, with Steve Niles as the writer, made a comic book sequel to the novel entitled *Frankenstein, Alive, Alive!* (see p. 6). Like Niles's *Criminal Macabre*, this late version of the story is full of black humor: the creature has become part of a sideshow. We watch his patient suffering as yokels make wisecracks—"That ain't Frankenstein! He's 'sposed to have a flat head!" one bleats, and his friend answers "Yeah! Where the heck's his bolts?"[9]

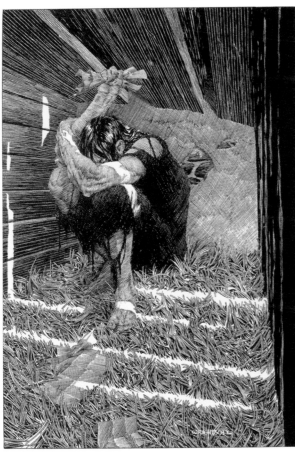

Barry Moser, 1983

Like Henry Fuseli and William Godwin before him, Barry Moser was briefly a Protestant minister. They all went on to different careers, but Moser's work is that of someone who listens to a stern-voiced conscience. When he came to illustrate the creature for his Pennyroyal Press edition, ethical considerations came to mind. The creature, Moser later wrote in an essay, is innocent until he suffers rejection because of his appearance. For this reason, "I decided to use color. Warm color as a metaphor of my empathy with him." Moser added later: "He could have been a Navajo in 1850, or a Japanese-American in 1942, or a Jew in Nazi Germany, or an African-American in Philadelphia, Mississippi, in 1964. For this I gave him color. No one else. Just him." The color develops along with the creature, growing into a "crescendo behind the sequence of black portraits of the demon, imitating the way light falls and modulates from a fire in a fireplace"—the fireplace at which, in the little hut by the Mer de Glace, the creature tells Victor his story.[10]

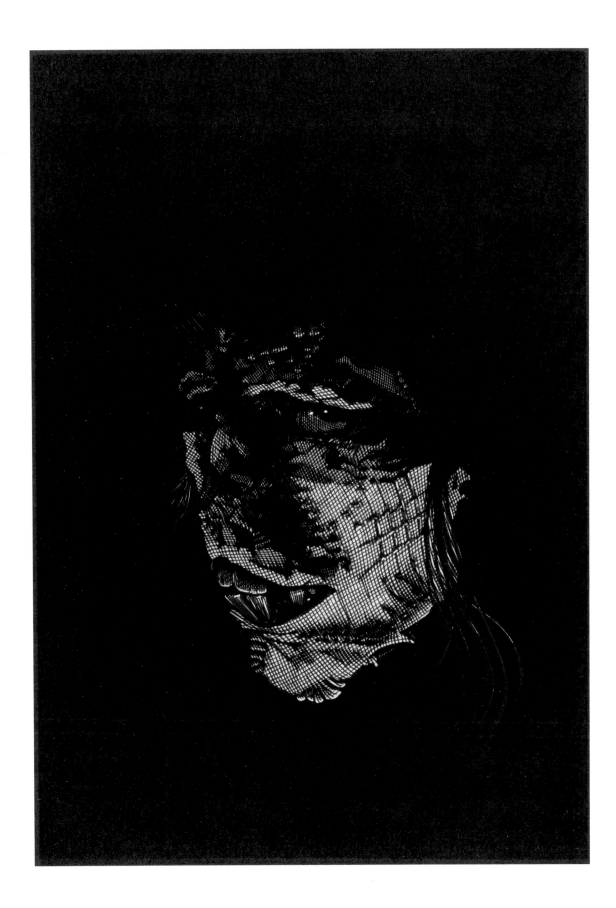

Moser's model for the creature

FOR HIS EDITION of the novel, Barry Moser built his own creature. First, like the mask makers of *I Was a Teen-age Frankenstein* (or God, in Genesis), he used clay, but Moser added it to a plastic replica of a human skull from which he had removed some teeth. With his daughter Ramona he "cut the skins from a couple of pounds of Frank Purdue's chick-en legs and thigh pieces and sewed them into a single, flat membrane," tough work even with upholstery needles. They stretched this membrane across the framework of the mod-eling clay and the skull. Moser cut slits at the ocular orbits and inserted slices of Ping-Pong balls "with irises and pupils drawn on them." After further preparations, omitted here

only for lack of space, he outfitted the head with long black hair and a hat, set it on a tripod in his backyard, and photo⁄graphed the daily decay. "Ultimately," he wrote, "the summer sun rendered all the fat out of the skin which drew it even tighter across the bones and plastilene. And of course the maggots came. Along with the smell. I memorized the writh⁄ing of the maggots and the smell of dead flesh and remem⁄bered them when I re⁄read the words Victor uttered when he had finished sewing together his blatant beast."[11] The dedica⁄tion and the decay are visible in the results. The portraits in the Pennyroyal *Frankenstein* are quite distinct from one an⁄other, though all are hideous and none looks foolish.

Barry Moser, The Frankenstein Family Tomb

A N IMAGE of a quiet graveyard seemed like a fitting envoi for this volume. The creature has no place here, but perhaps Walton will carry Victor's body back for burial with his family. This gray and gloomy place bears a strong resemblance to graveyards of western Massachusetts not far from Moser's home. Its representation falls solidly in the tradition of Gothic art with which this book began, except that here no one is trying to raise the dead, and no nightmares are threatened. While nightmares sometimes come true and rage out of control in the forms of war or weather, Mary Shelley created a nightmare who takes responsibility for himself. Even as his blood still boils at the injustices committed against him, the creature is also "torn by the bitterest remorse," and seeks to complete his murderous work by self-immolation, after which his spirit "will sleep in peace; or if it thinks, it will not surely think thus." So saying, he leaps onto his raft and takes off for his resting place of fire and ice. Soon he is lost to human eyes, borne across the frozen sea in darkness and distance.

NOTES

1. Young 2008, p. 4.

2. Quoted in Young 2008, p. 4.

3. Nicholas Basbanes, blurb for Moser 2000, back cover.

4. Miserocchi 2010, p. 120.

5. Wolk 2007, p. 13.

6. Briefer 2010, p. 17.

7. Briefer 2010, p. 14.

8. Spiegelman, Introduction to Ward 2010, p. xxiv.

9. Wrightson and Niles 2013. In the 1970s, he was working as Berni Wrightson, to distinguish himself from the Olympic diver Bernard Wrightson. Later, he restored the *e.*

10. Moser 2000, pp. 146–47.

11. Moser 2000, p. 146.

ILLUSTRATIONS

40: Francisco de Goya y Lucientes (1746–1828), *El Sueño de la razon produce monstruos,* 1799, etching, aquatint, drypoint, and burin on paper, no. 43 from *Los Caprichos.* The Metropolitan Museum of Art, gift of M. Knoedler & Co., 1918.

42–43: Henry Fuseli (1741–1825), *The Nightmare,* 1781, oil on canvas. Detroit Institute of Arts, Founders Society Purchase with funds from Mr. and Mrs. Bert L. Smokler and Mr. and Mrs. Lawrence A. Fleischman.

46–47: Henry Fuseli, *The Three Witches (or The Weird Sisters),* ca. 1782, oil on canvas. The Huntington Library, Art Collections, and Botanical Gardens; purchased with funds from the George R. and Patricia Geary Johnson British Art Acquisition Fund.

48: Thomas Rowlandson (1756–1827), *The Covent Garden Night Mare,* hand-colored etching on paper, [London]: W. Humphrey, 1784. The Lewis Walpole Library, Yale University.

49: James Gillray (1756–1815), *Wierd-Sisters, Ministers of Darkness, Minions of the Moon,* hand-colored aquatint with etching on paper, London: H. Humphrey, 1791. The Lewis Walpole Library, Yale University.

50: Queen Mab, *The Modern Minerva; or, The Bat's Seminary for Young Ladies, a Satire on Female Education,* London: Macdonald and Son, 1810. The Carl H. Pforzheimer Collection of Shelley and His Circle, The New York Public Library.

51: W. P. after B. G. Esq., hand-colored etching with stipple frontispiece in *Tales of Terror,* London: W. Bulmer and Co., 1801. The Carl H. Pforzheimer Collection of Shelley and His Circle, The New York Public Library.

52: Percy Bysshe Shelley (1792–1822), *Original Poetry, by Victor and Cazire,* Worthing: C. and W. Phillips, 1810. The Carl H. Pforzheimer Collection of Shelley and His Circle, The New York Public Library.

55: Hand-colored etched frontispiece in *Wolfstein; or, The Mysterious Bandit,* London: J. Bailey, ca. 1820–22. The Carl H. Pforzheimer Collection of Shelley and His Circle, The New York Public Library.

55: Hand-colored etched frontispiece in *The Foundling of the Lake: An Original Romance,* London: Thomas Tegg, 1810. The Carl H. Pforzheimer Collection of Shelley and His Circle, The New York Public Library.

58–59: James Gillray, *Tales of Wonder!* etching and aquatint, and watercolor on wove paper, London: H. Humphrey, 1802. The Morgan Library & Museum, bequest of Gordon N. Ray, 1987.

2. *The Spark of Being: Science in* Frankenstein

60: William Blake, frontispiece in *Europe, a Prophecy* (see p. 64).

64: William Blake (1757–1827), color relief etching frontispiece in *Europe, a Prophecy,* Lambeth: Printed by Will. Blake, 1794. The Morgan Library & Museum, gift of Mrs. Landon K. Thorne, 1972.

66–67: Joseph Wright (1734–1797), *An Experiment on a Bird in the Air Pump,* 1768, oil on canvas. The National Gallery, presented by Edward Tyrrell, 1863.

68: Vacuum pump with bell jar, ca. 1800–1850. Smithsonian's National Museum of American History.

71: Gabriel Jacques de Saint-Aubin (1724–1780), *The Lesson of the Chemist Sage at the Hôtel des Monnaies,* 1779, black chalk with smudging, brown and black wash, and opaque white watercolor on laid paper. The Morgan Library & Museum, purchased on the Sunny Crawford von Bülow Fund 1978.

72: Joseph Wright, *The Alchymist, in Search of the Philosopher's Stone, Discovers Phosphorus, and Prays for the Successful Conclusion of His Operation, as Was the Custom of the Ancient Chymical Astrologers,* exhibited 1771, reworked and dated 1795, oil on canvas. Derby Museums Trust.

75: Moses Haughton (1773–1849) after Henry Fuseli, stipple and engraved frontispiece in Erasmus Darwin (1731–1802), *The Temple of Nature; or, The Origin of Society, a Poem, with Philosophical Notes,* London: Joseph Johnson, 1803. The Morgan Library & Museum, bequest of Gordon N. Ray, 1987.

76: William Hogarth (1697–1764), *The Reward of Cruelty,* ca. 1751, red chalk with smudging, squared in graphite, on laid paper, incised with stylus; verso rubbed with red chalk for transfer. The Morgan Library & Museum, purchased by Pierpont Morgan in 1909.

78: William Austin (1721/33–1820), *Anatomist Overtaken by the Watch,* 1773, hand-colored etching. The Carl H. Pforzheimer Collection of Shelley and His Circle, The New York Public Library.

79: Surgical kit, ca. 1790, instruments by William Pepys and others. The New York Academy of Medicine Library.

80–81: Benoît Pecheux (1779–1831), plate no. 4, etching and engraving, in Giovanni Aldini (1762–1834), *Essai théorique et expérimental sur le galvanisme, avec une série d'expériences faites en présence des commissaires de l'Institut national de France, et en divers amphithéatres anatomiques de Londres,* Paris: De l'imprimerie de Fournier fils, 1804. The Morgan Library & Museum, purchased on the Gordon N. Ray Fund, 2016.

3. *Romantic Childhoods*

4. *The Summer of 1816*

123: Armand Cuvillier, *Genève vu de Cologny (séjour de Lord Byron)*, color lithograph on paper, Geneva: Briquet & fils, Imp. Lemercier, Paris, 1803. Bibliothèque de Genève, Centre d'iconographie genevoise.

125: George Gordon Byron, Lord Byron (1788–1824), "Darkness," manuscript in the hand of Claire Clairmont, 1816. John Murray Archive, National Library of Scotland.

126–27: John William Polidori (1795–1821), *The Vampyre*, London: Sherwood, Neely, and Jones, 1819. The Morgan Library & Museum, bequest of Gordon N. Ray, 1987.

128–29: Percy Bysshe Shelley, letter to Thomas Love Peacock, 22–25 July and 2 August 1816. The Morgan Library & Museum, purchased by Pierpont Morgan before 1913.

130–31: Mary Wollstonecraft Shelley and Percy Bysshe Shelley, *History of a Six Weeks' Tour Through a Part of France, Switzerland, Germany, and Holland, with Letters Descriptive of a Sail Round the Lake of Geneva and of the Glaciers of Chamouni*, London: T. Hookham, Jun. and C. and J. Ollier, 1817. The Morgan Library & Museum, purchased by Pierpont Morgan before 1906.

5. Frankenstein *in Her Time*

132: Marek Oleksicki (born 1979), *Castle Frankenstein*, illustration in Warren Ellis (born 1968), *Frankenstein's Womb*, Rantoul, Illinois: Avatar Press, 2009. Collection of John Bidwell.

136–37: Mary Wollstonecraft Shelley, *Frankenstein*, 1816–17; MS Abinger c. 56, fol. 20v–21r. The Bodleian Libraries, University of Oxford.

140–41: Mary Wollstonecraft Shelley, *Frankenstein*, 1816–17; MS Abinger c. 56, fol. 58v–59r. The Bodleian Libraries, University of Oxford.

142–43: Mary Wollstonecraft Shelley, *Frankenstein*, 1816–17; MS Abinger c. 56, fol. 61v–62r. The Bodleian Libraries, University of Oxford.

146–47: Mary Wollstonecraft Shelley, *Frankenstein*, 1816–17; MS Abinger c. 57, fol. 1v–2r. The Bodleian Libraries, University of Oxford.

148: Harry Brockway (born 1958), *The Monster in the Hovel*, wood engraving in a suite of prints containing illustrations made for Mary Wollstonecraft Shelley, *Frankenstein; or, The Modern Prometheus*, London, The Folio Society, 2004. The Morgan Library & Museum, purchased on the Gordon N. Ray Fund, 2016.

150–51: Title page and frontispiece, etching and engraving, in Constantin-François de Chasseboeuf, comte de Volney (1757–1820), *The Ruins; or, A Survey of the Revolutions of Empires*, 2nd ed., London: Printed for J. Johnson, 1795. The Carl H. Pforzheimer Collection of Shelley and His Circle, The New York Public Library.

152–53: Title page and frontispiece by John Dadley (1767–1817) after Edward Francis Burney (1760–1848), etching and engraving with stipple, in *A Selection of the Lives of Plutarch*, London: R. Phillips, [1800]. The Morgan Library & Museum, purchased in 1986.

154: Jean-Baptiste Blaise Simonet (1742–1813?) after Moreau le Jeune (1741–1814), *C'est pour la dernière fois*, etching and engraving, plate in an extra-illustrated copy of Johann Wolfgang von Goethe (1749–1832), *Die Leiden des jungen Werthers*, Leipzig: In der Weygandschen Buchhandlung, 1774. The Morgan Library & Museum, bequest of Gordon N. Ray, 1987.

156: Manuscript inscription of Percy Bysshe Shelley in a copy of Milton's *Paradise Lost*.

157: First page of text, John Milton (1608–1674), *Paradise Lost: A Poem, in Twelve Books*, edited by John Hawkey, Dublin: Printed by S. Powell, for the editor, 1747. Department of Rare Books and Special Collections, Princeton University Library.

158: Title page, Mary Wollstonecraft Shelley, *Frankenstein; or, The Modern Prometheus*, London: Lackington, Hughes, Harding, Mavor & Jones, 1818. The Morgan Library & Museum, purchased by Pierpont Morgan in 1910.

159: Paste paper boards on a copy of Mary Wollstonecraft Shelley, *Frankenstein; or, The Modern Prometheus*, 3 vols., London: Lackington, Hughes, Harding, Mavor & Jones, 1818. The Carl H. Pforzheimer Collection of Shelley and His Circle, The New York Public Library.

161: Claire Clairmont, letter to George Gordon Byron, Lord Byron, 12 January 1818. John Murray Archive, National Library of Scotland. The text of this letter is published in Clairmont 1995, Vol. 1, p. 111.

162–63: Percy Bysshe Shelley and Mary Wollstonecraft Shelley, joint letter to Claire Clairmont, 2 April 1821. The Carl H. Pforzheimer Collection of Shelley and His Circle, The New York Public Library.

164: Miniature portrait of Margaret King Moore, Lady Mount Cashell (1772–1835), ca. 1831, watercolor on ivory. The Carl H. Pforzheimer Collection of Shelley and His Circle, The New York Public Library.

165: Ivory alphabet discs and cylindrical container, inscribed and hand colored, after 1824. The Carl H. Pforzheimer Collection of Shelley and His Circle, The New York Public Library.

167: The author's manuscript revisions in Mary Wollstonecraft Shelley, *Frankenstein; or, The Modern Prometheus*, London: Lackington, Hughes, Harding, Mavor & Jones, 1818. The Morgan Library & Museum, purchased by Pierpont Morgan in 1910.

6. *Living On*

168: Portrait of Mary Shelley (see p. 181).

172: Portrait of Percy Bysshe Shelley, attributed to Edward Ellerker Williams (1793–1822), 1822, watercolor over black chalk and graphite on wove paper. The Morgan Library & Museum, gift of Mrs. W. Murray Crane, 1949.

174–75: Percy Bysshe Shelley, "Indian Serenade," 1821–22, autograph manuscript. The Morgan Library & Museum, purchased by Pierpont Morgan, 1907.

177: William Bell Scott (1811–1890), *Shelley's Grave in the New Protestant Cemetery at Rome*, 1873, oil on canvas. Ashmolean Museum of Art and Archaeology, University of Oxford.

178: Percy Bysshe Shelley, *Posthumous Poems*, London: John and Henry L. Hunt, 1824. The Morgan Library & Museum, purchased in 1910.

180: Percy Bysshe Shelley, skull fragments, 1822. The Carl H. Pforzheimer Collection of Shelley and His Circle, The New York Public Library.

181: Richard Rothwell (1800–1868), portrait of Mary Wollstonecraft Shelley, painted 1831, exhibited 1840, oil on canvas. National Portrait Gallery, London.

183: Mary Wollstonecraft Shelley, *The Last Man*, 3 vols., London: Henry Colburn, 1826. The Carl H. Pforzheimer Collection of Shelley and His Circle, The New York Public Library.

184: T. H., *The Grocer*, etching and engraving, London: W. B. Cooke, 1828. The Lewis Walpole Library, Yale University.

185: George Cruikshank (1792–1878), *Tugging at a High Eye Tooth*, colored etching, London: G. Humphrey, 1821. Graphic Arts Collection, Department of Rare Books and Special Collections, Princeton University Library.

186: Mary Wollstonecraft Shelley, *The Fortunes of Perkin Warbeck*, London: G. Routledge & Co., 1857. The Carl H. Pforzheimer Collection of Shelley and His Circle, The New York Public Library.

188–89: William Chevalier (1804–1866) after Theodor von Holst (1810–1844), frontispiece and title-page vignette, etching and engraving with stipple, in Mary Wollstonecraft Shelley, *Frankenstein*, London: Henry Colburn and Richard Bentley, 1831. The Morgan Library & Museum, purchased in 1968.

191: Mary Wollstonecraft Shelley, letter to Charles Ollier, [February–early March 1831?]. The Carl H. Pforzheimer Collection of Shelley and His Circle, The New York Public Library.

7. Frankenstein *on Stage and Screen*

194: *Mr Cooke dans le rôle du monstre* (see p. 259).

198: Lyceum Theatre, *This Evening, Monday, July 28th, 1823, Will be produced (for the First Time) an entirely new Romance of a peculiar interest, entitled Presumption! Or, The Fate of Frankenstein*, London: s.n., 1823. The Morgan Library & Museum, purchased on the Gordon N. Ray Fund, 2015.

201: Lyceum Theatre, *This present Tuesday, July 13, 1824, will be acted the Comedy of John Bull . . . To conclude with, for the 3d time at this Theatre, (by permission of S. J. Arnold, Esq.) the highly popular Romance, of peculiar and terrific interest, called Presumption: Or, The Fate Of Frankenstein. The Musick composed by Mr. Watson*, London: Printed by W. Reynolds, 1824. The Morgan Library & Museum, purchased on the Cary Fund, 1998.

202: Lyceum Theatre, *Last Night but Two of Mr. Mathews' Engagement . . . Mr. T. P. Cooke every Evening, as The Monster, in Presumption; or, the Fate of Frankenstein*, London: Lowndes, 1826. The Carl H. Pforzheimer Collection of Shelley and His Circle, The New York Public Library.

205: Theatre Royal, Plymouth, *Mr. Sandford most respectfully begs leave to acquaint the Nobility, Gentry, his Patrons, and the Public generally that he has been fortunate enough to engage that most distinguished and justly Celebrated Actor, Mr. T. P. Cooke*, Plymouth: Nettleton, 1833. The Carl H. Pforzheimer Collection of Shelley and His Circle, The New York Public Library.

206: Nathaniel Whittock (1791–1860) after Thomas Charles Wageman (1787–1863), *Mr. T. P. Cooke, of the Theatre Royal Covent*

Garden, in the Character of the Monster in the Dramatic Romance of Frankenstein, lithograph, London, 1832–34. The Carl H. Pforzheimer Collection of Shelley and His Circle, The New York Public Library.

207: Pierre-Jacques Feillet (1794–1855) after N. G., *Zametti. C'est lui! Ô désespoir! . . . Le monstre et le magicien. Mr. Cooke, rôle du monstre, Mr. Ménier, rôle de Zametti*, lithograph, Paris: Bezou, 1826. The Carl H. Pforzheimer Collection of Shelley and His Circle, The New York Public Library.

208: Jean-François Villain after ***, *Théâtre de la Porte St. Martin. Le Monstre, acte premier, scène dernière*, 1826, hand-colored lithograph. Département des Arts du spectacle—Bibliothèque nationale de France.

211: *Mr. O. Smith as the Monster*, frontispiece, etching and engraving with stipple, Henry M. Milner, *Frankenstein; or, The man and the monster! A peculiar romantic, melo-dramatic pantomimic spectacle, in two acts.* London: printed and published by J. Duncombe, [1826]. The Carl H. Pforzheimer Collection of Shelley and His Circle, The New York Public Library.

212–13: Hoster, *Théâtre de L'Ambigu-Comique . . . Aujourd'hui samedi 22 juin 1861 . . . Le Monstre et le magicien, drame-fantastique à grand spectacle, cinq actes et onze tableaux . . . représentations de M. François Ravel, mime américain, rôle du monstre . . . rentrée de M. Castellano, rôle de Zametti le magicien*, 1861, color lithograph. Département des Estampes et de la Photographie—Bibliothèque nationale de France.

214: *Le Monstre et le magicien . . . Ambigu-Comique*, souvenir fan, 1861, color lithograph. Matthieu Biger (CPHB Collection).

217: Gaiety Theatre, *Frankenstein*, London: Waterlow & Sons, 1887. Performing Arts Research Collections, The New York Public Library.

218: *The Edison Kinetogram* 2, no. 4, 15 March 1910. Courtesy of Special Collections and Institute Archives, California Institute of the Arts Library.

220: *Carl Laemmle Presents Frankenstein, the Man Who Made a Monster*, color lithograph, Cleveland: Morgan, 1931. Stephen Fishler, comicconnect.com.

222: Garrett Fort (1900–1945) and Francis Edwards Faragoh (1895–1966), *Frankenstein*, typescript screenplay, 12 August 1931. Billy Rose Theatre Division, New York Public Library for the Performing Arts, gift of Philip Riley, 1990.

224–25: Boris Karloff (1887–1969) in *The Bride of Frankenstein*, photograph by Roman Freulich, 1935. The John Kobal Foundation.

226: Jack Pierce (1889–1968) making up Boris Karloff for *The Bride of Frankenstein*, photograph by Roman Freulich, 1935. The John Kobal Foundation.

229: Jason S. Joy (1886–1959), letter to Carl Laemmle, Jr. (1908–1979), 18 August 1931. MPAA Production Code Administration Records, Margaret Herrick Library, Academy of Motion Picture Arts & Sciences.

230–31: Colin Clive in *Frankenstein*, movie clip, 1931.

234–35: Gavin Gordon (1901–1983), Elsa Lanchester (1902–1986), and Douglas Walton (1901–1961) in *The Bride of Frankenstein*, photograph, 1935. Core Collection. Production Files, Margaret Herrick Library, Academy of Motion Picture Arts & Sciences.

236: *Carl Laemmle Presents Karloff in The Bride of Frankenstein*, Los Angeles: Universal Studios, ca. 1935. Core Collection. Production Files, Margaret Herrick Library, Academy of Motion Picture Arts & Sciences.

239: Elsa Lanchester and Boris Karloff in *The Bride of Frankenstein*, photograph, 1935. Core Collection. Production Files, Margaret Herrick Library, Academy of Motion Picture Arts & Sciences.

240: Josephine Turner (1909–2003) and Leland Crawford, reproduction of wig for Elsa Lanchester in *The Bride of Frankenstein*, 1991. Courtesy of Museum of the Moving Image, New York, gift of Josephine Turner and Leland Crawford.

241: Elsa Lanchester in *The Bride of Frankenstein*, photograph, 1935. The John Kobal Foundation.

242: Gene Wilder (1933–2016), third draft script for *Young Frankenstein*, typescript, 1974. This copy belonged to the makeup artist William Tuttle (1912–2007) and contains his notes on the "green pancake mix" he devised for Peter Boyle (1935–2006). William Tuttle Papers, Margaret Herrick Library, Academy of Motion Picture Arts & Sciences.

245: William Tuttle, portrait of Peter Boyle in *Young Frankenstein*, 1974, graphite and opaque watercolor on illustration board. William Tuttle Papers, Margaret Herrick Library, Academy of Motion Picture Arts & Sciences.

246: Peter Boyle in *Young Frankenstein*, color photograph, 1974. Gift of Steve Newman, Core Collection. Production Files, Margaret Herrick Library, Academy of Motion Picture Arts & Sciences.

249: Robert De Niro (born 1943) in *Mary Shelley's Frankenstein*, photograph, 1994. Core Collection. Production Files, Margaret Herrick Library, Academy of Motion Picture Arts & Sciences.

250: Daniel Parker, torso model of Robert De Niro's makeup for his role as the creature in *Mary Shelley's Frankenstein*, fiberglass, 1994. Harry Ransom Center, University of Texas, Austin.

252: Title-page vignette, wood engraving, Richard Brinsley Peake (1792–1847), *Frankenstein: A Romantic Drama*, London: Dicks' Standard Plays, ca. 1863–78. The Carl H. Pforzheimer Collection of Shelley and His Circle, The New York Public Library.

254: John R. Neill (1877–1943), illustration in L. Frank Baum (1856–1919), *John Dough and the Cherub*, Chicago: Reilly and Britton, 1906. Cotsen Children's Library, Department of Rare Books and Special Collections, Princeton University Library.

255: Creation scene in *Frankenstein*, movie clip, 1910. Courtesy of the Library of Congress, Moving Image Section.

256–57: Edward Van Sloan (1882–1964), Colin Clive, and Dwight Frye in *Frankenstein*, photograph by Roman Freulich, 1931. The John Kobal Foundation.

259: Alexandre Cheyère after Henri Daniel Plattel (1803–1859), *Mr. Cooke dans le rôle du monstre*, color lithograph, [Paris]: Genty, [1826]. Bibliothèque de l'Arsenal—Bibliothèque nationale de France.

259: Pierre-Jacques Feillet after Victor (active 1830–40), *Zametti. Je m'offre à tes coups, mais, mon fils épargne ses jours!*, ca. 1826, lithograph. The Carl H. Pforzheimer Collection of Shelley and His Circle, The New York Public Library.

260: Boris Karloff and Marilyn Harris (1924–1999) in *Frankenstein*, photograph, 1931. Core Collection. Production Files, Margaret Herrick Library, Academy of Motion Picture Arts & Sciences.

263: Peter Boyle and Anne Beesley in *Young Frankenstein*, photograph, 1974. Core Collection. Production Files, Margaret Herrick Library, Academy of Motion Picture Arts & Sciences.

264: Lady Caroline Lamb (1785–1828), *Nude Woman in Bed, Stabbed in the Heart by Cupid, His Hand Guided by a Skeletal Spectre*, ca. 1810–28, watercolor and pencil on card, mounted in an album. The Carl H. Pforzheimer Collection of Shelley and His Circle, The New York Public Library.

266–67: Mae Clarke (1910–1992) and Boris Karloff in *Frankenstein*, photograph by Roman Freulich, 1931. William Friedkin Papers, Margaret Herrick Library, Academy of Motion Picture Arts & Sciences.

268: Mach Tey, dust jacket, Mary Wollstonecraft Shelley, *Frankenstein; or, The Modern Prometheus*, New York: Grosset & Dunlap, ca. 1931. The Morgan Library & Museum, purchased on the Gordon Ray Fund, 2016.

270: Lynd Ward (1905–1985), wood-engraved illustration in Mary Wollstonecraft Shelley, *Frankenstein; or, The Modern Prometheus*, New York: Harrison Smith and Robert Haas, 1934. Collection of Robert Dance.

271: Cover artwork, Mary Wollstonecraft Shelley, *Frankenstein; or, The Modern Prometheus*, New York: Lion Books, 1953. The Carl H. Pforzheimer Collection of Shelley and His Circle, The New York Public Library.

272: Ernest Thesiger, Elsa Lanchester, and Colin Clive in *The Bride of Frankenstein*, photograph, 1935. The Museum of Modern Art.

8. Frankenstein *Delineated*

274: Bernie Wrightson, *Accursed Creator!* (see p. 311).

279: *Bud Abbott and Lou Costello Meet Frankenstein*, 1948, color offset lithograph poster. Poster Collection, Margaret Herrick Library, Academy of Motion Picture Arts & Sciences.

280: *Bride of the Monster*, 1956, color offset lithograph poster. Poster Collection, Margaret Herrick Library, Academy of Motion Picture Arts & Sciences.

283: *I Was a Teenage Frankenstein*, 1958, color offset lithograph poster. Poster Collection, Margaret Herrick Library, Academy of Motion Picture Arts & Sciences.

284: *Frankenstein 1970*, 1958, color offset lithograph poster. Poster Collection, Margaret Herrick Library, Academy of Motion Picture Arts & Sciences.

286: *Frankenstein Conquers the World*, 1966, color offset lithograph poster. Poster Collection, Margaret Herrick Library, Academy of Motion Picture Arts & Sciences.

289: *Andy Warhol's Frankenstein*, 1974, color offset lithograph poster. Poster Collection, Margaret Herrick Library, Academy of Motion Picture Arts & Sciences.

290: Charles Addams (1912–1978), *Boiling Oil*, cartoon in *The New Yorker*, 21 December 1946. © 1946 Charles Addams, renewed 1975, with permission Tee and Charles Addams Foundation.

292: Roz Chast (born 1954), *Bro of Frankenstein*, cartoon in *The New Yorker*, 21 November 2016. Cartoon Bank.

293: Nicholas Hobart (born 1939), *In accepting this Nobel prize on behalf of my colleague . . .*, cartoon in *Punch*, 21 December 1983. © Punch Limited.

294: Robert Hayward Webb (1915–2000) and Ann Brewster (1918–2005), cover art, *Frankenstein*, Classics Illustrated no. 26, New York: Gilberton Co., 1945. The Carl H. Pforzheimer Collection of Shelley and His Circle, The New York Public Library.

297: Norman Saunders (1907–1989), cover art, *Frankenstein*, Classics Illustrated no. 26, New York: Gilberton Co., 1958. The Carl H. Pforzheimer Collection of Shelley and His Circle, The New York Public Library.

298: Dick Briefer (1915–1980), cover art, *Frankenstein*, no. 10, New York: Prize Comics, Nov.–Dec. 1947. From the collection of Craig Yoe and Clizia Gussoni.

299: Dick Briefer, cover art, *Frankenstein*, no. 21, New York: Prize Comics, Oct.–Nov. 1952. From the collection of Craig Yoe and Clizia Gussoni.

300: Mike Ploog (born 1942), cover art, *The Monster of Frankenstein*, no. 1, New York: Marvel Comics Group, January 1973. The Carl H. Pforzheimer Collection of Shelley and His Circle, The New York Public Library.

303: Mike Ploog, cover art, *The Monster of Frankenstein*, no. 2, New York: Marvel Comics Group, March 1973. The Carl H. Pforzheimer Collection of Shelley and His Circle, The New York Public Library.

304: J. W. Somerville, cover art, *Mary Shelley's Frankenstein: The Legend Retold*, no. 1, Newbury Park, CA: Eternity Comics, 1990. Collection of John Bidwell.

305: Vincent Locke, cover art, *Frankenstein; or, The Modern Prometheus*, Livonia, MI: Caliber Press, 1994. Collection of John Bidwell.

306: Justin Erickson, cover art, Michelle Madsen, colors, *Criminal Macabre: The Eyes of Frankenstein*, no. 1, Milwaukie, OR: Dark Horse Comics, 2013. Collection of John Bidwell.

307: Christopher Mitten, art, Steve Niles (born 1965), text, Michelle Madsen, colors, Nate Piekos (born 1975), letters, *Criminal Macabre: The Eyes of Frankenstein*, no. 1, Milwaukie, OR: Dark Horse Comics, 2013. Collection of John Bidwell.

308: Lynd Ward, *The Newly Created Monster Tries to Get into Victor Frankenstein's Bed*, proof wood engraving for an illustration in Mary Wollstonecraft Shelley, *Frankenstein; or, The Modern Prometheus*, New York: Harrison Smith and Robert Haas, 1934. Eberly Family Special Collections Library, Pennsylvania State University Libraries.

309: Lynd Ward, *The Monster and Victor Frankenstein Encounter Each Other in the Swiss Alps, in a Field of Ice*, proof wood engraving for an illustration in Mary Wollstonecraft Shelley, *Frankenstein; or, The Modern Prometheus*, New York: Harrison Smith and Robert Haas, 1934. Eberly Family Special Collections Library, Pennsylvania State University Libraries.

310: Bernie Wrightson (1948–2017), *The Stars Often Disappeared in the Light of Morning Whilst I Was Yet Engaged in My Laboratory*, offset lithograph in Mary Wollstonecraft Shelley, *Frankenstein; or, The Modern Prometheus*, New York: Tyrannosaurus Press, 1977. The Morgan Library & Museum, purchased on the Gordon N. Ray Fund, 2017.

311: Bernie Wrightson, *Accursed Creator! Why Did You Form a Monster So Hideous That Even You Turned from Me in Disgust?*, offset lithograph in *Mary Shelley's Frankenstein*, New York: Tyrannosaurus Press, 1978. The Morgan Library & Museum, purchased on the Gordon N. Ray Fund, 2017.

313: Barry Moser (born 1940), *My Organs Were Indeed Harsh*, wood engraving in Mary Wollstonecraft Shelley, *Frankenstein; or, The Modern Prometheus*, West Hatfield, MA: Pennyroyal Press, 1983. The Morgan Library & Museum, gift of Jeffrey P. Dwyer.

314: Barry Moser, *No Father Had Watched My Infant Days*, wood engraving in Mary Wollstonecraft Shelley, *Frankenstein; or, The Modern Prometheus*, West Hatfield, MA: Pennyroyal Press, 1983. The Morgan Library & Museum, gift of Jeffrey P. Dwyer.

315: Barry Moser, *Divine Sounds Enchanted Me*, wood engraving in Mary Wollstonecraft Shelley, *Frankenstein; or, The Modern Prometheus*, West Hatfield, MA: Pennyroyal Press, 1983. The Morgan Library & Museum, gift of Jeffrey P. Dwyer.

317: Barry Moser, *The Frankenstein Family Tomb*, wood engraving in Mary Wollstonecraft Shelley, *Frankenstein; or, The Modern Prometheus*, West Hatfield, MA: Pennyroyal Press, 1983. The Morgan Library & Museum, gift of Jeffrey P. Dwyer.

Back endpapers: Barry Moser, *Arctic Landscape, 4*, wood engraving in Mary Shelley, *Frankenstein; or, The Modern Prometheus*, West Hatfield, MA: Pennyroyal Press, 1983. The Morgan Library & Museum, gift of Jeffrey P. Dwyer.

WORKS CITED IN ABBREVIATED FORM

Barbauld 1773

Anna Laetitia Aikin Barbauld, "The Mouse's Petition," in *Poems* (1773), in Romantic Circles Electronic Editions, accessed 5/6/2017.

Biger 2014

Pierre-Henri Biger, "*Le Monstre et le magicien,* un éventail de théâtre, de mode et d'actualité," in *Le Vieux Papier* 40 (2014), pp. 265–71 and plates VI–VII.

Blake 1790

William Blake, *The Marriage of Heaven and Hell,* London, 1790.

Briefer 2010

Dick Briefer, *Dick Briefer's Frankenstein,* edited by Craig Yoe, San Diego, 2010.

Brown 2003

Marshall Brown, "*Frankenstein:* A Child's Tale," in *Novel: A Forum on Fiction* 36, no. 2 (2003), pp. 145–75.

Byron 1976

'So late into the night': Byron's Letters and Journals, Vol. 5, 1816–1817, edited by Leslie A. Marchand, London, 1976.

Cameron 1974

Kenneth Neill Cameron, *Shelley: The Golden Years,* Cambridge, MA, 1974.

Cardwell 2004

Donald Cardwell, "Andrew Ure, 1778–1857," in *Oxford Dictionary of National Biography,* Oxford, 2004, accessed 7/9/2017.

Clairmont 1970

Claire Clairmont, *Journal,* in *Shelley and His Circle,* edited by Kenneth Neill Cameron, Cambridge, MA, 1970 [1814], Vol. 3, pp. 342–75.

Clairmont 1995

The Clairmont Correspondence: Letters of Claire Clairmont, Charles Clairmont, and Fanny Imlay Godwin, 2 vols., edited by Marion Kingston Stocking, Baltimore, 1995.

Clément 1988

Catherine Clément, *Opera; or, The Undoing of Women,* translated by Betsy Wing, Minneapolis, 1988.

Crook 2000

Nora Crook, "Mary Shelley, Author of *Frankenstein,*" in *A Companion to the Gothic,* edited by David Punter, Oxford, 2000, pp. 58–69.

Curtis 1998

James Curtis, *James Whale: A New World of Gods and Monsters,* London, 1998.

Darwin 1803

Erasmus Darwin, *The Temple of Nature; or, The Origin of Society: A Poem, with Philosophical Notes,* London, 1803.

Donald 1996

Diana Donald, *The Age of Caricature: Satirical Prints in the Reign of George III,* New Haven, 1996.

Doody 1977

Margaret Anne Doody, "Deserts, Ruins, and Troubled Waters: Female Dreams in Fiction and the Development of the Gothic Novel," *Genre* 10 (1977), pp. 529–72.

Douthwaite 2009

Julia Douthwaite with Daniel Richter, "The Frankenstein of the French Revolution: Nogaret's Automaton Tale of 1790," *European Romantic Review* 20:3 (2009), pp. 381-411.

Forry 1990

Steven Earl Forry, *Hideous Progenies: Dramatizations of* Frankenstein *from Mary Shelley to the Present*, Philadelphia, 1990.

Frayling 2006

Christopher Frayling, "Fuseli's *The Nightmare:* Somewhere Between the Sublime and the Ridiculous," in *Gothic Nightmares: Fuseli, Blake, and the Romantic Imagination*, edited by Martin Myrone, London, 2006, pp. 9-20.

Frayling and Myrone 2006

Christopher Frayling and Martin Myrone, "The Nightmare in Modern Culture," in *Gothic Nightmares: Fuseli, Blake, and the Romantic Imagination*, edited by Martin Myrone, London, 2006, pp. 207-212.

Godwin 1798

William Godwin, *Memoirs of the Author of A Vindication of the Rights of Woman*, in Vol. 1, *Collected Novels and Memoirs of William Godwin*, edited by Mark Philp, London, 1992 [1798].

Goya 1799

Francisco Goya y Lucientes, *Los Caprichos*, New York, 1969 [1799].

Guerlac 1976

Henry Guerlac, "Sage, Balthazar-Georges," in *Dictionary of Scientific Biography*, Vol. 12, edited by Charles Coulston Gillespie, New York, 1976.

Heilbron 1976

J. L. Heilbron, "Volta, Alessandro Giuseppe Antonio Anastasio," in *Dictionary of Scientific Biography*, Vol. 14, edited by Charles Coulston Gillespie, New York, 1976.

Jacobs 2011

Stephen Jacobs, *Boris Karloff: More than a Monster: The Authorised Biography*, Sheffield, UK, 2011.

Lanchester 1983

Elsa Lanchester, *Elsa Lanchester, Herself*, New York, 1983.

Lewis 1796

Matthew Gregory Lewis, *The Monk*, New York, 1952 [1796].

Linebaugh 1992

Peter Linebaugh, *The London Hanged: Crime and Civil Society in the Eighteenth Century*, Cambridge, 1992.

Miserocchi 2010

H. Kevin Miserocchi, *The Addams Family: An Evilution*, New York, 2010.

Moser 2000

Barry Moser, *In the Face of Presumptions: Essays, Speeches & Incidental Writings*, edited by Jessica Renaud, Boston, 2000.

Moskal 1996

Jeanne Moskal, "Appendix 2: 'Mounseer Nongtongpaw,'" in Mary Shelley, *Travel Writing*, edited by Jeanne Moskal, in Vol. 8 of *Novels and Selected Works of Mary Shelley*, general editor Nora Crook, London, 1996.

Myrone 2006

Martin Myrone, "Witches and Apparitions," in *Gothic Nightmares: Fuseli, Blake, and the Romantic Imagination*, edited by Martin Myrone, London, 2006, pp. 123-45.

Nicolson 1968

　Benedict Nicolson, *Joseph Wright of Derby, Painter of Light*, 2 vols., London, 1968.

Peck 1925

　Walter Edwin Peck, "Shelley, Mary Shelley, and Rinaldo Rinaldini," *Publications of the Modern Language Association* 40:1 (1925), pp. 165–71.

Poe 1846

　Edgar Allan Poe, "The Philosophy of Composition," 1846, accessed through the website of the Poetry Foundation, 8/27/2017.

Powers 2017

　Jonathan Powers, *Searching for the Philosopher's Stone: The Story Behind Joseph Wright's* Alchymist, Derby, UK, 2017.

Queen Mab 1810

　Queen Mab, *The Modern Minerva; or, The Bat's Seminary for Young Ladies, a Satire on Female Education*, London, 1810.

Richardson 1987

　Ruth Richardson, *Death, Dissection, and the Destitute*, London, 1987.

Robinson 1996

　Charles E. Robinson, "Chronology," in Mary W. Shelley, *The Frankenstein Notebooks*, edited by Charles E. Robinson, part 1, New York, 1996.

Seymour 2000

　Miranda Seymour, *Mary Shelley*, London, 2000.

Shelley 1817

　Mary W. and Percy B. Shelley, *History of a Six Weeks' Tour Through a Part of France, Switzerland, Germany, and Holland: With Letters Descriptive of a Sail Round the Lake of Geneva and of the Glaciers of Chamouni*, London, 1817.

Shelley 1818

　Mary W. Shelley, *Frankenstein; or, The Modern Prometheus*, edited by Marilyn Butler, Oxford, 1998 [1818].

Shelley 1980

　Mary W. Shelley, *The Letters of Mary Wollstonecraft Shelley*, 3 vols., edited by Betty T. Bennett, Baltimore, 1980–88.

Shelley 1987

　Mary W. Shelley, *The Journals of Mary Shelley 1814–1844*, edited by Paula Feldman and Diana Scott-Kilvert, Baltimore, 1987.

Shelley 1996

　Mary W. Shelley, *The Fortunes of Perkin Warbeck, a Romance*, edited by Doucet Devin Fischer, in Vol. 5 of *Novels and Selected Works of Mary Shelley*, general editor Nora Crook, London, 1996.

Stott 2013

　Andrew McConnell Stott, *The Vampyre Family: Passion, Envy, and the Curse of Byron*, Edinburgh, 2013.

Ure 1819

　Andrew Ure, "An Account of Some Experiments Made on the Body of a Criminal Immediately After Execution, with Physiological and Practical Observations," in *The Quarterly Journal of Science, Literature, and the Arts* 6 (1819), London, pp. 283–95.

Verhoeven 2006

　Wil Verhoeven, "Gilbert Imlay and the Triangular Trade," *The William and Mary Quarterly*, Third Series, 63, no. 4 (October 2006), pp. 827–42.

Walpole 1796

 Horace Walpole, *Horace Walpole's Miscellaneous Correspondence*, 48 vols., edited by W. S. Lewis and John Riely, New Haven, 1980 [1796].

Ward 2010

 Lynd Ward, *Gods' Man; Madman's Drum; Wild Pilgrimage*, edited by Art Spiegelman, New York, 2010.

Wolk 2007

 Douglas Wolk, *Reading Comics: How Graphic Novels Work and What They Mean*, Cambridge, MA, 2007.

Wollstonecraft 1792

 Mary Wollstonecraft, *A Vindication of the Rights of Woman*, edited by Miriam Brody, New York, 1992 [1792].

Wrightson and Niles 2013

 Bernie Wrightson and Steve Niles, *Frankenstein Alive! Alive!*, San Diego, 2013.

Young 2008

 Elizabeth Young, *Black Frankenstein: The Making of an American Metaphor*, New York, 2008.

ACKNOWLEDGMENTS

John Alexander, Sylvie Aubenas, Ross Auerbach, Lucy Bamford, B. C. Barker-Benfield, Jacques Berchtold, Sheelagh Bevan, Pierre-Henri Biger, Nicole Bouché, Michael P. Burton, Charles C. Carter, Jean-Marc Chatelain, Linden Chubin, Anne Coco, Simon Crocker, Nora Crook, Steven Crossot, Hope Cullinan, Jacqueline Z. Davis, Sandrine Decoux, Daniel Dibbern, Derick Dreher, Matt Edwards, Patricia Emerson, Christine Falcombello, Stephen Ferguson, Doucet Devin Fischer, Stephen Fishler, Benoît Forgeot, Daniel Friedman, Meredith Gamer, Peter Gammie, Anne Garner, Adrian Giannini, Margaret Grandine, Karen Green, Judith Guston, Graham Haber, Kiowa Hammons, Matthew Hargraves, Deborah Hautzig, Sean Hayes, Stephen Hebron, Joël Huthwohl, Andrea L. Immel, Athena Jackson, Dawn Jaros, Keith Johnson, William P. Kelly, Declan Kiely, Bob Kosovsky, Joy Ladin, Thomas Lannon, Nicole Leist, David McClay, David McNeff, Patrick McQuillan, John McQuillen, John Marciari, Amy Meyers, Barbara Miller, Kevin Miserocchi, Kaitlin Mondello, Anne Morra, Barry Moser, Yvette Mugnano, Christine Nelson, Laura O'Brien-Miller, Wendy Olson, Marilyn Palmeri, Martin Parsekian, Lucy Peltz, Gloria C. Phares, Jannette Pinson, Jonathan Powers, Liza Rawson, Sonja Reid, Douglas Reside, Cynthia Roman, Jenny Romero, Patrizia Roncadi, Kevin Salatino, Salvador Salort-Pons, Roger Sherman, Eric Shows, Madeline Slaven, Brena Smith, Bridget Smith, Reba Snyder, Eva Soos, David Spurr, Deirdre C. Stam, Sandra Stelts, Deborah Straussman, Gabriel A. Swift, Jennifer Tonkovich, Annemarie van Roessel, John Walako, Leila Walker, Henry Wessells, Frederick C. Wiebel, Jr., George R. Willeman, Steve Wilson, Paula Zadigian.

◖ FOR THE MORGAN LIBRARY & MUSEUM

Karen Banks, *Publications Manager*
Patricia Emerson, *Senior Editor*
Eliza Heitzman, *Assistant Editor*
Olivia Maccioni, *Editorial Assistant*

◖ PROJECT STAFF

John Bidwell, *Astor Curator and Department Head, Printed Books and Bindings; Curatorial Chair*

Marilyn Palmeri, *Imaging and Rights Manager*
Eva Soos, *Imaging and Rights Associate Manager*
Kaitlyn Krieg, *Imaging and Rights Administrative Assistant*
Graham S. Haber, *Photographer*
Janny Chiu, *Assistant Photographer*

The Morgan wishes to thank Min Tian.

◖ Designed by Jerry Kelly
Typeset in Nonpareil Foundry Centaur,
A-I Koch Antiqua, and Maximillian CS

◖ For D Giles Limited: Produced by GILES,
an imprint of D Giles Limited, London

◖ Printed by Friesens

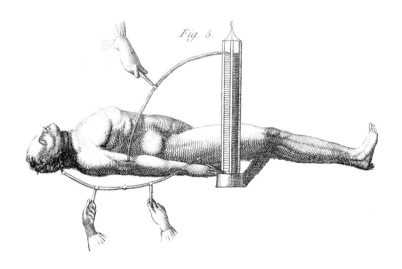

Fig. 5.